MODERN PHOTOGRAPHIC EXPLORER

WORLD WAR II
BATTLEFIELDS

BATTLE SITES TODAY

MODERN PHOTOGRAPHIC EXPLORER

WORLD WAR II
BATTLEFIELDS

BATTLE SITES TODAY

PAUL WOODADGE

amber
BOOKS

First published in 2022

Copyright © 2022 Amber Books Ltd

Published by Amber Books Ltd
United House
London N7 9DP
United Kingdom
www.amberbooks.co.uk
Facebook: amberbooks
Instagram: amberbooksltd
Twitter: @amberbooks
Pinterest: amberbooksltd

ISBN: 978-1-83886-157-5

Editor: Michael Spilling
Designer: Mark Batley
Picture research: Terry Forshaw

Printed in China

Contents

Introduction

ORLD WAR II was without doubt the most calamitous and costly conflict in human history. Few areas anywhere across the globe escaped the ravages of the first truly modern war, where the death toll ran to tens of millions and the devastation to towns and cities took decades to repair. It led to the end of old empires, the emergence of new ones and the creation of the United Nations, a global initiative intended to prevent such events from happening again.

Yet, despite the wanton destruction and the almost incomprehensible human cost of the war, people around the world are still fascinated by it. Podcasts and internet discussions about the battles and leaders are becoming increasingly popular, movies are still

being made depicting the events and the ongoing quest for new literature is seeing more books being published year on year. This book is primarily a photographic study of the conflict, combining famous and iconic contemporary images with stunning modern images – some from underneath the waves and others taken from the air by drone.

It is hoped that by bringing together these images the reader will be reminded of the breadth and scope of the war. All who read about history tend to do so through the lens of nationality. For the people of the United Kingdom it is the Blitz, the Battle of Britain and perhaps the Battle of Normandy that shape their understanding of the struggle. For Russians it is the epic battles for Moscow, Leningrad and Stalingrad

World War II Memorial, Washington, D.C., United States
Dedicated in 2004, the memorial is designed to commemorate the fallen of World War II. The design includes 56 pillars, representing US states and territories, and two small triumphal arches for the Atlantic and Pacific theatres.

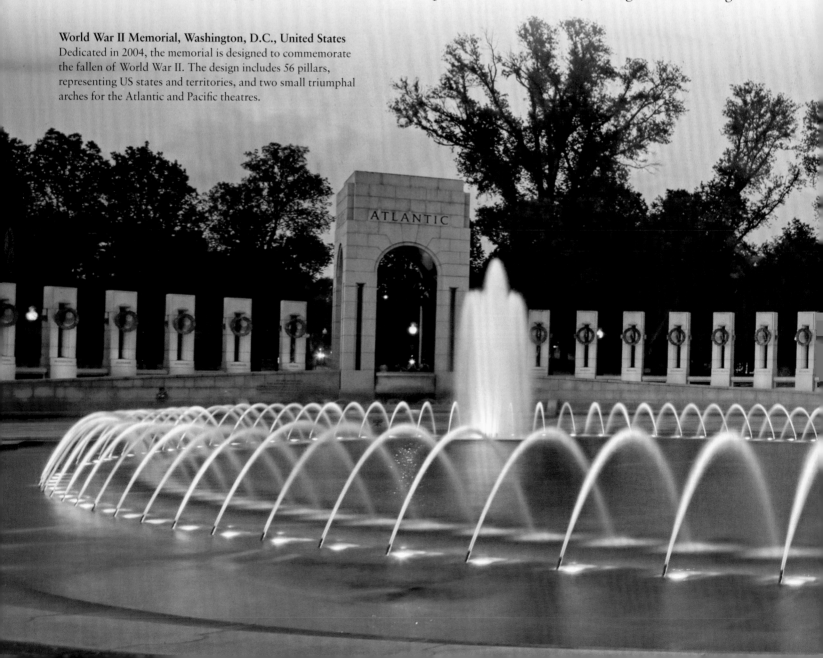

that resonate. Even the start and end dates of the war change as one traverses the globe. For the United States, it is the surprise attack on Pearl Harbor on 7th December 1941 that heralded their entry into the war. A year earlier while Britain and France talked about the so-called 'Phoney War' of the spring of 1940, the Nazi regime had already killed tens of thousands in Poland and other territories. However, many scholars now include the Sino-Japanese War of 1937 as being the true beginning of the conflict.

This book includes photos of battlefield locations the reader will be familiar with and others that will probably have them reaching for an atlas. Every photograph has a caption summarising the battle or campaign depicted and the reader can follow the history of the war across the world just from the images. The accompanying text provides a broader perspective on the overall aims and objectives of each theatre of operations, with greater detail about overarching themes such as logistics, air and sea power and leadership.

The book is not an exhaustive list of battles and campaigns, and neither is it a definitive history of the war. It will, however, take the reader on a journey across several continents and numerous countries to tropical islands, barren deserts, sprawling cities and war-scarred fortifications. Some battlefields are resplendent with striking monuments and museums honouring the sacrifices of the past. Others have been completely transformed and show no signs of their dramatic history. The reader will see bullet-holed buildings, vast concrete bunkers and rusting wrecks – all of which pay silent witness to the fleets and armies that have long since departed.

– Paul Woodadge

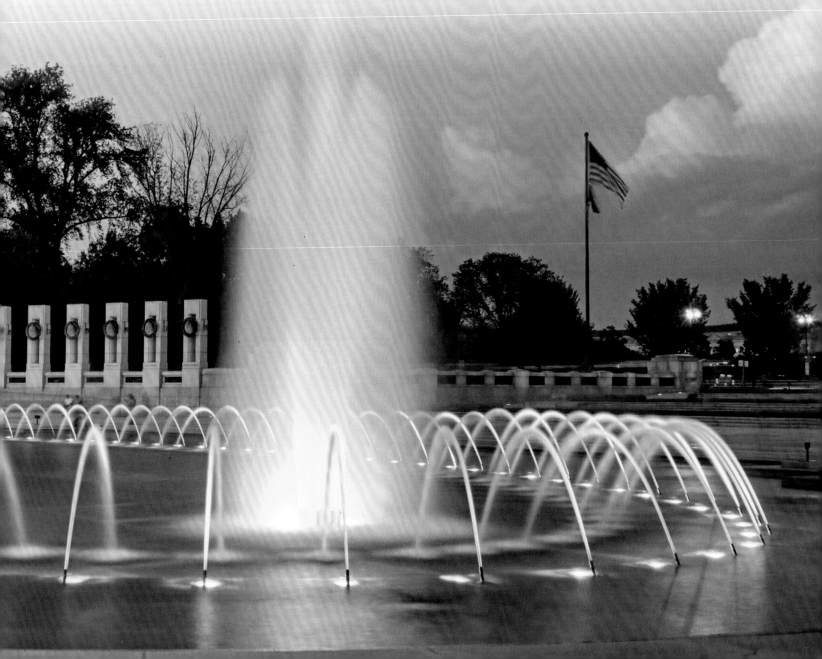

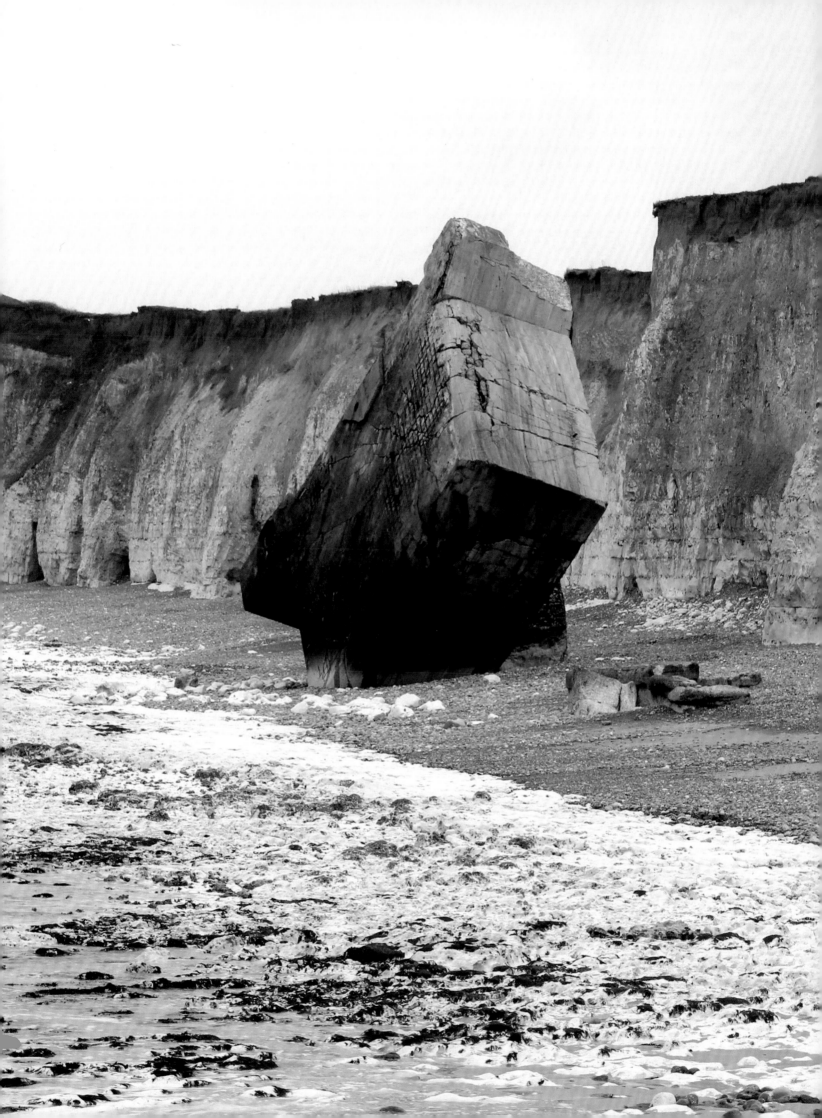

Western Europe

War clouds had been gathering over Western Europe for a considerable time before war broke out with the invasion of Poland by Germany on 1 September 1939. Indeed, it is argued that it was almost a continuation (after an uneasy two-decade hiatus) of issues left unsettled by the Great War. Although the period between September 1939 and May 1940 is referred to as one of inactivity, it presents a false view of events. The Royal Air Force's Bomber Command began operations almost immediately and, though restricted by the number of aircraft available and their limited range, German targets including airfields and harbours were attacked. The damage caused by these raids was minimal, but Britain was sending a clear message to Hitler to not underestimate her resilience. The losses, however, were worryingly high; on 18 December 1939, half of a raiding force of 22 Vickers Wellingtons was shot down by German fighters on a mission against shipping off Wilhelmshaven. Meanwhile at sea, the Royal Navy began anti-shipping activity by mine-laying off Britain's ports, and together with the French Navy commenced a blockade of Germany. Across Great Britain the population braced itself for war and possible invasion. Barrage balloons were deployed, 28,000 pillboxes were built to defend strategic points and 400 million sandbags were piled around the entrances to public buildings.

OPPOSITE:
German bunkers, Quiberville, Normandy, France
Remains of the Atlantic Wall can still be seen and explored on the beaches of Normandy. Built to defend the Reich, they are now part of the French landscape but are gradually succumbing to erosion and damage.

THE BATTLE FOR NORWAY

The German invasion on 8–9 April 1940 was not the
first action in Norway. It followed the Altmark incident
of 16 February, when the destroyer HMS Cossack
entered Norwegian territorial waters and intercepted
and boarded the German auxiliary ship Altmark. Both
Germany and Great Britain had ignored Norway's
neutrality, largely because of its resources including
iron ore and fish oil – the oil being an ingredient
in both lubricants and in the manufacture of high
explosives, including nitroglycerin.

Within three weeks the southern part of Norway
including Oslo had fallen. A noble but doomed attempt
to deny Norway's resources to the Germans and
keep them from using its ports – vital to Germany's
operations in the Atlantic – led to the sea battles
for Narvik and the landing of a British, French and
Polish expeditionary force of 38,000 soldiers around
Trondheim.

Though it had moderate success, it ultimately
exposed many of the shortcomings of Allied tactical
thinking that were to plague the expeditionary force

ABOVE & RIGHT:
Trondheim, Norway
When the citizens of the port of Trondheim drew their curtains and went
to bed on 8 April 1940 they did so as free Norwegians. When they awoke
the next morning, five German war ships were anchored in the harbour
and German infantry had occupied the city. Within just nine weeks,
despite valiant attempts by the British to drive the Germans from the
country, Norway had been occupied.

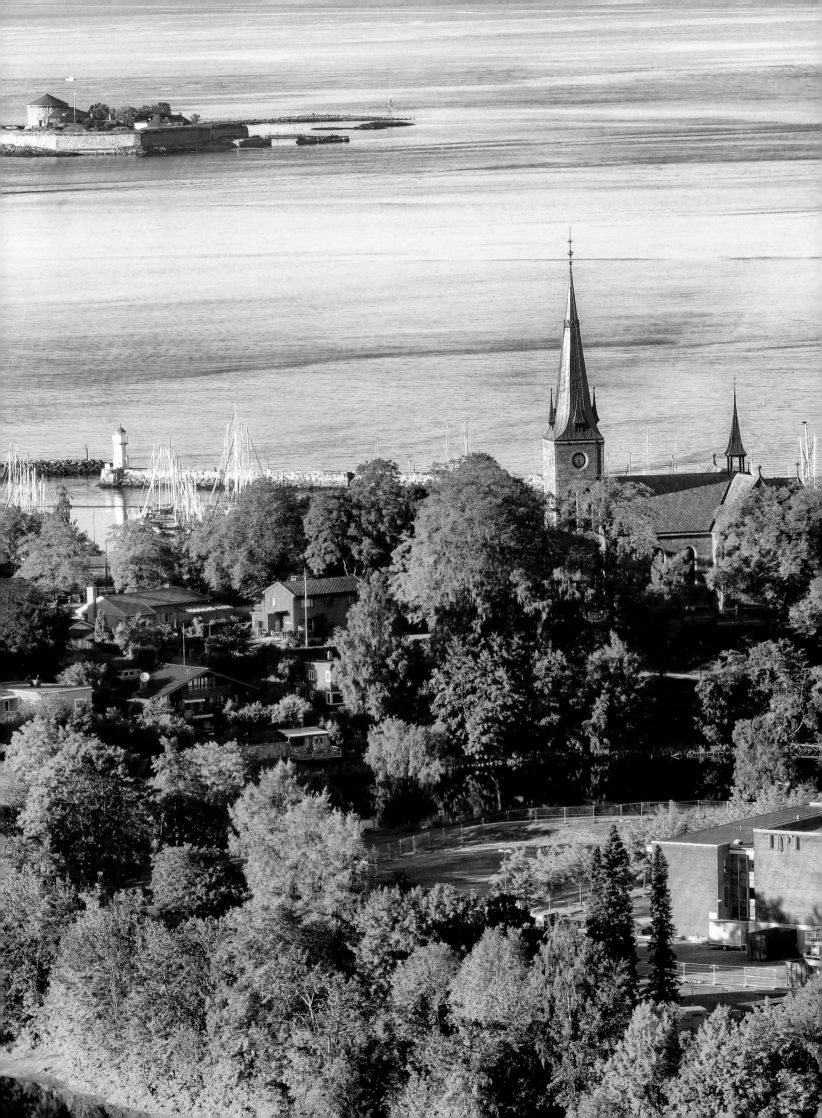

ALL PHOTOGRAPHS:
Fort Eben-Emael, Belgium
The capture of Fort Eben-Emael close to Belgium's border with the Netherlands is now famous as the war's first gliderborne attack.

At dawn on 10 May 1940 German DFS 230 gliders crammed with assault troops landed directly on the roof of the fort. Deplaning swiftly, within minutes they had secured the position and destroyed most of the Belgian guns with brand new 'shape-charge' explosives. Eben Emael had been the central link of 12 fortified positions in the Visé gap, through which it was always anticipated that German forces would pour when they began their invasion of the Low Countries.

With its loss, all of Belgium would be open to invasion, which would in turn lead to Allied forces being pushed all the way back to Dunkirk.

and the French Army in the Battle for France that began on 10 May, namely slow communications, a lack of coordination between ground, sea and air operations and poor equipment.

The loss of Norway became inevitable; its government sought exile in London and the country was fully occupied by Germany. However, crucial losses and damage to Germany's warships at Narvik meant that the Kriegsmarine never really recovered from the losses sustained there, which in the immediate aftermath prevented it from affecting the evacuation of Dunkirk or supporting an invasion of Britain.

INVASION OF FRANCE AND THE LOW COUNTRIES

For troops of the British Expeditionary Force (BEF) the town names were famous: Passchendaele, Arras and Messines, their fathers having fought there two

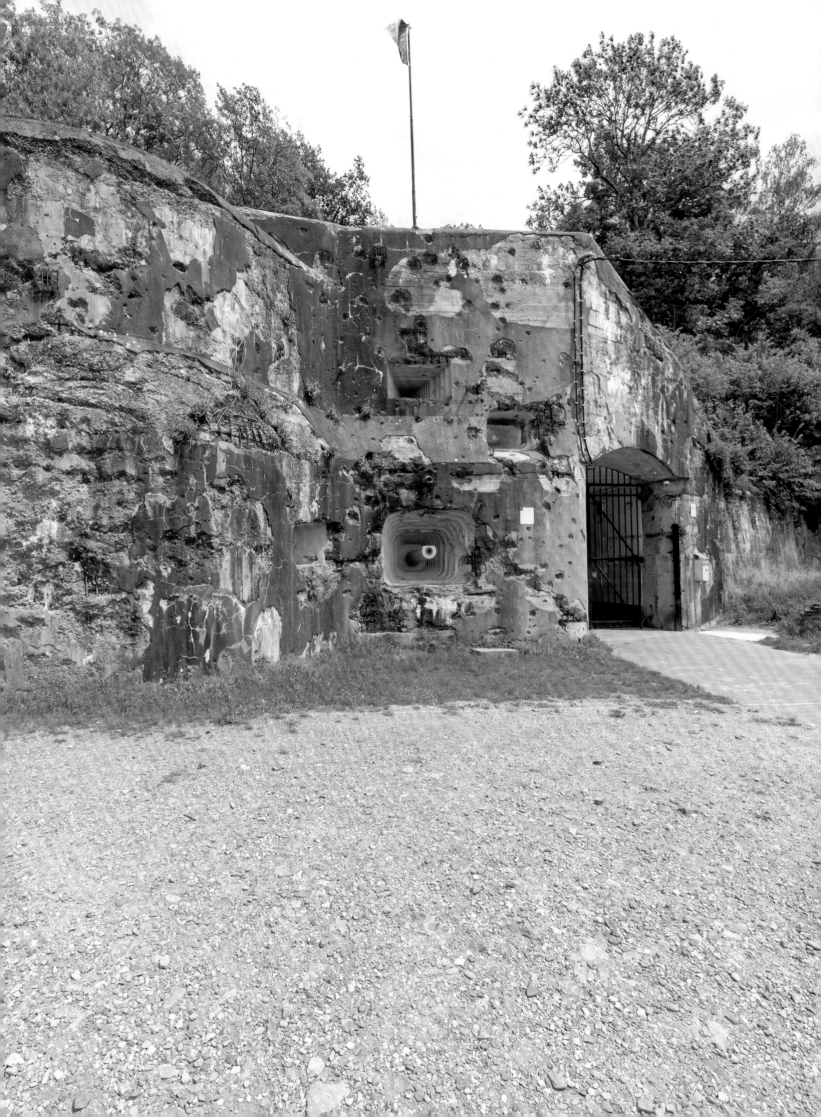

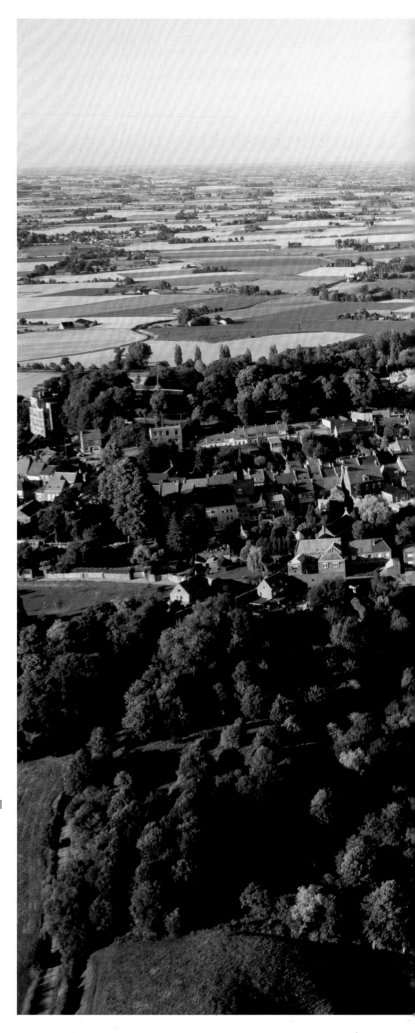

decades earlier. The places were familiar, but the campaign unleashed by the Germans was not. Blitzkrieg was a new concept. Fast-moving columns of tanks and mobile units supported by Stuka dive-bombers in the air had torn through the Netherlands and Belgium and now faced France.

On paper, the combined strength of the French and British Armies was enough to withstand the German threat, but much of the Allied leadership was poor and modern communications were lacking – the French Army especially relying on telephone lines and runners. General Heinz Guderian's successful armoured thrust through the Ardennes forest was due as much to his mastery of communications as it was to surprise. The pace of the German advance towards the Channel was so fast that the rear echelon could not

Cassel, Nord, France
With a history dating back to the Iron Age, the strategic importance of the hill town of Cassel, with its dominating views to the coast 32km (20 miles) away, is obvious to all who visit. (Serving as capital to a Belgic tribe called the Menapii, it was from this area that a rebellion was fought against Julius Caesar until quelled in 53 BCE.) While men of the BEF fell back to the Dunkirk perimeter, a rearguard action took place between 25 and 29 May 1940 at Cassel and Hazebrouck on the western perimeter of the escape route to the beach.

This perimeter was organized by General Ronald Adam, who, having relinquished command of III Corps, was instructed by Lord Gort in Dunkirk to hold the two towns until the last man. Although Hazebrouck was overwhelmed quite quickly, Cassel, in its strategic position overlooking French Flanders, held out for much longer. Adam's troops included Territorials of the 4th Oxfordshire and Buckinghamshire Light Infantry and Regulars from the 2nd Battalion Gloucestershire Regiment who, together with other ad-hoc units, set up an effective defence, with anti-tank guns covering the narrow streets and approaches. For three days the position held firm, but as German air attacks intensified and ground attacks persisted the situation soon became hopeless. Much of Cassel was destroyed by the bombing and many of the gallant defenders were killed or captured. But their noble defence bought valuable time for the men awaiting rescue on the beaches of Dunkirk.

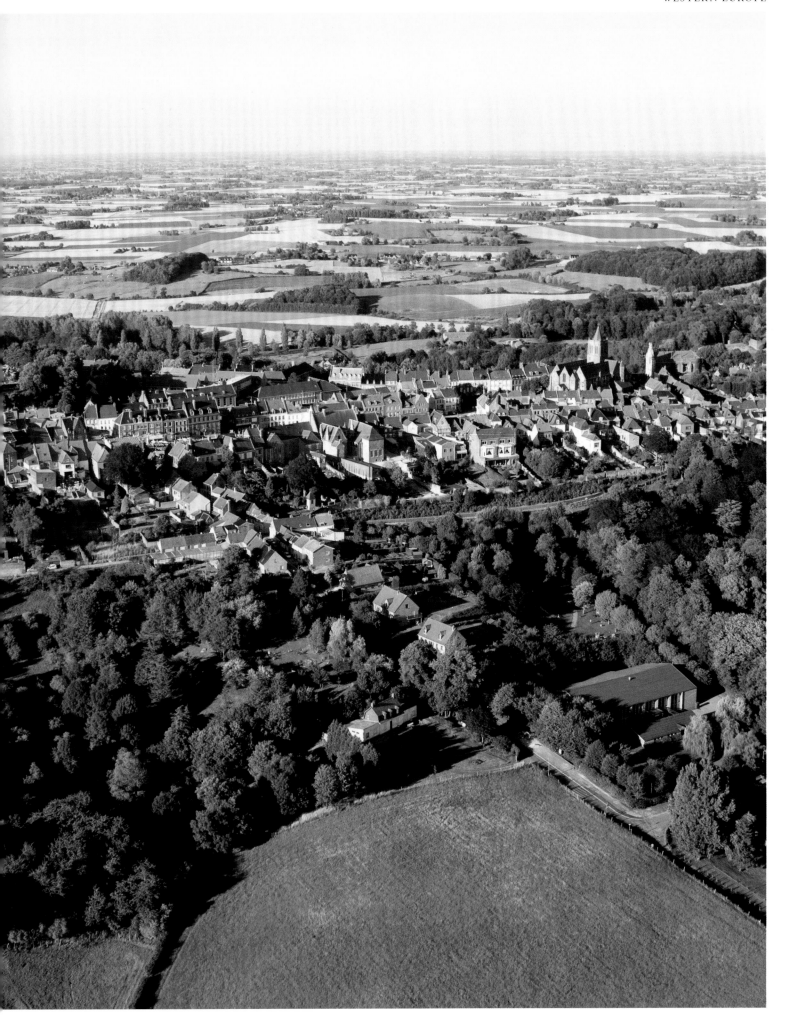

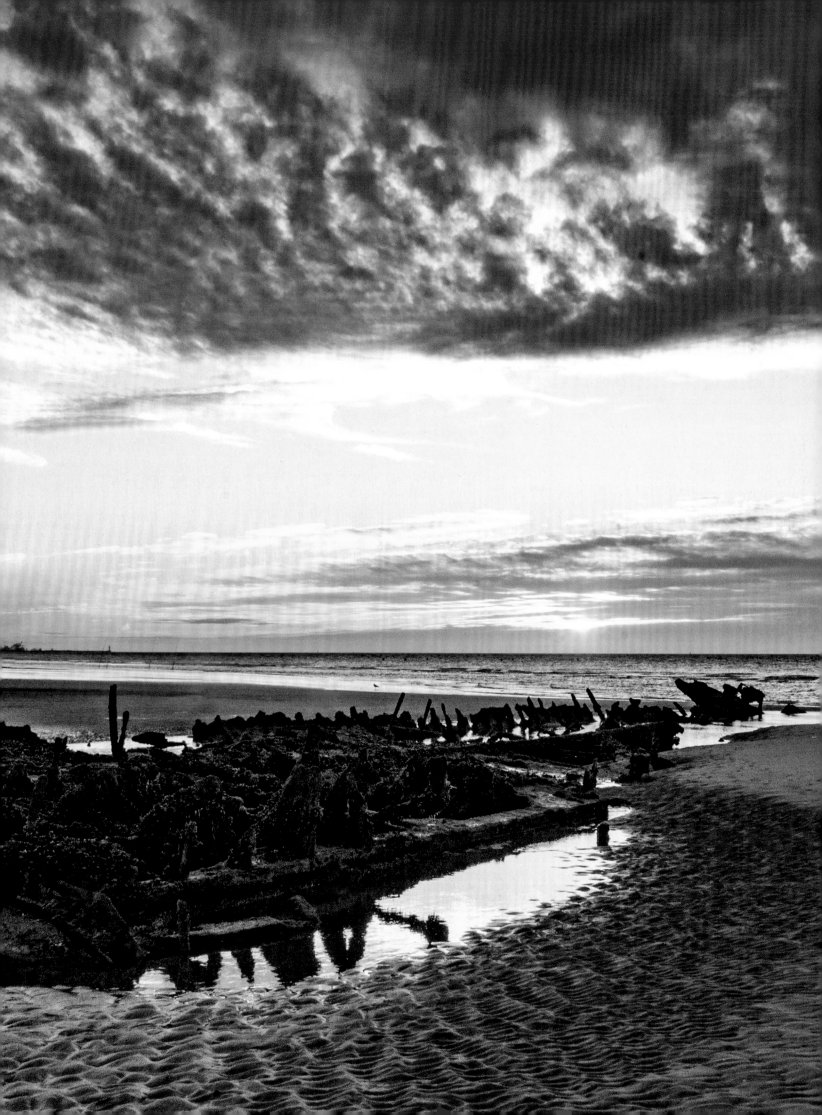

Dunkirk beach, northern France
The barnacled hulks of several vessels lost during Operation Dynamo, which sit partially buried on the sands of Dunkirk and Bray-Dunes, are visible reminders of the events of May 1940. The successful evacuation of most of the British Expeditionary Force (BEF), along with troops from other countries, is quite rightly regarded as one of the greatest rescue operations in military history. It was a brilliant combination of planning, dash and efficiency and is a testament to the calm leadership of its primary architect, Admiral Bertram Ramsay. But the successful evacuation of 338,226 troops was also dependant on the heroic last-stand defensive actions of 40,000 British and French units located elsewhere, such as in Calais and inland from the Dunkirk perimeter. Most of these defenders became prisoners of war, spending the next five long years in captivity. Some prisoners, however, fell victim to the murderous actions of the SS and were killed in cold blood in places like Wormhoudt and Le Paradis. Their deaths should be remembered alongside the stirring stories of the 'Little Ships' on the beaches.

always keep up, and, for reasons that are still debated by historians, Guderian's forces halted short of the beaches. This bought the British the time they needed to evacuate the BEF from Dunkirk and prepare for the defence of Great Britain.

BRITAIN STANDS ALONE

A popular myth is that, following the Battle of France, Britain stood alone against the Nazis. The metaphorical image of prime minister Churchill clenching his fist in defiance across the Channel endures to this day. Of course, it's far from being true.

In 1940, Britain had a massive empire, the largest navy in the world and volunteers from Norway, Denmark, Czechoslovakia, Poland, the Netherlands, Belgium and France joined troops from the Dominions to stand shoulder to shoulder alongside the people of Britain. For example, newsreels delighted in showing Indian units, fresh from the fighting in France, parading through the streets of England.

If the Germans were to launch Operation Sealion, the invasion of Britain, they would need to eliminate the Royal Air Force first. This led to one of the defining battles of 1940, the Battle of Britain, which involved crews from a host of countries. The pilots of Fighter

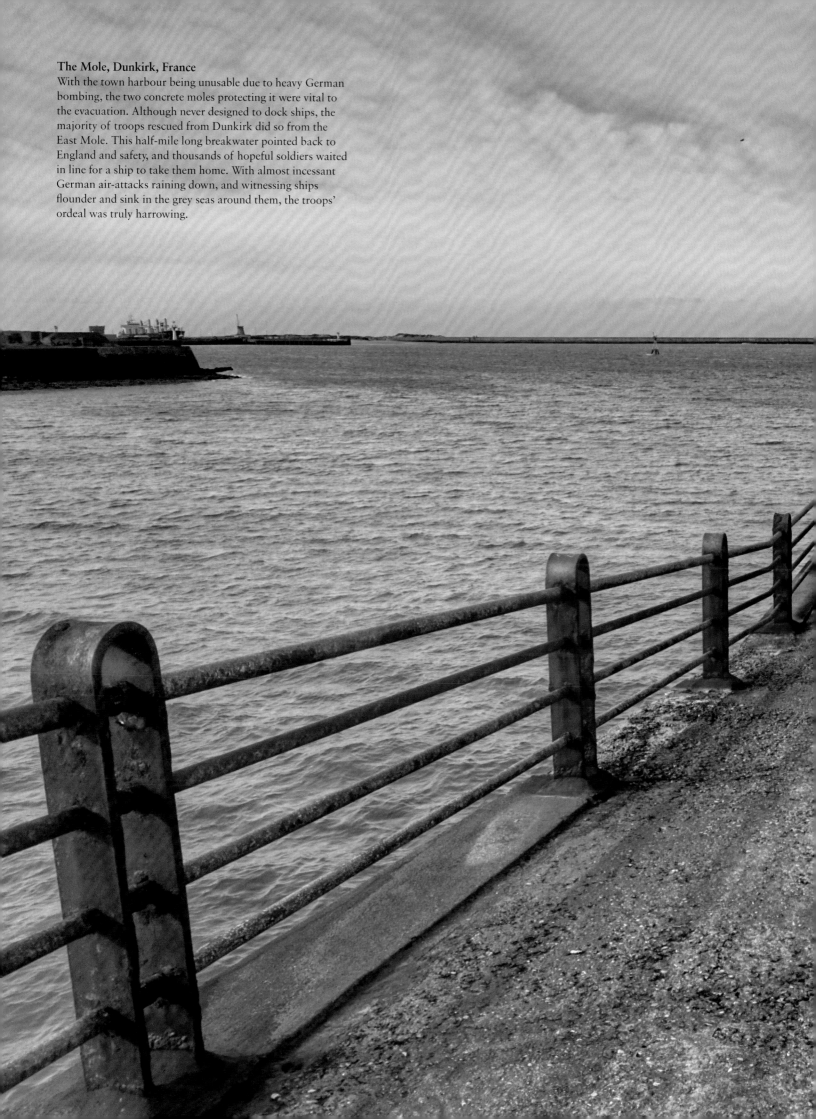

The Mole, Dunkirk, France
With the town harbour being unusable due to heavy German bombing, the two concrete moles protecting it were vital to the evacuation. Although never designed to dock ships, the majority of troops rescued from Dunkirk did so from the East Mole. This half-mile long breakwater pointed back to England and safety, and thousands of hopeful soldiers waited in line for a ship to take them home. With almost incessant German air-attacks raining down, and witnessing ships flounder and sink in the grey seas around them, the troops' ordeal was truly harrowing.

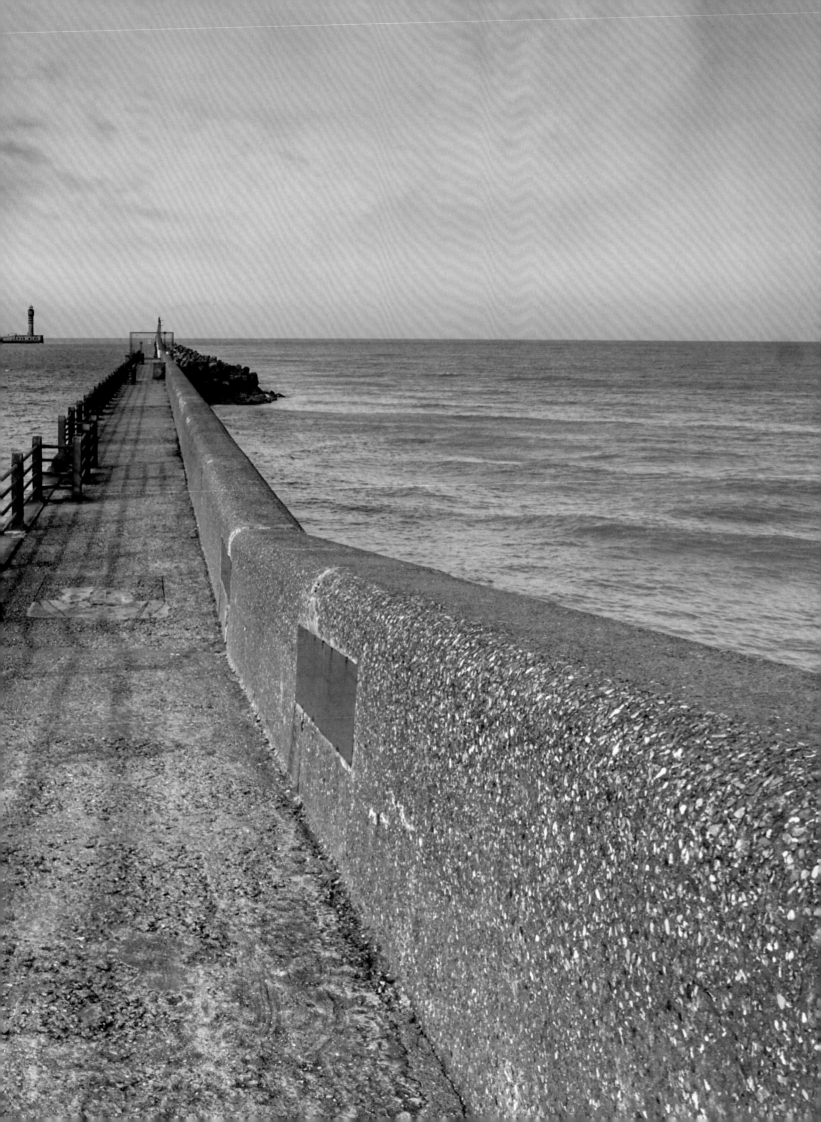

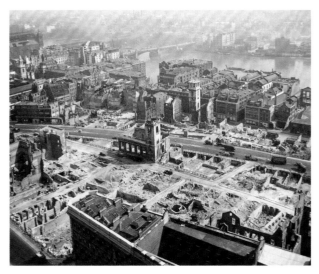

ABOVE & RIGHT:

St Paul's Cathedral and the City, London, England
Situated just half a mile from Fleet Street, where most of the
wartime newspapers were located, the distinctive dome of St
Paul's Cathedral was photographed numerous times during the
war. During a bombing raid on 29 and 30 December 1940, in
which more than 160 people died and over 500 were injured,
the cathedral survived unscathed. This devastating raid became
known as the 'Second Great Fire of London' and although
many buildings were destroyed, the survival of St Paul's came
to symbolize the 'Blitz Spirit'.

Taken in 1942, the photograph above shows the devastation
wrought by the Luftwaffe's bombing campaign on the area
between St Paul's Cathedral and Southwark Bridge over the
River Thames.

Command in their Hurricanes and Spitfires
became lauded as 'The Few' for their courage
and sacrifice, but their eventual victory in
the skies was made possible by the incredible
work and determination of 'The Many': the
ground crews who kept the aircraft flying, the
radar operators that maintained the 'Dowding
System' of air defence, the observers whose eyes
scanned the skies for enemy formations and the
men and women of numerous other units were
vital to the cause.

By October 1940, the Battle of Britain
had morphed into a different type of war.
Abandoning their plans to invade, the Germans
instead cranked up their terror bombing of
British cities and towns, which continued until
April 1941 when the Germans turned their
attentions east with Operation Barbarossa.

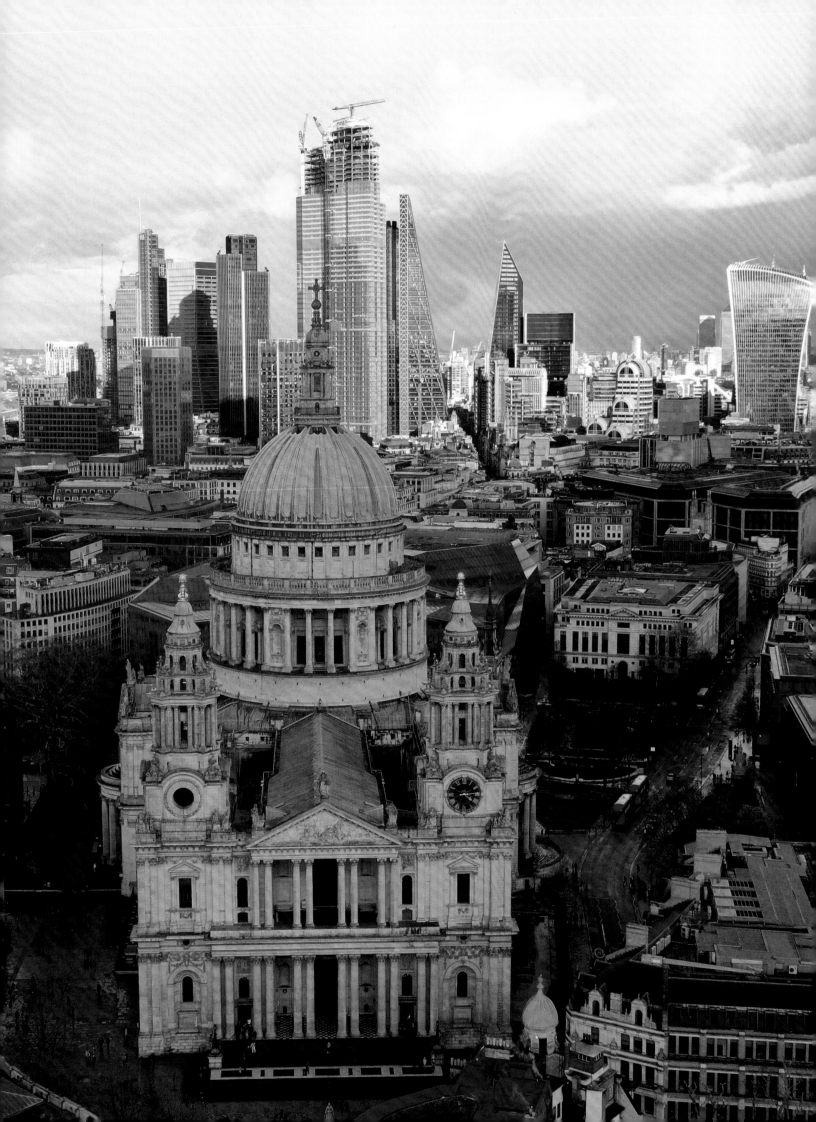

LEFT & ABOVE:

RAF Kenley, Greater London, England

In 1940, the responsibility for defending London from air attack fell principally on three airfields: Kenley, Croydon and Biggin Hill. Dating back to 1917, Kenley had been modernized in 1939 to accommodate newer types of aircraft, such as Hurricanes, Spitfires and Blenheims. Old hangars from the World War I were demolished and two concrete runways were built, along with a perimeter track, blast pens, an armoury and fuel stores.

RAF Kenley suffered its worst damage in a Luftwaffe attack on 18 August 1940, when two of its three hangers and various other buildings were destroyed, along with 10 aircraft, including six Hurricanes. Enemy bombs left smoking craters in the runway and the Sector Operations Room had to be moved to an emergency location away from the airfield. Repairs were made and the airfield was soon operational again and continued to play a key role in the Battle of Britain.

Many famous squadrons and flyers served at RAF Kenley over the course of the conflict, including the legendary South African pilot Adolph 'Sailor' Malan and British ace J.E. 'Johnnie' Johnson, later Air Vice-Marshal, who took over the Canadian wing there in 1943.

Kenley is still used by the Ministry of Defence, but only gliders now use the field and facilities.

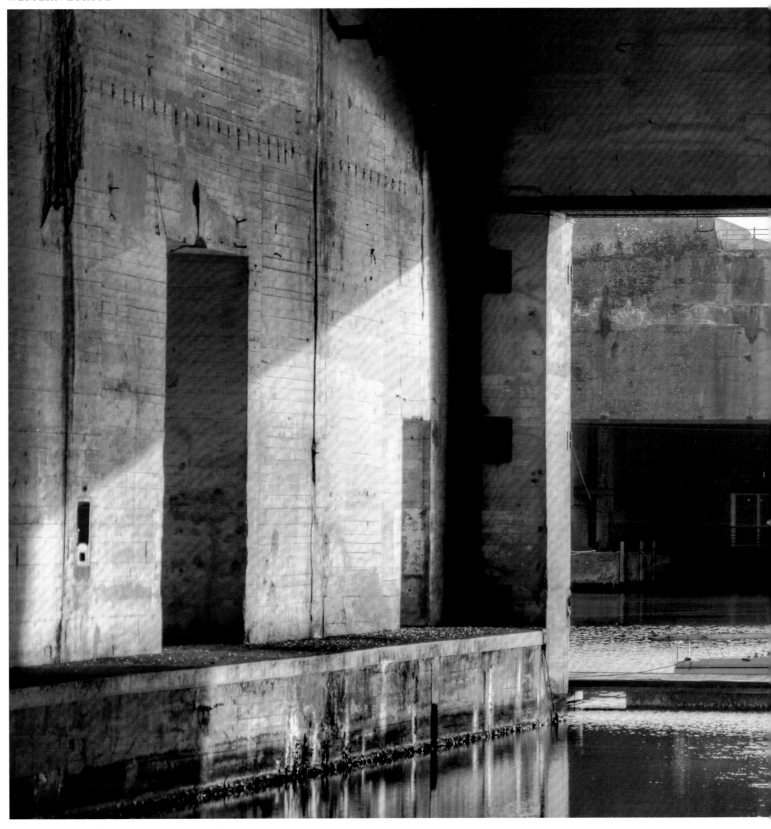

ABOVE & OVERLEAF:

U-Boat pens, Saint-Nazaire, France

The Germans built vast concrete U-boat pens at five key locations of the Atlantic coast: Lorient, Brest, La Rochelle, Bordeaux and Saint-Nazaire. Yet even before the construction of the pens, the *Kriegsmarine* (German navy) had recognized the importance of the location, and submarines first used the harbour at Saint-Nazaire in June 1940, just one month after the fall of France. Later, the town became home to the 6th and 7th U-boat Flotillas and U-boats departing from the five bases caused havoc to Allied shipping in the Atlantic.

Construction of the 14 docks at Saint-Nazaire began in February 1941 using 4600 Todt forced-labour workers. They poured 480,000m³ (16.9 million ft³) of concrete. The base was equipped with 62 workshops, 97 magazines, 150 offices and 92 dormitories for the U-boat crews, together with kitchens, bakeries, a restaurant and a fully equipped hospital. On 30 June 1941, Vice-Admiral Karl Dönitz formally opened the base and U-203 became the first boat to occupy one of the new pens.

With walls and ceilings up to 8m (26ft) thick, the pens were effectively invulnerable to bombing until the Allies were able to drop 'Tall Boy' bombs, which they used with success at Brest in August 1944. The pens at Saint-Nazaire, however, survived intact and today house a museum, venues, shops and cafes. Visitors are able to ascend to the roof via a lift to survey the harbour.

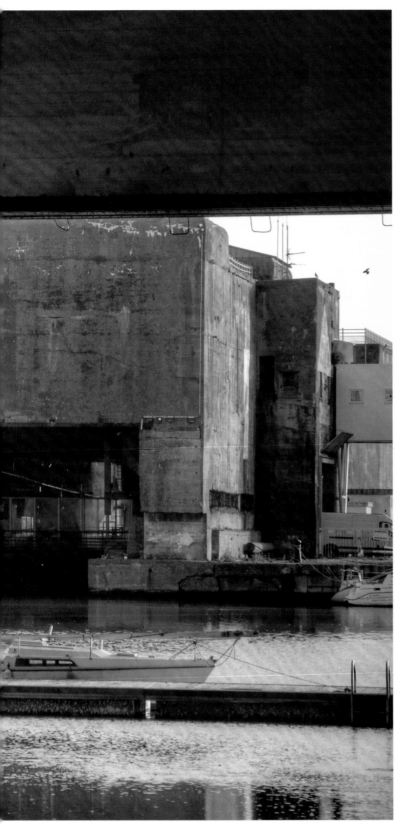

BATTLE OF THE ATLANTIC

To wage war in Western Europe, both in the defensive operations of 1940 and in the offensive operations that followed, the Allies needed to maintain a constant flow of men and supplies between North America and Europe. Equally, the Germans wanted to cut these supply lines and frequently came close to doing so using U-boats and other vessels that prowled the Atlantic Ocean, sinking transports and the warships that escorted them. There were moments of absolute crisis during 1942 and 1943 especially, with upwards of 200 operational U-boats causing devastating shipping losses.

Stocks of oil in Britain were perilously low and leaders wondered if shipyards would be able to build merchant ships fast enough to replace the tonnage being sunk. Many factors contributed to the Allies surviving this difficult period.

Ultra – intelligence derived by intercepting and cracking German Engima codes – played a massive role, along with the mass production of Liberty cargo ships in US shipyards. The Allies also developed better weapons and communications, including much improved radar and sonar equipment.

Allied sinking of German submarines began to escalate, with 57 being sunk in the months of April and May 1943. The Battle of the Atlantic continued, but the worst was over. All told, it cost the lives of around 72,000 Allied seamen and 30,000 Kriegsmarine – many on U-Boats.

GERMANY DEFENDS

When their invasion of the Soviet Union ground to a halt over the winter of 1942–43, the Germans turned their attention to defending the west. American and Canadian troops had been steadily arriving in huge numbers to join Britain's now rebuilt and re-equipped post-Dunkirk forces, and by 1942 small-scale raids along the coast were becoming increasingly common. To deal with this immediate threat and that of a future full-scale seaborne Allied invasion, the German

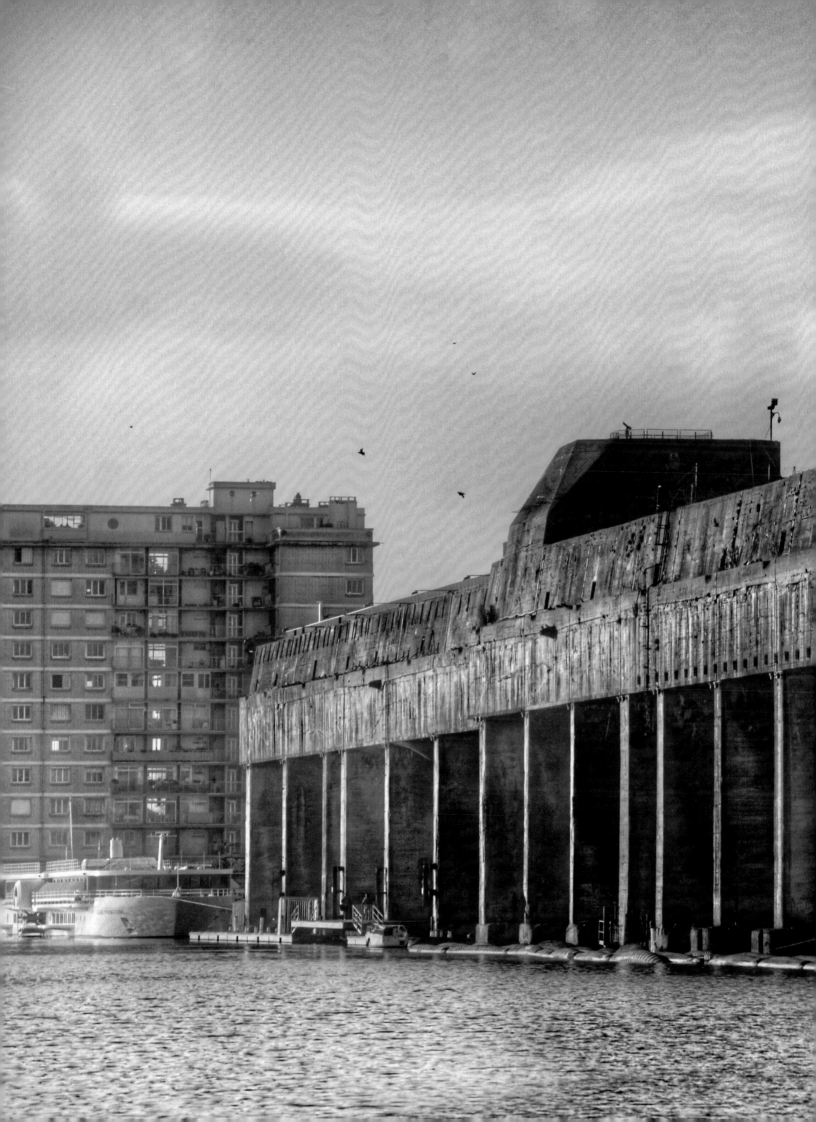

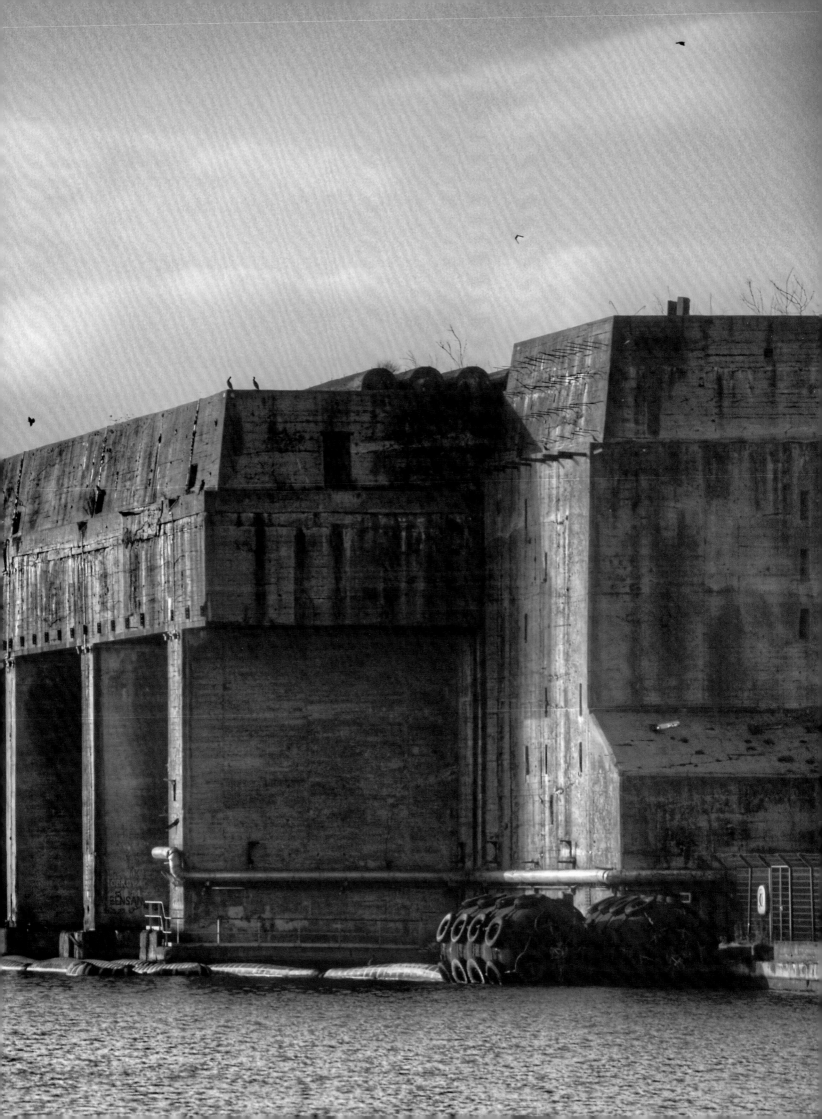

Saint-Nazaire, France
In addition to its U-boat pens, Saint-Nazaire is also famous for a British commando raid in 1942. Operation Chariot was an audacious Combined Operations raid on the Ecluse Louis-Joubert, better known as the dock built to accommodate the *Normandie*, the pride of the pre-war French passenger fleet. More importantly, the dry dock was big enough to accommodate the German battleship *Tirpitz*, sister ship to

Bismarck, which is why the Allies mounted Operation Chariot to prevent the Germans using Saint-Nazaire for this 50,800 tonne (50,000 ton) monster.

On 28 March 1942 the destroyer, HMS *Campbeltown*, packed with high explosives, was rammed into the gates of the dock. The resulting explosion put the dry dock out of action for the rest of the war, but the cost of the mission was high.

Of the 612 commandos and Royal Navy servicemen who took part in the raid, only 228 returned to England.

solution was to begin construction of the Atlantic Wall, or 'Festung Europa'. The 'Wall' was not continuous, as the name implies, but in fact a series of interlocking positions that were usually around half a mile apart, consisting of man-made concrete bunkers, gun batteries and other defences. It would extend 5150km (3200 miles) from the north of Norway to the Spanish border, the plan being that it would form an impregnable fortress that could be held by relatively few troops.

Fortunately for the Allies, building the Wall took longer and was more difficult than Germany had hoped. Insufficient and underskilled manpower and material shortages plagued the construction programme, and by 1 May 1943 only 6000 of the 15,000 bunkers planned for the Dutch, Belgian and French coasts had been completed. Hitler assigned Field Marshal Rommel to inspect work on the Atlantic Wall.

Rommel's influence improved things somewhat, and he oversaw the installation of cheaper and quicker-to-construct hindrances along the water's edge at potential landing beaches. These included mine-topped wooden poles buried in the sand, along with triangular concrete barricades and iron 'hedgehogs'. Furthermore, he fortified the infrastructure inland from the beaches, flooding low-lying areas, adding minefields, anti-tank ditches and anti-glider poles. More than 200,000

forced labourers from across Europe built the Atlantic Wall under harsh conditions. Albert Speer's Organisation Todt directed the construction effort, with German architects and site managers overseeing works. The use of concrete was not just for defensive bunkers. The same organization also built vast installations for the V-weapons programme, along with submarine pens to protect U-boats on offensive operations in the Atlantic.

COMMANDO RAIDS AND OPERATION JUBILEE
Immediately after Dunkirk, Winston Churchill stated in a minute to the British general Hastings Ismay on 6 June 1940 that, 'Enterprises must be prepared, with specially-trained troops of the hunter class, who can develop a reign of terror down these coasts.' This launched the 'Butcher and Bolt' policy of continual harassment of German targets across Western Europe.

Between 1940 and 1944, many raids were carried out by a huge array of newly formed forces that had sprung up in response to Churchill's war cry. The Commandos, the SAS, the SBS, the Parachute Regiment and the SOE are just a few of the now world-famous units that undertook these missions.

The raids had several purposes – each had a specific military objective, but they also served to bolster morale and give confidence to

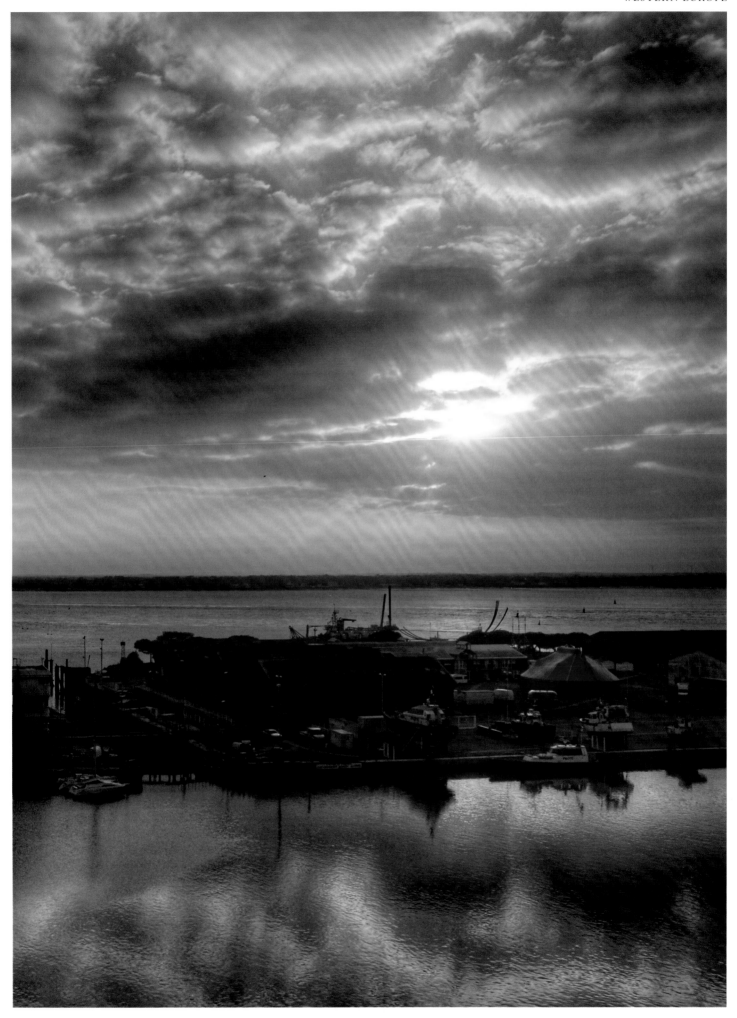

Red Beach, Dieppe, France

On 19 August 1942, 553 officers and soldiers from the Essex Scottish Regiment set sail from England to Dieppe, Normandy, as part of Operation Jubilee. This large raid had many goals, including seizing information about the new four-rotor Naval Enigma machine and codes from the German Kriegsmarine HQ in the town.

Later that day, a misleading message received by commanders of the fleet led them to believe that the Essex Scottish had breached the seawall at Red Beach successfully and were making headway into the town alongside Churchill tanks of the Calgary Regiment. In fact, they were still pinned down by murderous enfilading enemy fire on the pebble-covered beach. By nightfall, only 51 men of the Essex Scottish had managed to return to England. The remainder were left behind in France – either killed, wounded, missing or held as prisoners of the Germans.

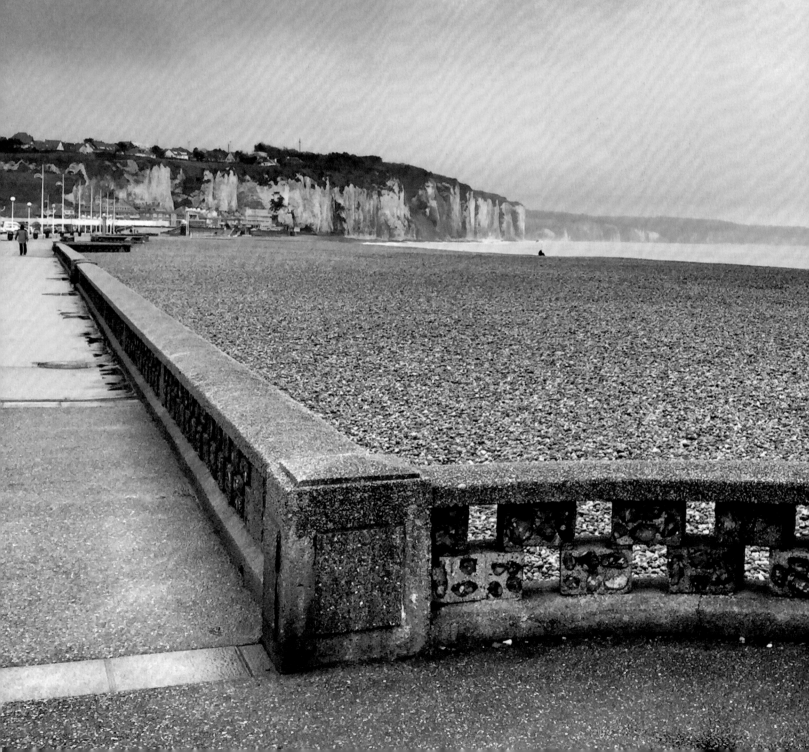

THE
ESSEX SCOTTISH
REGIMENT

19TH AUGUST 1942

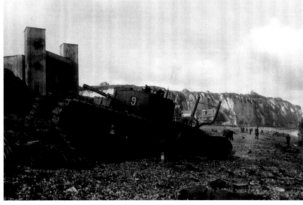

ABOVE:
White Beach, Dieppe, France
An abandoned Churchill tank from the 14th Canadian Army Tank Regiment ('Calgary Tanks') in front of the Casino building on White Beach in Dieppe.

LEFT:
Green Beach, Pourville-sur-Mer, France
To the west of Dieppe in Pourville-sur-Mer at Green Beach and running late, landing craft carrying the Queen's Own Cameron Highlanders and the Canadian South Saskatchewan Regiment came ashore. The Camerons were to head east to Petit Appeville but were forced to retreat under pressure from arriving German reinforcements. The Saskatchewans were to neutralize the German defences in town and knock out the nearby Freya radar station. Bitter combat ensued in the streets of Pourville, especially by a narrow bridge spanning the Scie River, causing numerous casualties.

Despite cutting off the electrical power to the radar station, the attack proved unsuccessful. Of the 1026 men from the two regiments who landed, 160 were killed and 256 were taken prisoner. Only 610 returned to England.

Britain's allies around the world. The largest 'Butcher and Bolt' raid was the disastrous Operation Jubilee attack on the German-held French port of Dieppe on 19 August 1942. Recent research suggests that the primary goal of Operation Jubilee was for No. 30 Commando to steal one of the new German four-rotor Enigma code machines, plus associated code books.

The Naval Intelligence Division (NID) planned the whole operation around this 'pinch' raid, with the intention of passing the items to cryptanalysts at Bletchley Park to assist with the Ultra project. However, the raid was a failure and no machine was obtained.

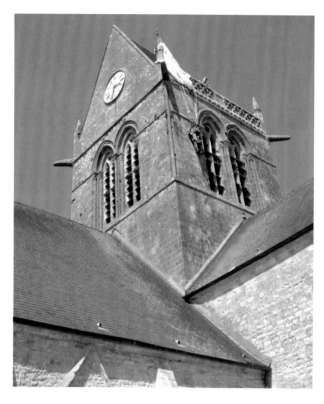

NORMANDY AND BEYOND

Operation Overlord was the code name for the Allied invasion of northwest Europe and it comprised two landings, one in Normandy on 6 June 1944 and a second in the south of France on 15 August.

The success of the landings was due in part to the deception campaign that had been running in conjunction with Overlord. Operation Fortitude was a series of initiatives including fake landing craft and armoured vehicles deployed in the east of England that the Luftwaffe would photograph.

It was bolstered by carefully created false information fed to German Military Intelligence by double agents and other methods. It was all intended to convince the Germans that the forthcoming invasion would take place in the Pas-de-Calais and that any landing in Normandy would be diversionary.

The ruse worked, and the Germans kept units in reserve that would have been better used to counter the actual landings in Normandy. The foothold gained on the five landing beaches on 6 June, though not quite as large as planned and with gaps between the beaches, was secure.

As the days passed and the Germans realized that a second larger landing in Calais was not going to occur, they moved most of their remaining armoured and infantry divisions in France towards the beaches and the real battle

ABOVE:

Sainte-Mère-Église, Normandy
Sainte-Mère-Église is located on a crossroads a few kilometres inland from Utah Beach and the Norman market town was a key objective of the 505th Parachute Infantry Regiment of the 82nd Airborne Division on D-Day. The plan had been for the town to be taken overnight on 5/6 June 1944, in a swift military manoeuvre by two battalions of paratroopers moving in from Drop Zone O, just to the west of the town.

With low cloud and heavy German anti-aircraft fire affecting the accuracy of the drops, tragically two or three sticks descended directly into the town square. Although it was in the middle of the night, German troops were out monitoring the townspeople who were dealing with a fire that had broken out in a large house on the edge of the square. It was very nearly a total massacre; paratroopers were killed still in their jump harnesses, their bodies left hanging in trees for several hours. A mannequin still hangs on the church representing these mis-drops and a museum explains the role of American Airborne troops in the Normandy campaign.

OPPOSITE:

Bunkers at Pointe du Hoc, Normandy
Approximately every 16km (10 miles) along the Normandy coast stood a German gun battery, in place to fire at enemy ships and troops. The most famous of the batteries in the American sector was at Pointe du Hoc (the Normans are ancestors of Scandinavian Vikings, and 'Hoc' is a Norse word meaning 'high point'). Here the Allies believed six 155mm (6.1in) guns had been built into concrete bunkers. Because these guns could theoretically fire on Utah to the west and Omaha to the east, their elimination was deemed necessary.

The Allies had repeatedly bombed the site in the weeks running up to D-Day, and again on the morning of 6 June 1944. The result of this bombing is still evident today, with huge chunks of concrete littering the site like discarded children's building blocks.

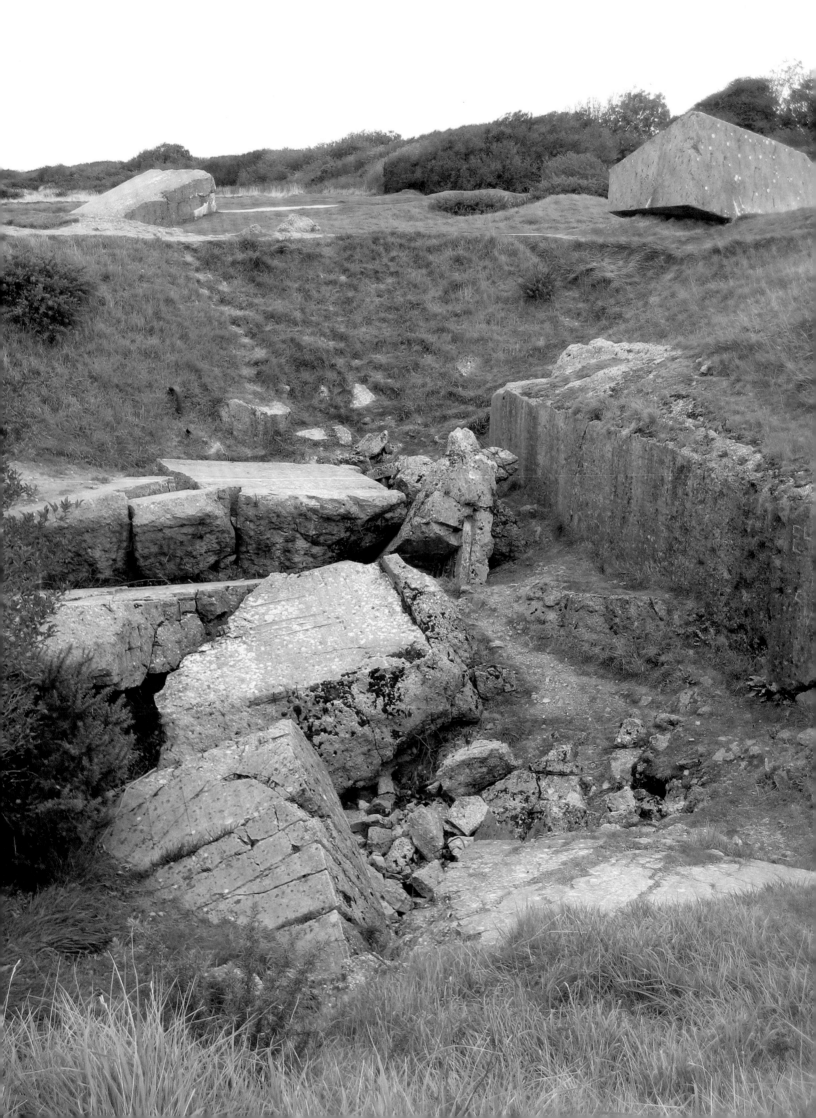

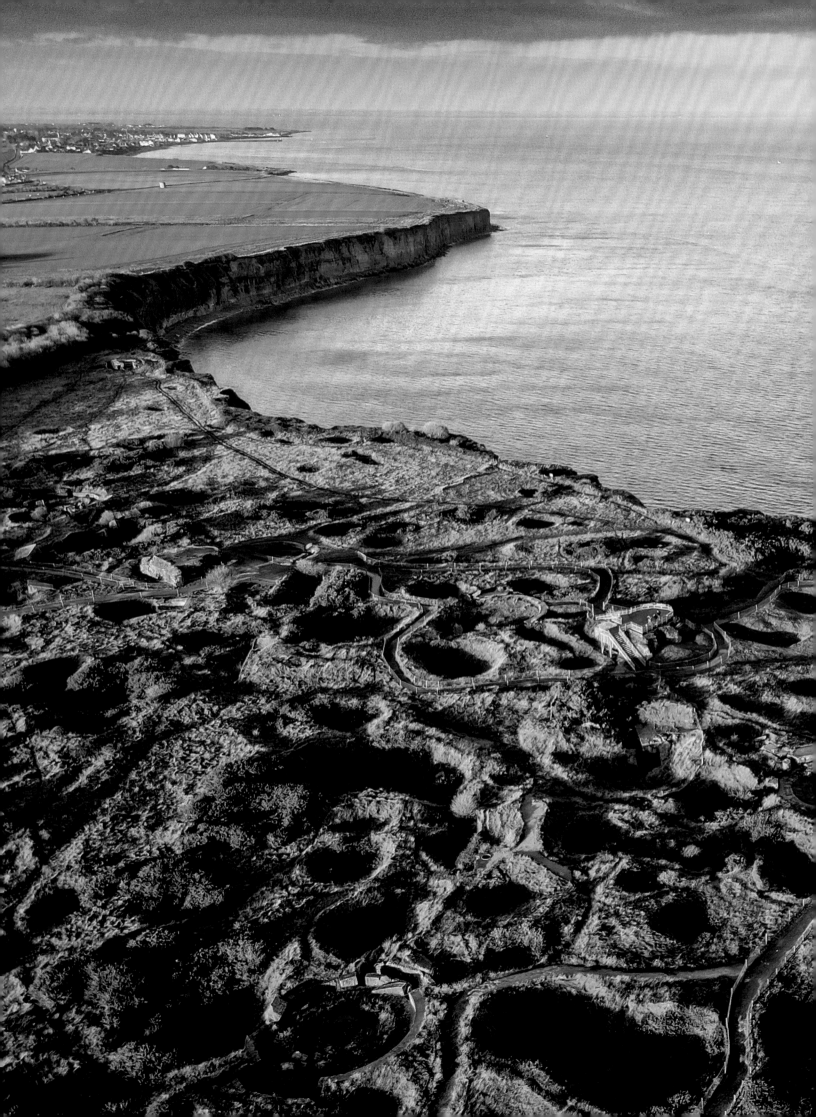

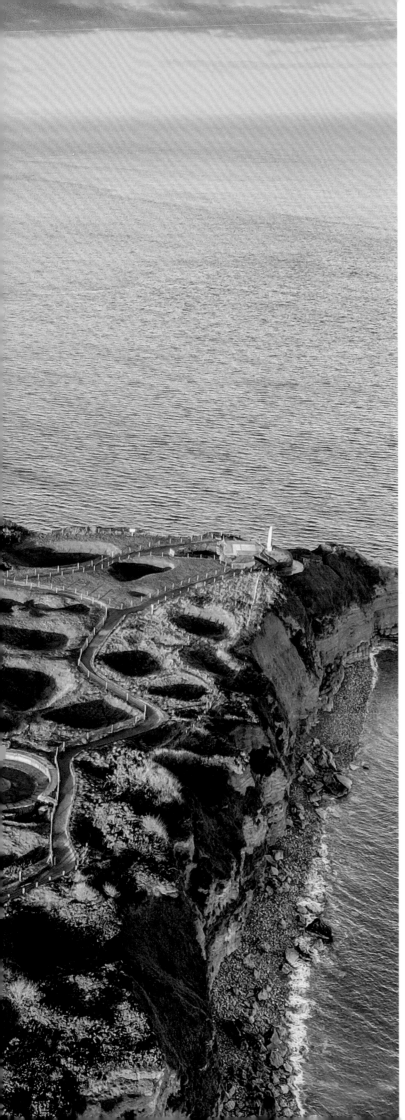

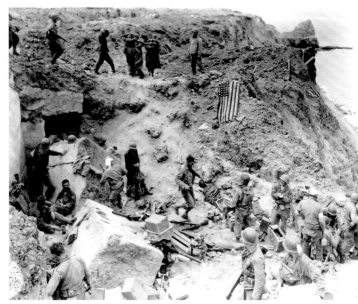

LEFT & ABOVE:

La Pointe du Hoc , Normandy
To deal with the threat of the guns, a direct assault by the 2nd Battalion of the US Rangers in British-crewed landing craft was planned for D-Day. Disembarking on the beach below the battery, 225 Rangers began to scale the near vertical 30m (100ft) cliffs using ladders and ropes with grappling hooks fired by rocket. Though many of the rockets failed, the Rangers fought their way up and cut through the barbed wire along the cliff edge.

Upon reaching the top of the cliffs, although under fire, the Rangers found fewer defenders than they had been expecting and, despite some losses, moved their way efficiently over the cratered plateau. To their surprise, they found that the dangerous German guns were not actually inside the bunkers. Having lost one gun to an earlier bombing raid, the Germans had moved the remaining guns a kilometre inland. A few hours later, on a patrol from their forward positions near the coastal road, a handful of Rangers found at least three of the guns concealed in a hedgerow and disabled them with thermite grenades.

Historians are now aware that the local French Resistance had told the Allies the guns had been moved and some of the American commanders almost certainly knew this. Nevertheless, the perceived threat was considerable, and the attack went in as originally planned.

Longues-sur-Mer, Normandy

The gun battery at Longues-sur-Mer is located between Gold and Omaha beaches and housed four 150mm (5.9in) Skoda guns. The battery was bombed before and on D-Day and was engaged by several Allied ships, including HMS *Ajax* and HMS *Argonaut*. While the German guns fired without success at targets on Gold Beach, the British cruisers returned fire. Later they were joined by the French cruisers *Georges Leygues* and *Montcalm* and ably assisted by the World War I dreadnought USS *Arkansas*.

By the end of 6 June the guns at Longues sur Mer had fired more than 100 shots, but three of its four guns had been knocked out by naval shells. It is one of the few German Atlantic wall batteries where the guns can still be seen today, as most of the guns elsewhere were scrapped after the war.

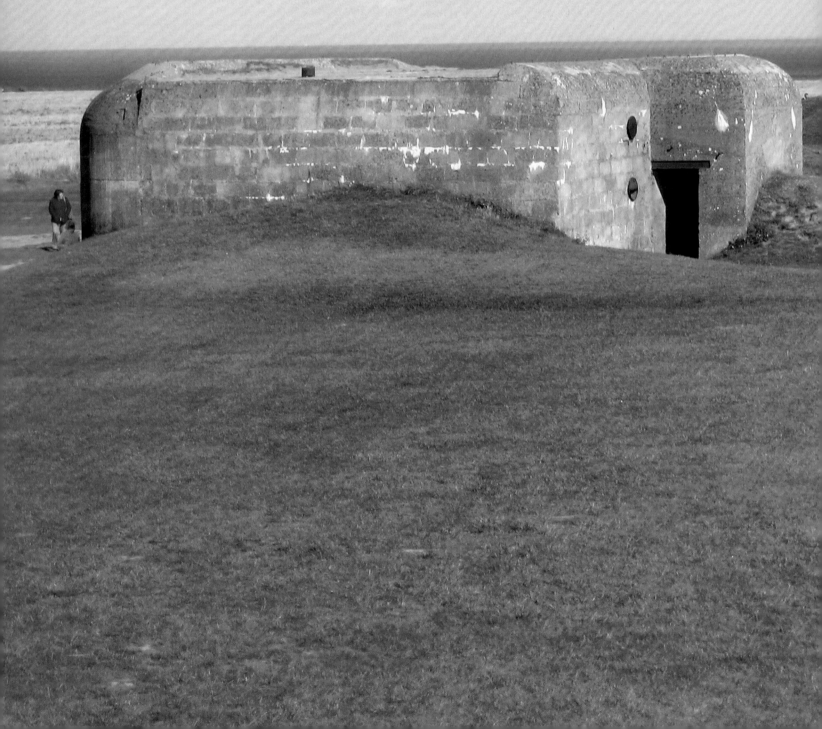

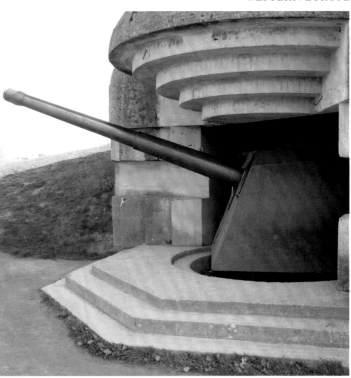

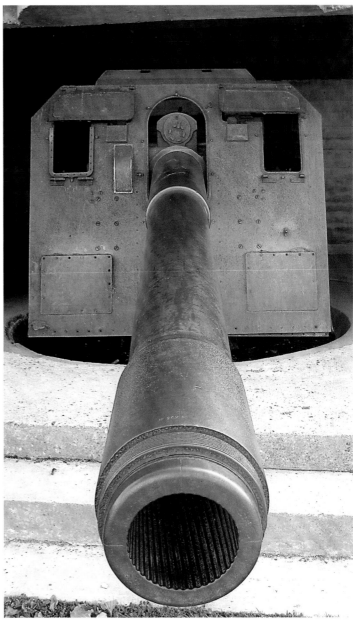

Omaha Beach, Normandy
The initial landings on Omaha beach have been forever immortalized in the movie *Saving Private Ryan* as a bloody tragedy and the losses in those first waves were greater than anticipated. But by mid-morning, follow-up waves from the American 29th and 1st Infantry divisions, together with engineers and armour, had broken up the bluffs and by sunset on 6 June 1944 the beachhead was secure. The price of freedom has not been forgotten, and there are memorials to the fallen along all five of the landing beaches and at many more significant sites in Normandy.

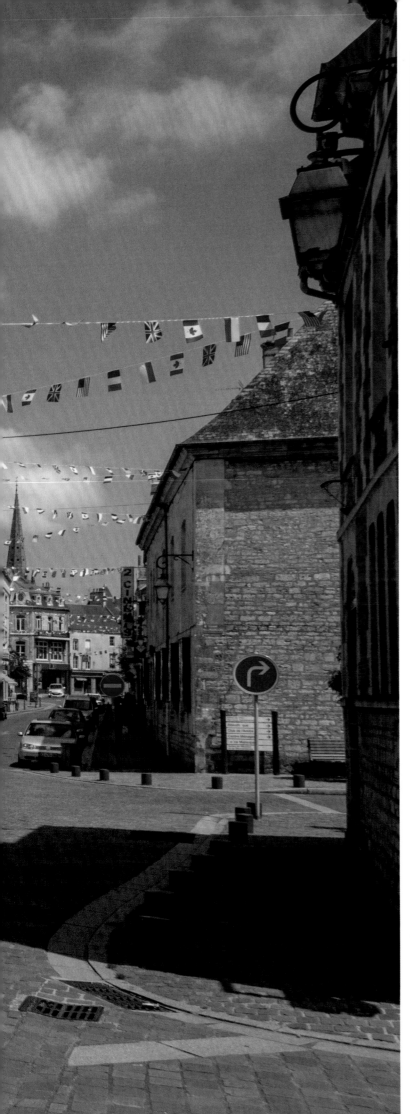

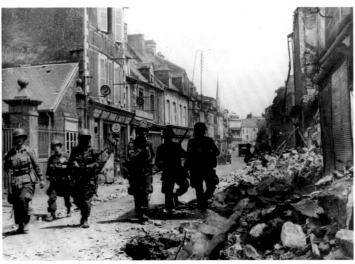

LEFT & ABOVE:

Carentan, Normandy

From autumn 1943 and as part of a general plan to dissuade the Allies from landing in the area, the Germans had allowed much of the lower Cotentin peninsula to flood and consequently Carentan was almost an island in June 1944. The town sat on a vital east–west highway with further roads heading inland towards Périers, Saint-Lô and across the peninsula to Carteret. Its capture would link the American beachheads on Utah and Omaha into one front to push inland. Because of its significance,

Carentan was staunchly defended by German *Fallschirmjäger* (parachute) troops and it took several days of fighting for parachute and glider troops from the US 101st Airborne Division to take the town.

Today, locations around the battlefield – such as Dead Man's Corner, Purple Heart Lane and Bloody Gulch – attest to the costly nature of this combat. A number of photos were taken of American troops in the streets and squares of Carentan and there are information panels, monuments and museums memorializing the battles of 1944.

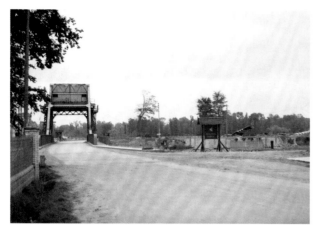

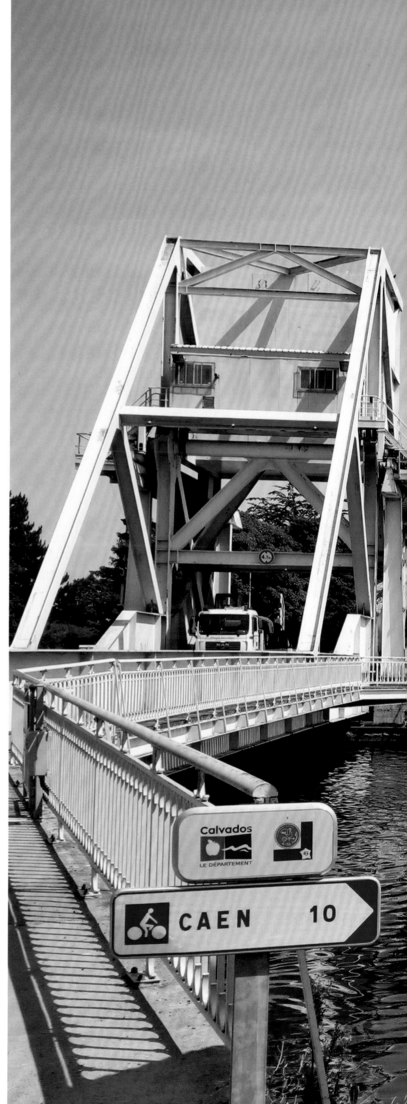

for Normandy, one of painstaking progression against a stubborn enemy, endured. Air power was to prove a decisive factor over the next few weeks. Although reasonably matched in terms of infantry and armour on the ground, the Allies had achieved near-air superiority.

This, combined with a vastly superior artillery arm, meant that although the Germans held off the Allies around Saint Lô and Caen for several weeks, in doing so they wore themselves into the ground. Both sides lost tanks and vehicles in operations such as Epsom, Goodwood and Bluecoat, but Allied losses could be replaced easily.

Supplies were now rolling off the artificial harbour at Arromanches and on Utah and Omaha beaches, and most German efforts to reinforce their units were dealt death

ABOVE & RIGHT:
Pegasus Bridge, Normandy
As the people of Benouville in Normandy closed their shutters for the evening and retired on the night of 5 June 1944 they did so blissfully unaware that Operation Overlord would begin by the banks of the canal that ran through their village to the sea. Hours later, just after midnight, British Horsa Gliders dived in from the night sky, bringing a highly trained coup de main force of infantry to secure the vital lift bridge over the canal and a swing bridge over the river a few hundred metres to the east. These two bridges were the only crossing points over the parallel waterways between Caen and Ouistreham, and, with the British 6th Airborne division set to land minutes later to their east to protect the whole flank of the invasion, the bridges had to be captured to allow reinforcements from Sword beach to join the 6th Airborne and prevent the Germans from rolling up the invasion. With lightning speed, both bridges had been captured intact within 10 minutes and the coded message 'Ham and Jam' was sent by radio to indicate that D Company of the Oxfordshire and Buckinghamshire Light Infantry had completed its mission.

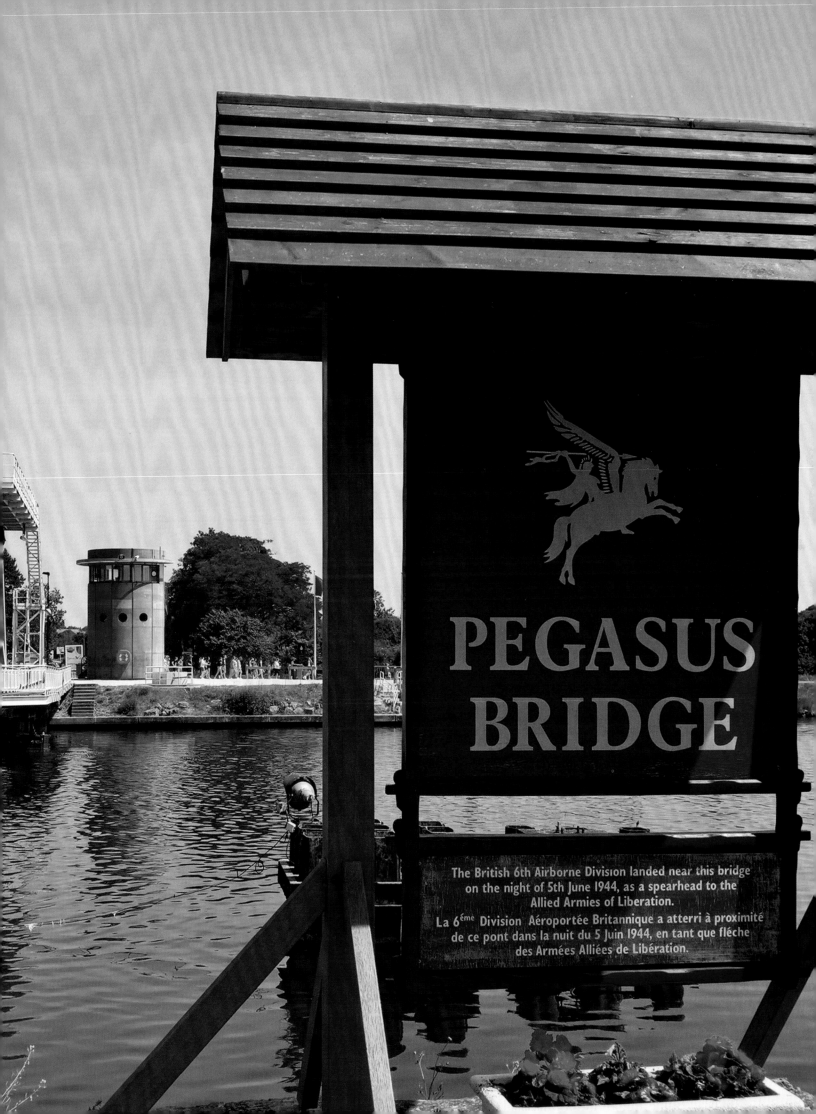

PEGASUS BRIDGE

The British 6th Airborne Division landed near this bridge
on the night of 5th June 1944, as a spearhead to the
Allied Armies of Liberation.

La 6éme Division Aéroportée Britannique a atterri à proximité
de ce pont dans la nuit du 5 Juin 1944, en tant que flèche
des Armées Alliées de Libération.

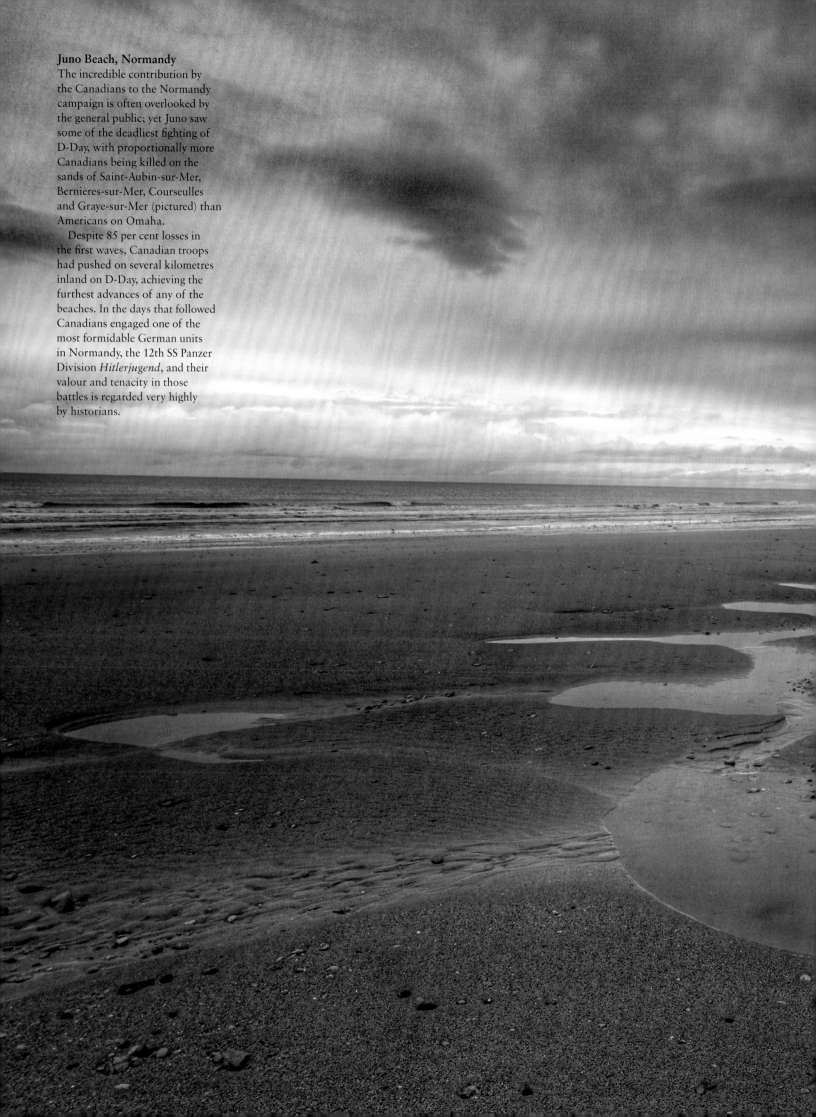

Juno Beach, Normandy

The incredible contribution by the Canadians to the Normandy campaign is often overlooked by the general public; yet Juno saw some of the deadliest fighting of D-Day, with proportionally more Canadians being killed on the sands of Saint-Aubin-sur-Mer, Bernières-sur-Mer, Courseulles and Graye-sur-Mer (pictured) than Americans on Omaha.

Despite 85 per cent losses in the first waves, Canadian troops had pushed on several kilometres inland on D-Day, achieving the furthest advances of any of the beaches. In the days that followed Canadians engaged one of the most formidable German units in Normandy, the 12th SS Panzer Division *Hitlerjugend*, and their valour and tenacity in those battles is regarded very highly by historians.

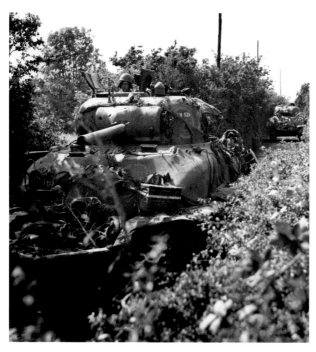

ABOVE & RIGHT:
Normandy *bocage*
Normandy has different types of terrain. The area south of
Sword and Juno beaches and around Caen consists largely of
open arable fields where the German tank divisions plied their
deadly trade. Further west and south inland of Gold, Omaha
and Utah beaches sits the *bocage*. This patchwork of small
fields surrounded by hedgerows atop earthen banks was to
prove difficult for both sides.

Vision was nearly impossible and advances were measured by
individual field rather than by the mile. Moving along the cover
of the sunken lanes left the Allies vulnerable to ambush from
camouflaged German defenders, while breaking out across the
fields put them under the threat of indirect mortar and artillery
fire. Lessons needed to be learned and air-power eventually
proved a winning factor, along with new techniques developed
by men on the ground.

The photograph on the right shows the *bocage* countryside
from Mortain, the site of a German counteroffensive on 7–13
August 1944, codenamed Operation Lüttich. The attack by the
German XLVII Panzer Corps was blunted by the determined
defence of the US 30th Infantry Division, superior Allied
air support and accurate artillery fire directed by forward
observers on Hill 314 in Mortain. The Germans lost more
than two-thirds of their committed armoured forces during
the offensive.

blows from the air by marauding Typhoons,
Thunderbolts and Spitfires. General
Montgomery is unfairly criticized for moving
slowly in Normandy. In fact, the 76-day
campaign came in 14 days ahead of schedule,
overall losses had been fewer than anticipated
and entire German units had been virtually
annihilated.

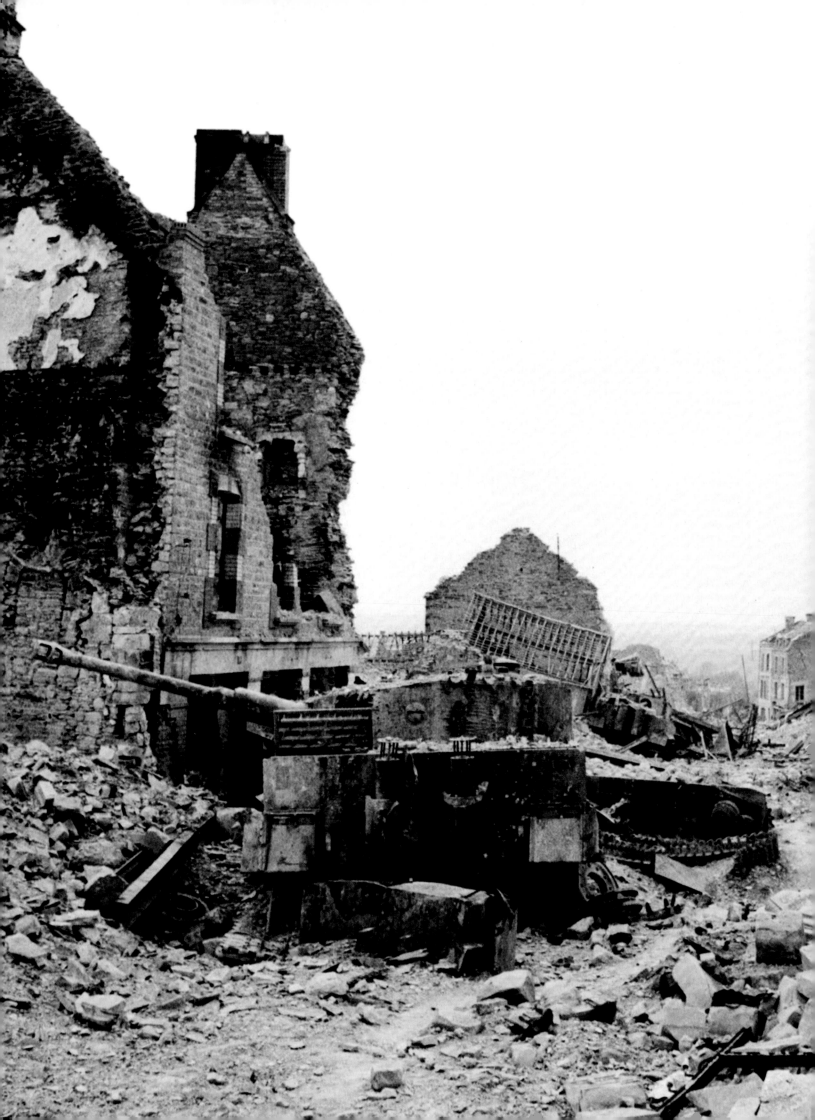

ALL PHOTOGRAPHS:

Villers-Bocage, Normandy

The town of Villers-Bocage is thriving today; its main street is always busy with people and its shops and businesses are modern and well-equipped. However, at the end of the summer of 1944 it lay in ruins, having falling victim to a devastating bombing campaign.

The battle had started on 13 June, when elements of the British 7th Armoured Division striking south from Gold Beach had attempted to take a left (east) turn through Villers-Bocage to attack the German stronghold of Caen from behind.

Unfortunately, a unit of German Tiger tanks had arrived in the area just hours before, and with deadly surprise a single Tiger commanded by German tank ace Michael Wittmann was able to wreak havoc on the British column of armour and infantry, commencing a bitter day-long battle.

The Germans profited from their initial success and took a series of photos and film footage that showed knocked-out British Cromwell tanks (*pictured below*). In reality, both sides had suffered heavy losses leading to something of a stalemate. It was not until 4 August that what was left of the almost-destroyed town was liberated.

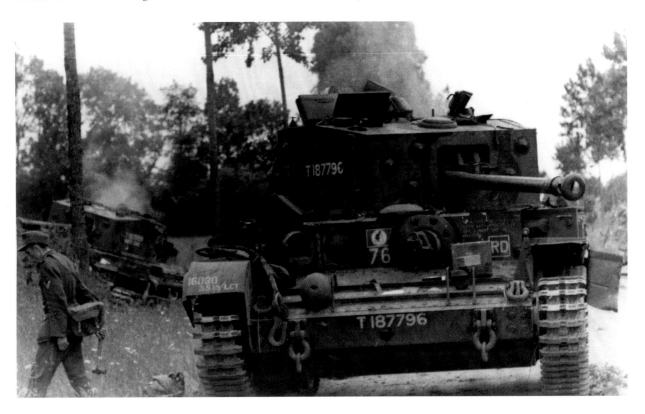

Hill 112, Normandy

Field Marshal Erwin Rommel declared that whoever held Hill 112 would hold the key to all of Normandy, and the sloping wheat fields south of Caen undoubtedly became one of the most contested battlefields in Western Europe. Throughout the month of July 1944, as General Montgomery sought to tie down the German Panzer divisions that stood blocking his advance south, the dominating location of Hill 112 was seen by both sides as vital.

After weeks of bitter fighting British soldiers from the 43rd Wessex, 53rd Welsh, 15th Scottish, 11th Armoured Division and associated support troops finally took control of the Hill. Operations Epsom and Jupiter had cost the lives of 10,000 men, and today a statue of a British infantryman stands near 112 trees planted in the shape of a Maltese Cross.

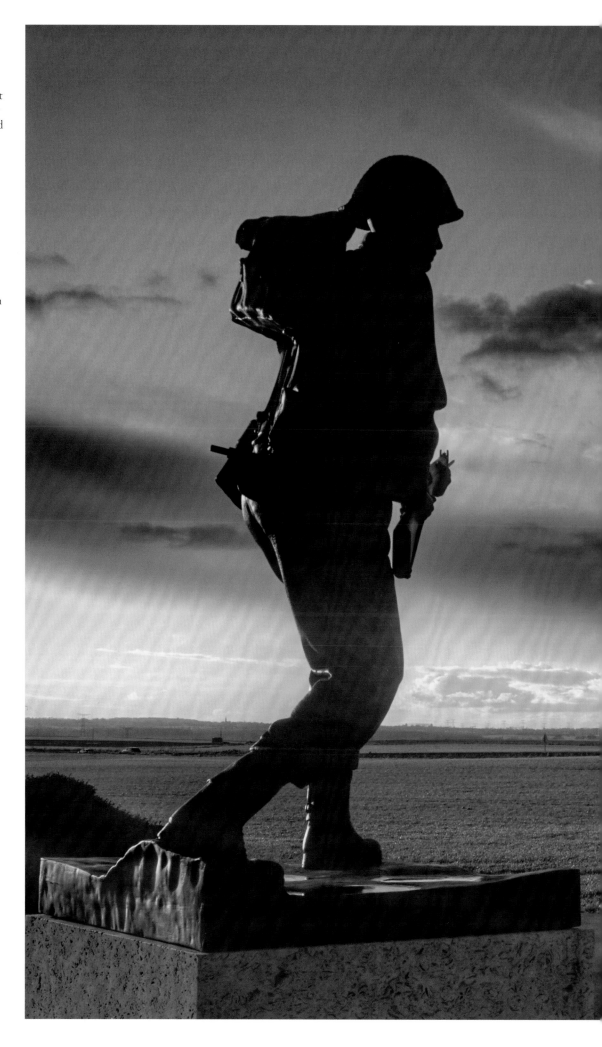

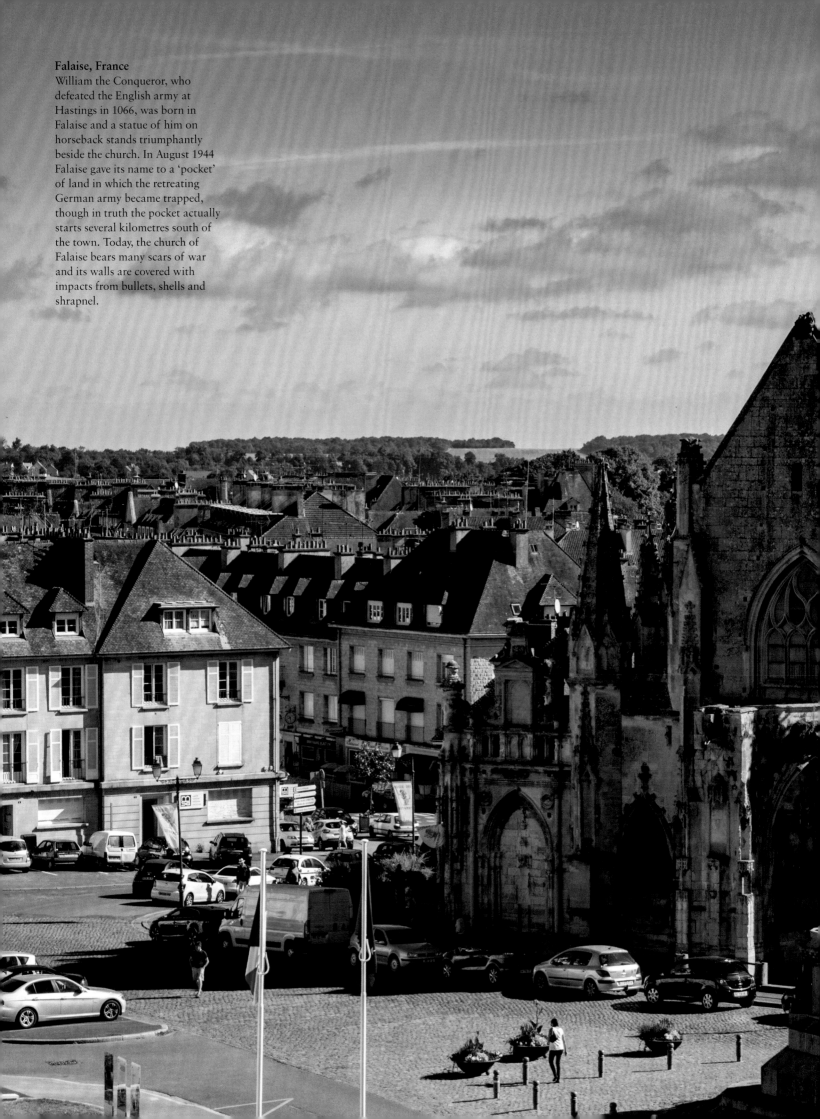

Falaise, France
William the Conqueror, who defeated the English army at Hastings in 1066, was born in Falaise and a statue of him on horseback stands triumphantly beside the church. In August 1944 Falaise gave its name to a 'pocket' of land in which the retreating German army became trapped, though in truth the pocket actually starts several kilometres south of the town. Today, the church of Falaise bears many scars of war and its walls are covered with impacts from bullets, shells and shrapnel.

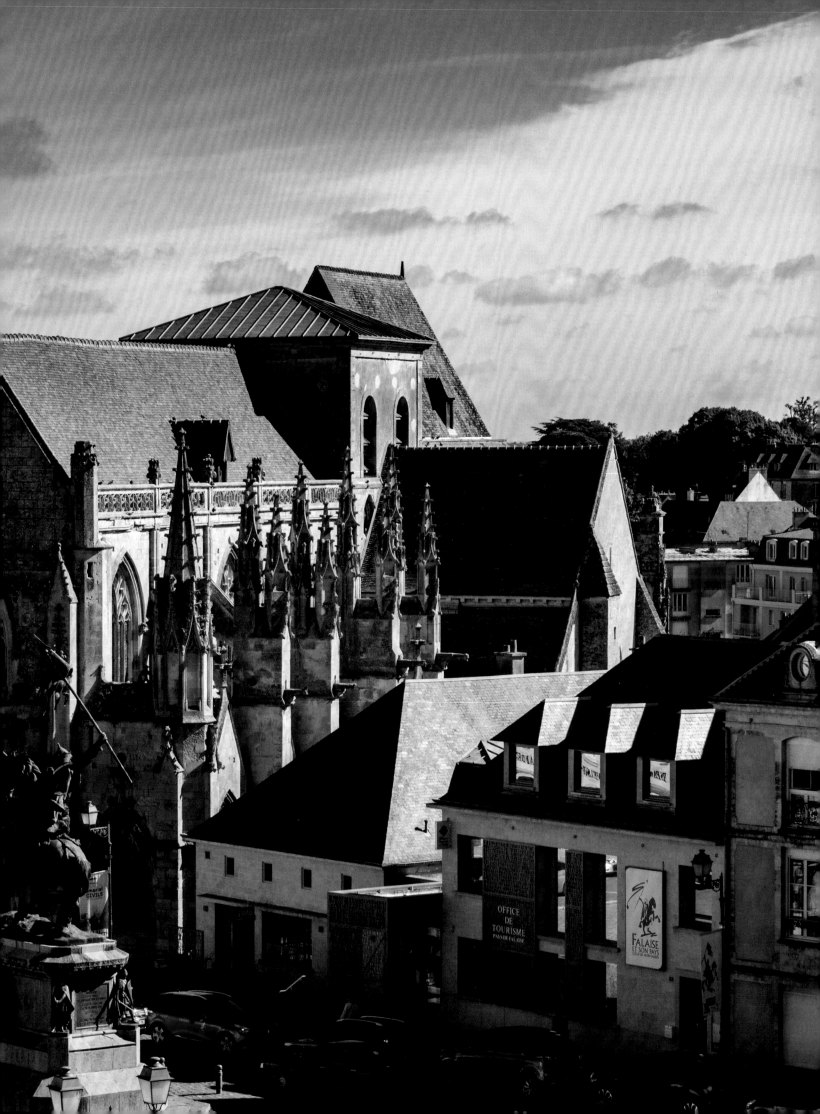

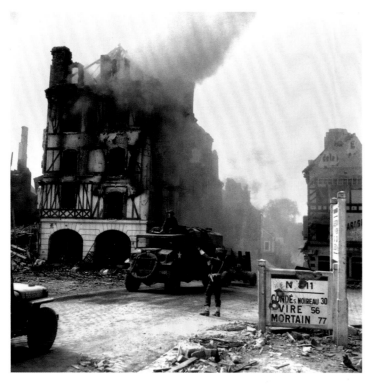

ABOVE & OPPOSITE:

Falaise, France

In late July the Americans broke out of the *bocage*, moving south at speed towards Avranches as part of Operation Cobra. This led to the Germans launching a counter-attack called Operation Lüttich, pulling a lot of their armour away from Caen in a bold and unsuccessful thrust west. Thwarted at Mortain, the Germans faced defeat and were compelled to fall back east.

By mid-August, with less German armour ahead of them, British, Canadian and Polish units advanced south of Caen to Falaise in Operations Totalize and Tractable. Taking advantage of this sudden change of events, American troops pulled away from their advance towards Brittany and pushed north. Allied commanders now realized they could trap the Germans between two great armies: one from the north and one from the south.

The Falaise Pocket might be better labelled the Saint-Lambert-sur-Dive/Chambois pocket because that is where the heaviest fighting occurred – the Germans eventually being pressed into a bottleneck just 5km (3 miles) wide.

Over the next week, Allied air power pounded the fleeing German units and although some Germans successfully fled over the Dive river to fight again, many more were encircled in the pocket. Leaving behind thousands of guns, tanks, vehicles and arms the main battle of Normandy was over when Polish and Canadian troops closed the gap near Montormel (*pictured right*).

Historians differ in their estimates of German losses in the Falaise Pocket. Most agree that 80,000 to 100,000 troops were caught in the encirclement, of whom up to 15,000 were killed. A further 40,000–50,000 were taken prisoner, and the remaining 20,000–50,000 escaped.

Le Muy, Provence-Alpes-Côte d'Azur, France
On 15 August 1944 a second invasion force landing took place in France. Operation Dragoon had originally been planned to run in conjunction with Operation Overlord. Its primary goal was to secure the vital ports on the French Mediterranean coast and increase pressure on the German forces in Normandy. French commandos and Allied parachutists landed on the Cap Nègre and in the beautiful area of Le Muy, followed a few hours later by troops in an amphibious landing on the coast. In complete disarray, the Germans only offered a sporadic resistance, and connections were soon established between airborne and ground troops. Dragoon is commemorated in the South of France with several museums and memorials, but it remains lesser known than the battles in Normandy.

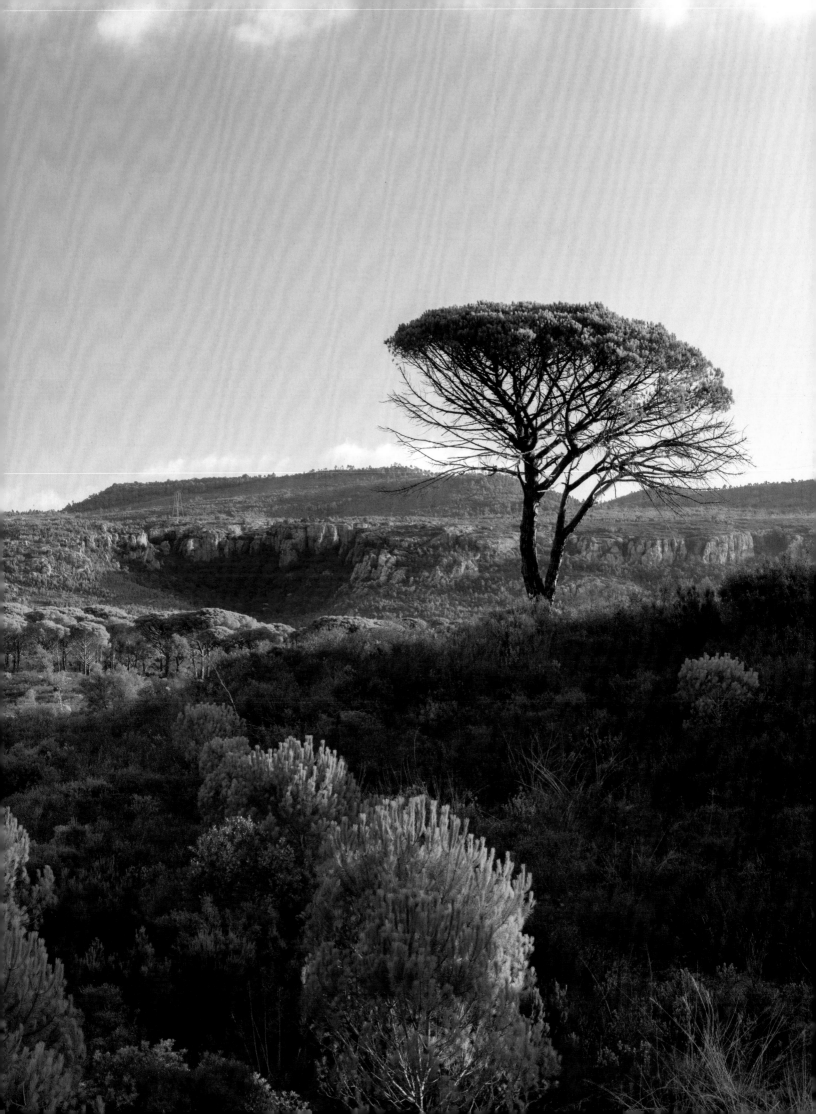

OPPOSITE & ABOVE:

Arnhem bridge, Netherlands

By September 1944 many Allied commanders believed the German
Army was broken and that all it would take was one bold move and
the war could be over by Christmas. Operation Market Garden was
set to exploit this German collapse and strike across the Rhine river
into northern Germany, creating a 97km (60 mile) bridgehead aimed
at Germany's industrial heartland. Launching on 17 September 1944, a
key objective was the bridge over the lower Rhine at Arnhem. Although
the Germans had indeed been falling back, the rout had slowed and
there was a strong force of German SS armour and infantry close to
Arnhem. Beset with difficulties from the outset, the ground-based part
of the Operation called for XXX Corps to push up 'Hells Highway'
from Belgium while a carpet of Airborne troops seized vital bridges
along the advance. Colonel John Frost and much of his 2nd Battalion
Parachute Regiment landed in good order and proceeded swiftly to the
bridge at Arnhem, but a quick reaction by German troops meant that
most reinforcements failed to arrive in support and Frost's men found
themselves attempting to hold an ever-decreasing perimeter.

MARKET GARDEN
AND THE ARDENNES

By September, the Allied advance beyond Normandy
through France and Belgium had covered so much
ground that it had put a huge strain on logistics. With
supplies still coming from Normandy, would there
be enough to continue General Eisenhower's broad-
front strategy of maintaining pressure on the Germans
across all theatres?

With the morale of his armies high, Eisenhower and
his staff wondered if one last ambitious gamble might
bring the war in Europe to a swift conclusion before
Christmas, thus solving the logistics issue. Since the

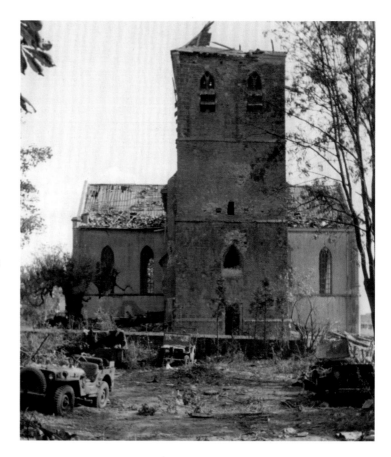

BELOW & RIGHT:
Oosterbeek Church, Arnhem, Netherlands

As the British Airborne situation near Arnhem deteriorated, Oosterbeek became the centre of the defence. The church was first involved on 19 September when Major Richard Lonsdale, second in command of the 11th Battalion Parachute Regiment, gathered the survivors of the fighting around St Elisabeths Hospital in Arnhem. Wounded himself, he climbed into the pulpit and delivered his now famous speech:

'You know as well as I do there are a lot of bloody Germans coming at us. Well, all we can do is to stay here and hang on in the hope that somebody catches us up. We must fight for our lives and stick together. We've fought the Germans before – in North Africa, Sicily, Italy. They weren't good enough for us then, and they're bloody well not good enough for us now. They're up against the finest soldiers in the world. An hour from now you will take up defensive positions north of the road outside. Make certain you dig in well and that your weapons and ammo are in good order. We are getting short of ammo, so when you shoot you shoot to kill. Good luck to you all.'

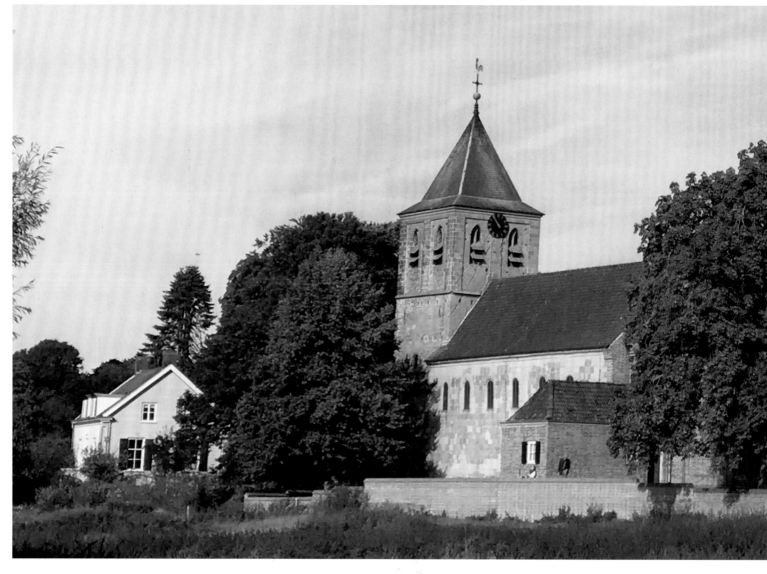

LEFT:

Hartenstein Hotel, Oosterbeek, Netherlands
Within two days of the jump, all attempts to reach Frost's beleaguered force near the northern ramp of Arnhem bridge had been blocked by the Germans, including armoured vehicles of the II SS Panzer Corps. Major General 'Roy' Urquhart, commanding the 1st Airborne Division, was still hopeful that XXX Corps would arrive from Nijmegen and selected the Hartenstein as his headquarters. By 25 September, despite an earlier attempt by the Polish Brigade to cross the lower-Rhine and join the remaining Airborne troops, the situation became untenable and Urquhart planned an evacuation. Overnight, 2400 survivors of the original 10,000 who had landed made their way back to Allied lines across the river in Operation Berlin. The Hartenstein is now a museum dedicated to telling the story of Operation Market Garden.

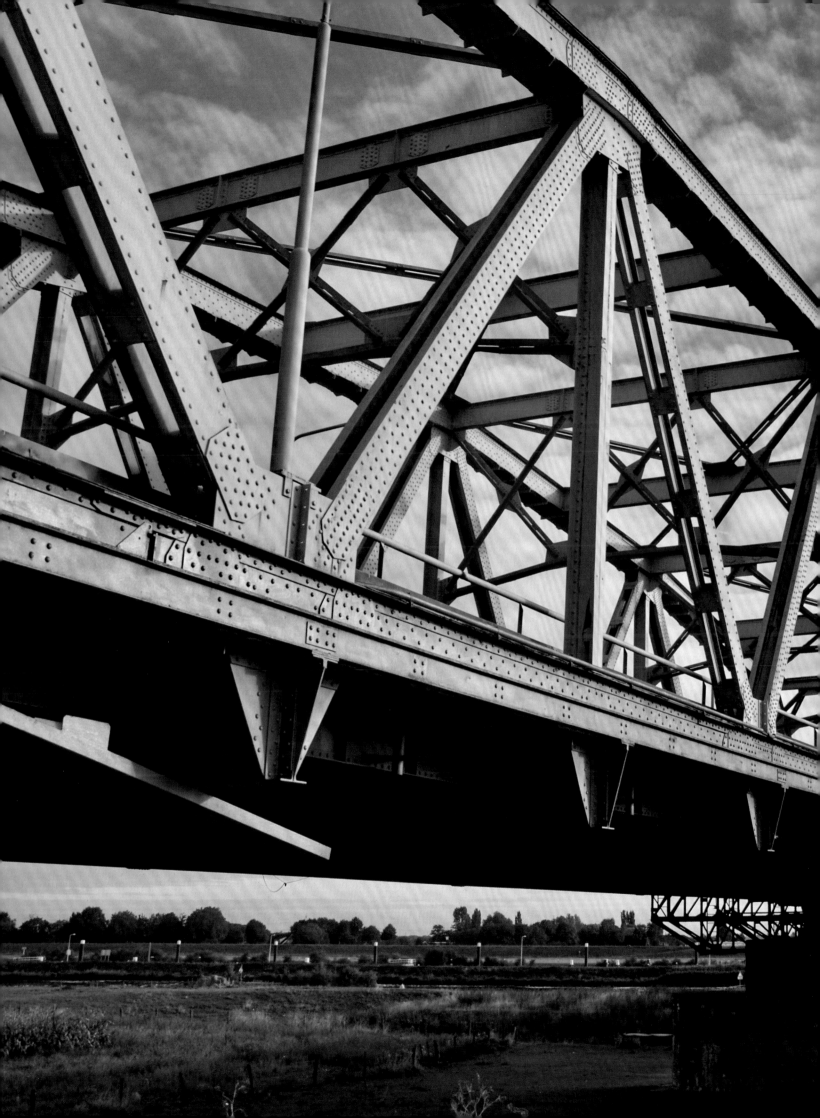

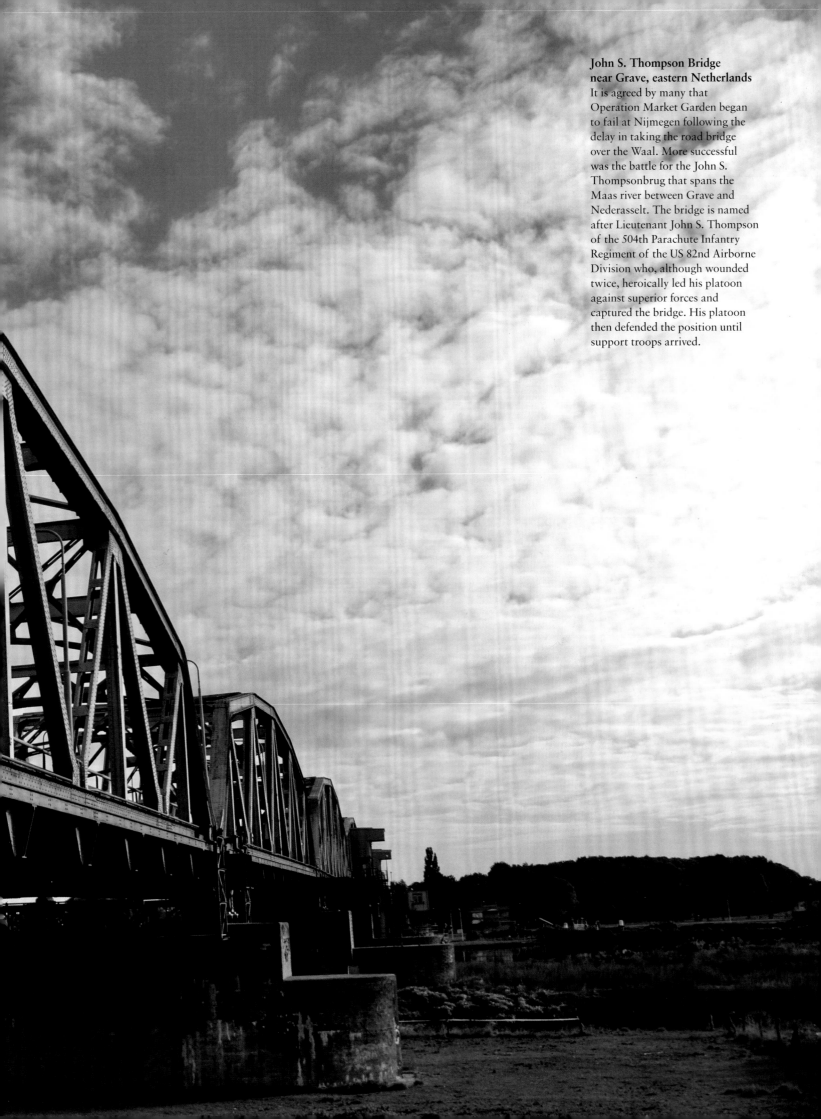

**John S. Thompson Bridge
near Grave, eastern Netherlands**
It is agreed by many that
Operation Market Garden began
to fail at Nijmegen following the
delay in taking the road bridge
over the Waal. More successful
was the battle for the John S.
Thompsonbrug that spans the
Maas river between Grave and
Nederasselt. The bridge is named
after Lieutenant John S. Thompson
of the 504th Parachute Infantry
Regiment of the US 82nd Airborne
Division who, although wounded
twice, heroically led his platoon
against superior forces and
captured the bridge. His platoon
then defended the position until
support troops arrived.

Arnhem memorial
Decisions made in the planning
and execution of Operation
Market Garden are still ferociously
debated by historians, and the
battle for Arnhem remains the
focus of much of this study. What
can never be questioned is the
bravery and dedication of the men
who fought there. This memorial
on Ginkelse Heide (Ginkel Heath)
near Ede pays tribute to the
Kings Own Scottish Borderers
of the Airlanding Brigade, who
fought in defence of this drop
zone on 17 and 18 September. It
is one of many memorials around
Oosterbeek, Wolfheze, Driel and
Arnhem to the fighting.

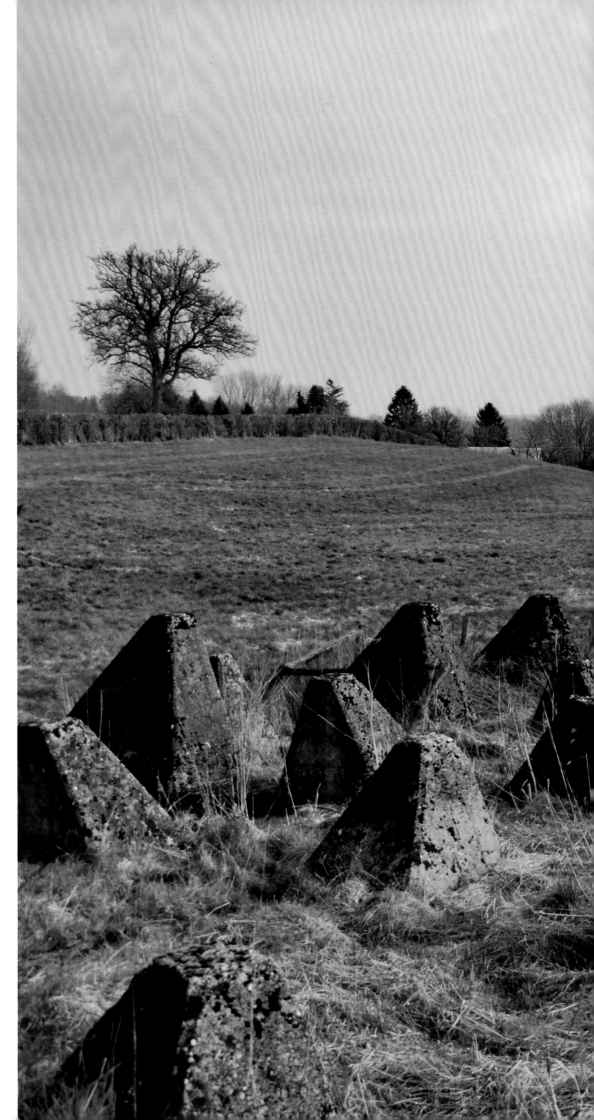

Siegfried Line, Aachen, Germany
'Dragons' Teeth' concrete tank
trap obstacles from the Siegfried
Line are still visible today around
the German border. Known by
the Germans as the Westwall, the
Siegfried Line was built during the
1930s opposite and mirroring the
renowned French Maginot Line of
defences. It stretched more than
630km (390 miles) from Kleve
on the Dutch border to the town
of Weil am Rhein on Germany's
border with Switzerland. It
incorporated more than 18,000
bunkers, tunnels and obstacles.
The first large-scale clashes on
the Westwall occurred in the
Hürtgenwald (Hürtgen Forest)
southeast of Aachen in September
1944. The Aachen Gap was the
logical route into the industrial
areas of the Rhineland and was
therefore heavily defended by the
Germans. After months of fighting
along different areas of the line,
the last positions fell to the Allies
in early 1945.

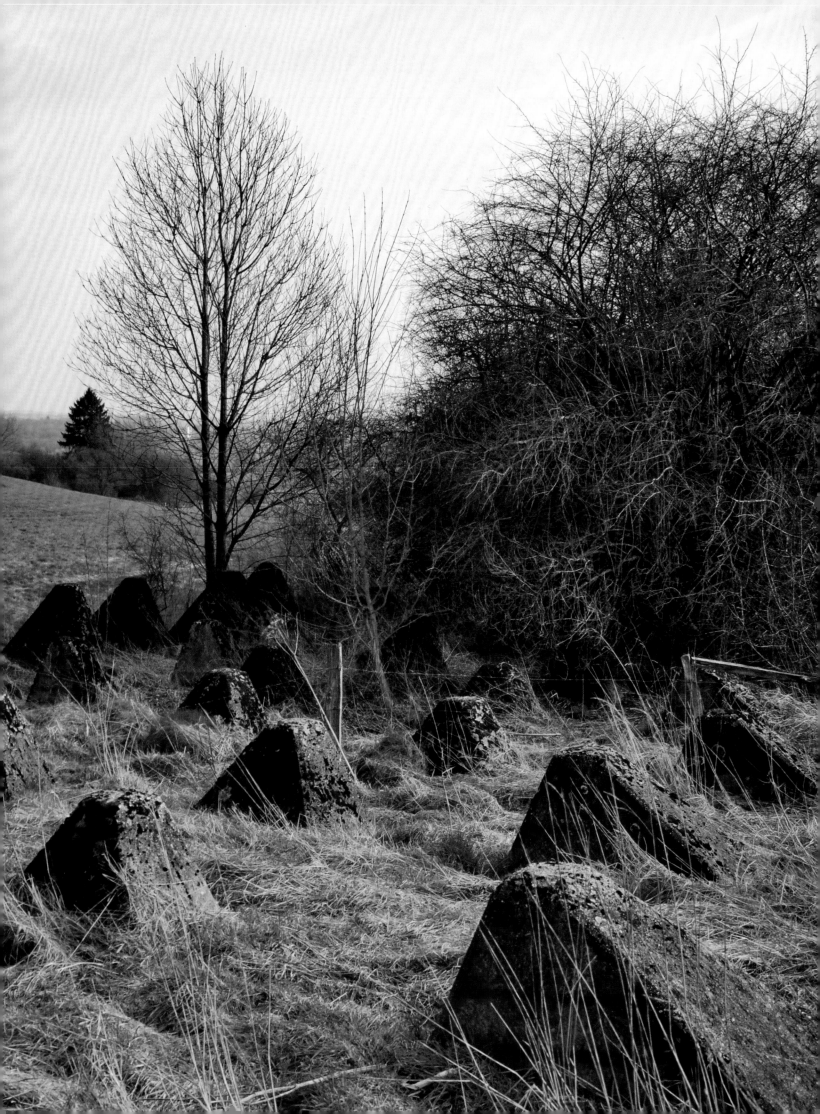

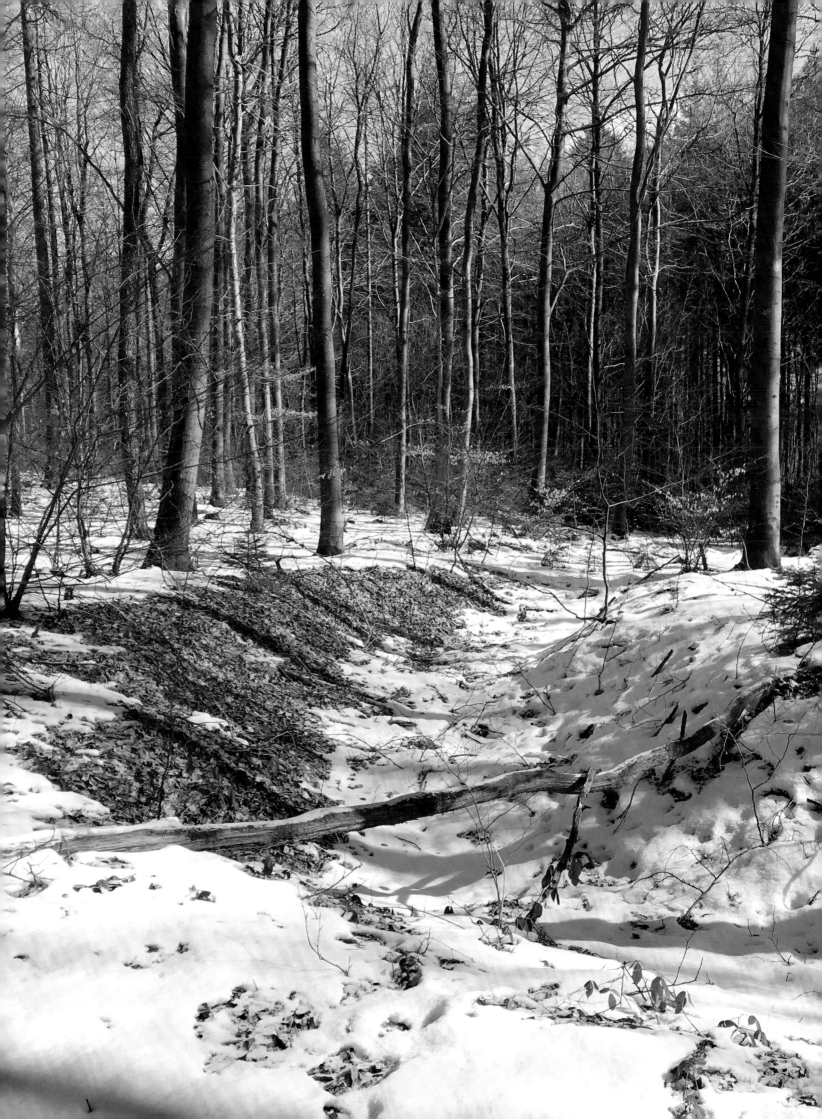

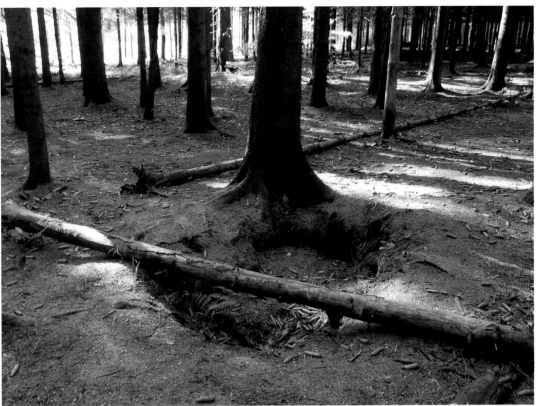

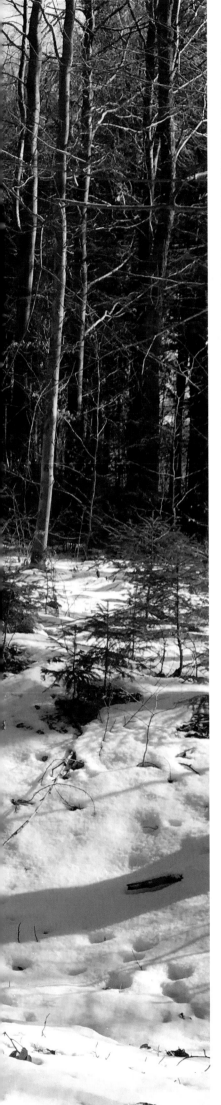

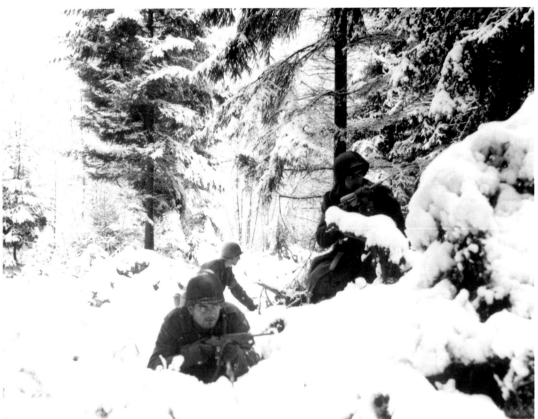

LEFT & ABOVE TOP:

Trenches and foxholes, Ardennes Forest, Belgium
The Battle of the Bulge was the largest ground campaign in western Europe and much of the combat occurred in the Ardennes forest in Belgium. Nearly eight decades after the fighting, evidence of the battle in the form of fox-holes and trenches can still be found in locations such as the Bois Jacques (*above top*). The best time to visit is in winter, when one can truly appreciate the difficulties faced by the soldiers of both sides in what was one of the harshest winters on record.

In the forest, many deaths came from artillery fire. Shells would sometimes explode at tree-top height, showering the men below with shrapnel and pieces of wood.

ABOVE LOWER:

Fox holes in the snow
US infantrymen of the 290th Regiment wait amidst fresh snowfall near Amonines, Belgium, 1 January 1945.

creation of the First Allied Airborne Army on 2 August 1944, the use of paratroopers and glider-borne troops, who had been so successful in Normandy, seemed the answer and the newly promoted Field Marshal Montgomery launched Operation Market Garden.

Directed towards Arnhem, its intention was to launch a swift thrust towards the industrial Ruhr. This massive air and ground operation commenced on 17 September 1944. Rather hastily planned and encountering a tougher German reaction than expected, the plan failed, causing the Allies to return to the broad-front strategy until after winter, which meteorologists predicted would be especially harsh. The static nature in places of the Allied line was such that green American divisions were starting to replace veteran units at the front and a sense of complacency set in.

Then, with little warning, the Germans launched a counter-offensive into the Ardennes on 17 December, thus beginning the Battle of the Bulge. Unlike the mostly clear summer skies of Normandy, the Ardennes' winter fog and

ABOVE & OPPOSITE:
Bastogne, Belgium
Seven important roads converge in Bastogne and in December 1944 it lay on the route towards Antwerp that German forces took during the opening days of the Battle of the Bulge offensive, which was designed to split the Allied lines. In freezing conditions and heavy fog, and desperately short of ammunition and supplies, the American 101st Airborne Division and men from other units held firm in the town, although surrounded by superior German units. Eventually the fog broke, supplies could be dropped from the air and General George Patton's 4th Armored Division relieved the town. During the siege the 'Battered Bastards of Bastogne' came to symbolize the defiant spirit of all paratroopers in combat.

bad weather hampered a swift Allied response from the air and the German attack gained ground. Stubborn and legendary defensive actions in places like Bastogne, St Vith and on the Elsenborn Ridge bought the Allies vital time, and when the fog lifted and air operations recommenced, armoured and infantry units poured into the area. Although fighting continued until February 1945, the Germans had rolled their last dice and the Allies were on the move to Berlin once again.

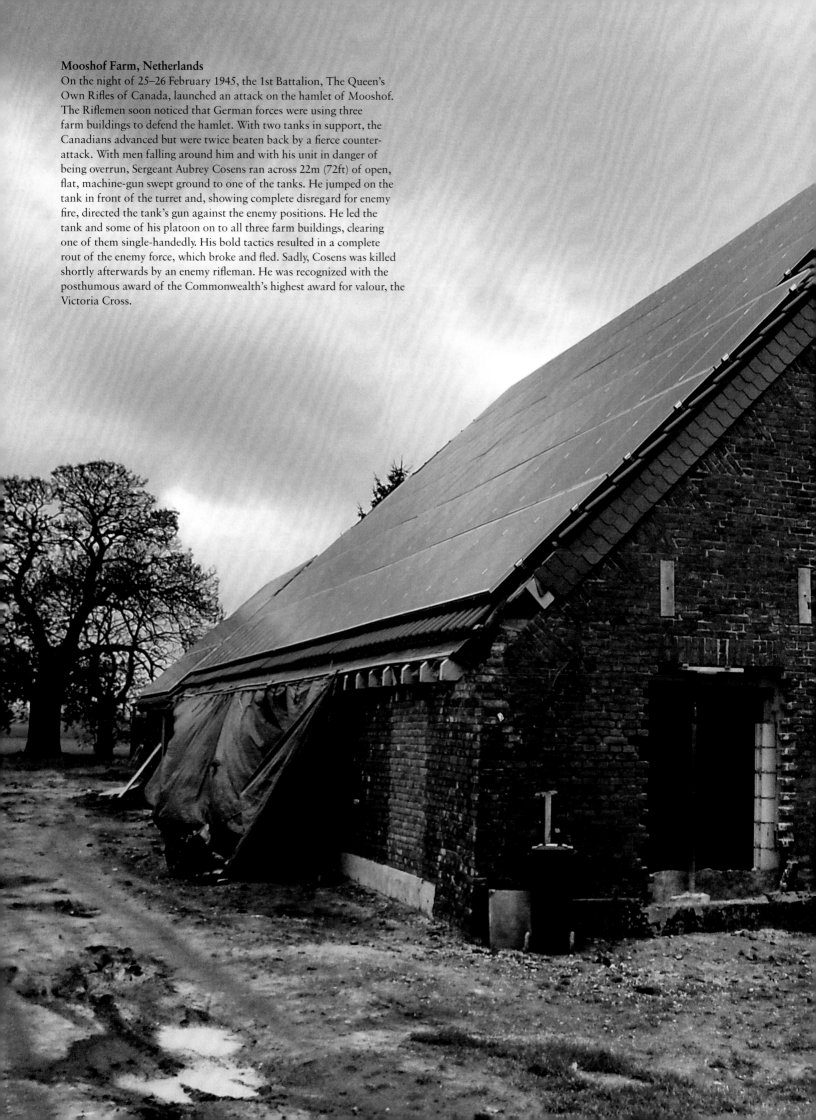

Mooshof Farm, Netherlands
On the night of 25–26 February 1945, the 1st Battalion, The Queen's
Own Rifles of Canada, launched an attack on the hamlet of Mooshof.
The Riflemen soon noticed that German forces were using three
farm buildings to defend the hamlet. With two tanks in support, the
Canadians advanced but were twice beaten back by a fierce counter-
attack. With men falling around him and with his unit in danger of
being overrun, Sergeant Aubrey Cosens ran across 22m (72ft) of open,
flat, machine-gun swept ground to one of the tanks. He jumped on the
tank in front of the turret and, showing complete disregard for enemy
fire, directed the tank's gun against the enemy positions. He led the
tank and some of his platoon on to all three farm buildings, clearing
one of them single-handedly. His bold tactics resulted in a complete
rout of the enemy force, which broke and fled. Sadly, Cosens was killed
shortly afterwards by an enemy rifleman. He was recognized with the
posthumous award of the Commonwealth's highest award for valour, the
Victoria Cross.

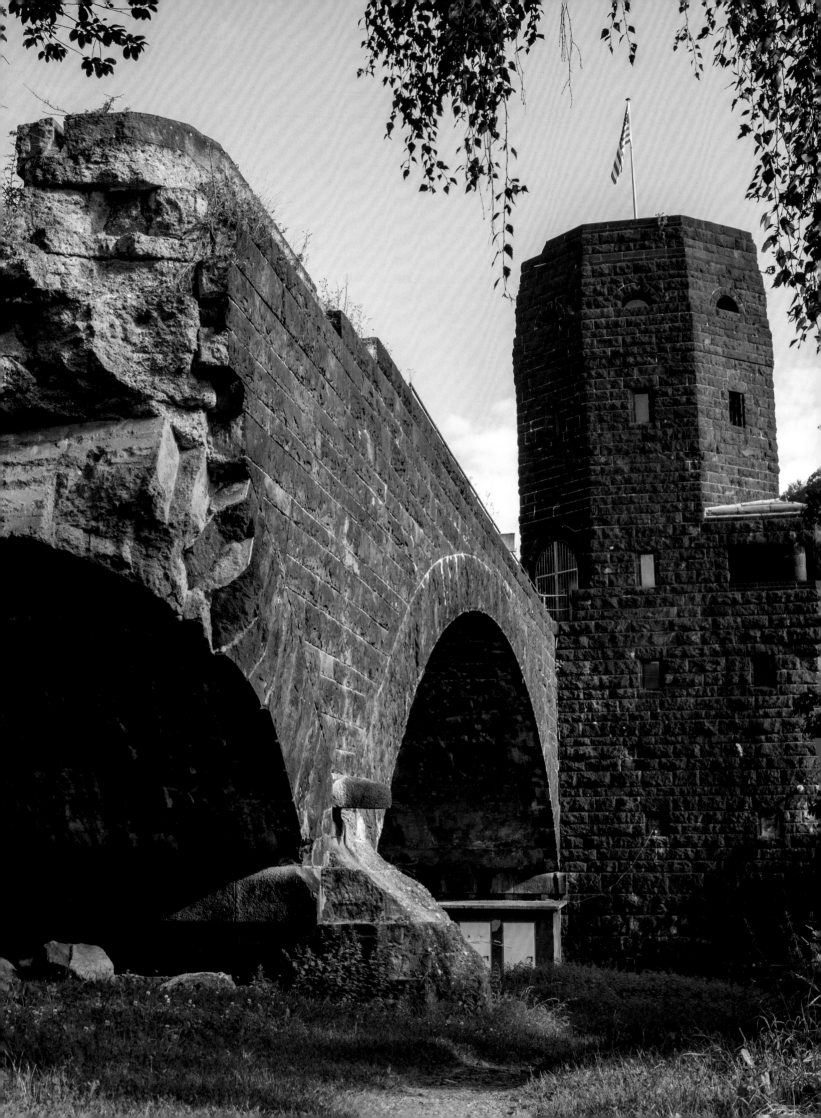

END OF THE REICH

Following the failure of the German counter-offensive in the Ardennes and with the Red Army's relentless advance westwards, the collapse of the Third Reich was inevitable. Germany therefore pinned its hopes on its remaining obstacles: the Siegfried Line and the Rhine river.

Despite their impressive gains since the summer of 1944, the terrible winter of 1944–45 had taken its toll on the Allied advance; its armies were worn out and weary and, despite being bombarded day and night from the air, the German will to fight seemed undampened. Allied troops had first reached the banks of the Rhine in 1944, but it was not until March 1945 when Allied forces finally crossed in strength at several points and could push on to the heart of Germany.

This was the morale boost Allied troops needed and they advanced with renewed vigour. One important crossing was at Remagen bridge on 7 March 1945, another was during Operation Varsity on 24 March 1945. This was probably the most successful airborne operation of the war, when 16,000 troops landed by parachute and glider on the German-held east bank of the Rhine near Wesel, 160km (100 miles) north of Remagen.

The War in Western Europe ended swiftly. The Red Army captured Berlin, and American and Soviet forces met on 3 May 1945 near the Elbe river at Torgau. At 2.41am on 7 May, at SHAEF headquarters in Reims, France, the chief-of-staff of the German Armed Forces High Command, General Alfred Jodl, signed an unconditional surrender document for all German forces. The world celebrated the final victory in Europe the following day.

OPPOSITE & BELOW:
Ludendorff bridge, Remagen, Germany
On 7 March 1945, the Ludendorff rail bridge at Remagen over the Rhine was captured intact by men of the American 9th Armored Division. They had fought their way across the bridge under withering enemy fire as the Germans attempted to destroy it with demolition charges. Several explosions damaged part of the bridge, but the main charges failed to detonate and the bridge stood firm. Within a few days seven US divisions had crossed the river and established a strong bridgehead east of the Rhine. On 17 March, the Ludendorff bridge, weakened further from the strain of heavy traffic, collapsed into the Rhine. Having successfully crossed the Rhine, the race was on to liberate the whole of Germany.

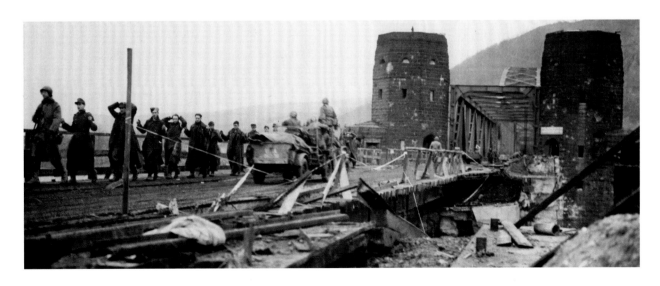

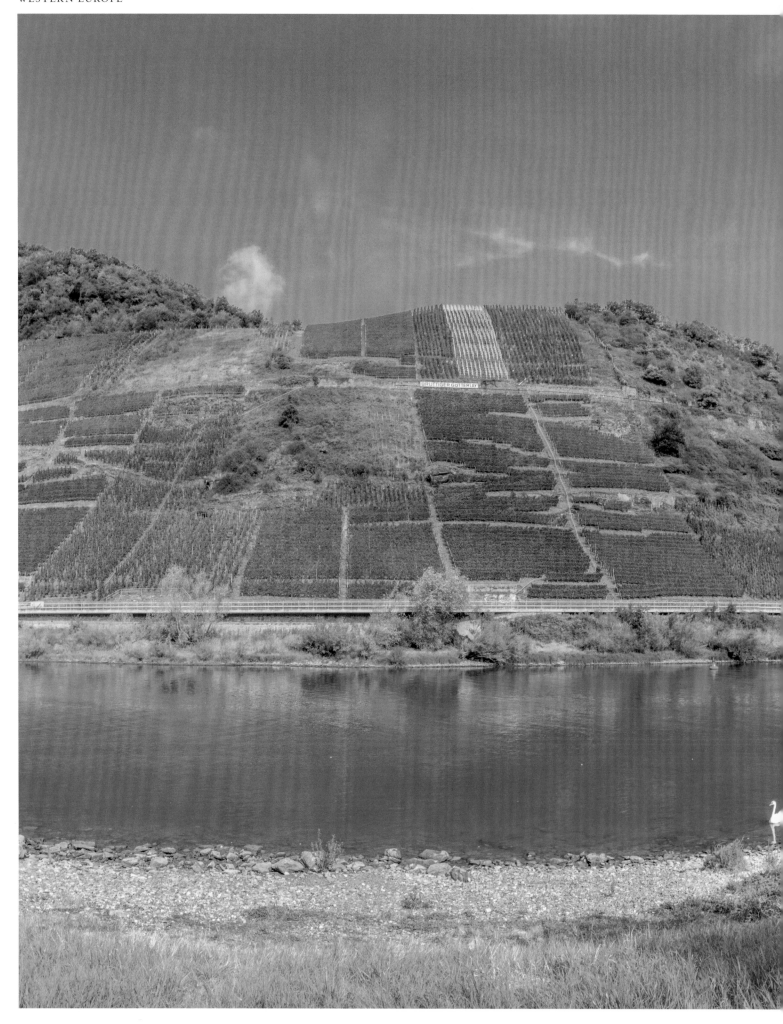

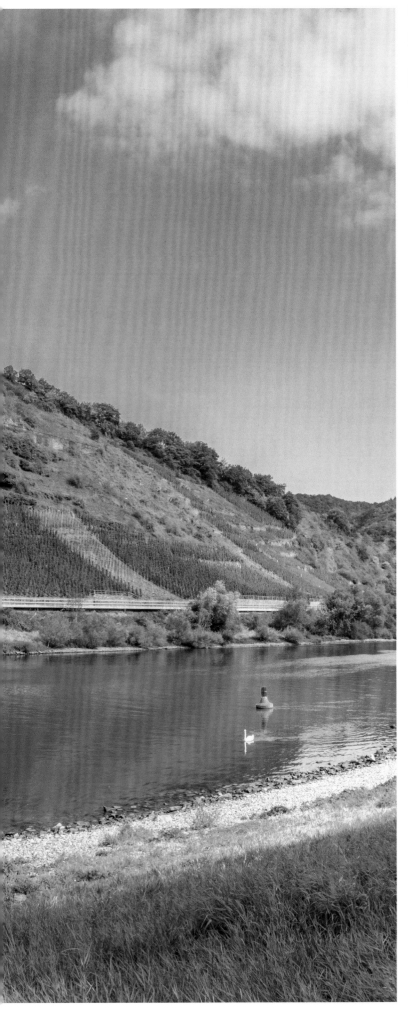

LEFT & ABOVE:

Oberwesel, River Rhine, Germany

The photograph above shows American soldiers from the 89th Infantry Division crouching low as they cross the Rhine at Oberwesel in an amphibious DUKW, 28 March 1945.

Oberwesel was one of a number of crossings, including the Luddendorff bridge at Remagen. At Oberwesel, six LCVPs (landing craft, vehicle, personnel) supported the 89th Division, moving all the division's men, vehicles and equipment within 48 hours. This was the beginning of the Western Allies' invasion of Germany.

Peenemünde, northeast Germany

Peenemünde sits on the island of Usedom in the Baltic Sea. It became a key location in the German rocket programme, especially the development and production of the V-2 rocket. Scientists such as Wernher von Braun worked at Peenemünde and the groundbreaking research carried out there led not only to the terrifying use of V weapons against Allied countries but also influenced the development of modern weapons of mass destruction, as well as space travel.

On the night of 17 August 1943, the RAF carried out Operation Hydra, one of the largest actions against a single target undertaken by Bomber Command in the whole of the war. Although the bombing caused limited damage, it did delay the production of V weapons and forced the Germans to move manufacturing to an underground site in Mittelwerk in central Germany.

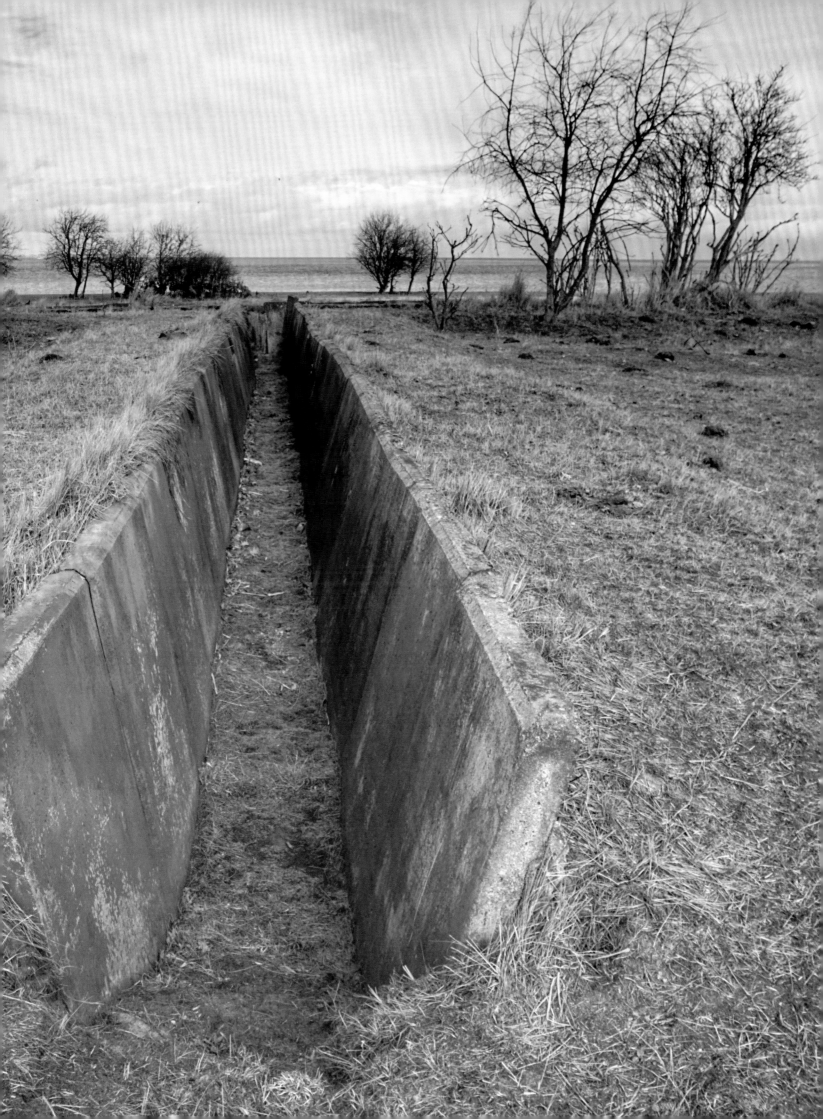

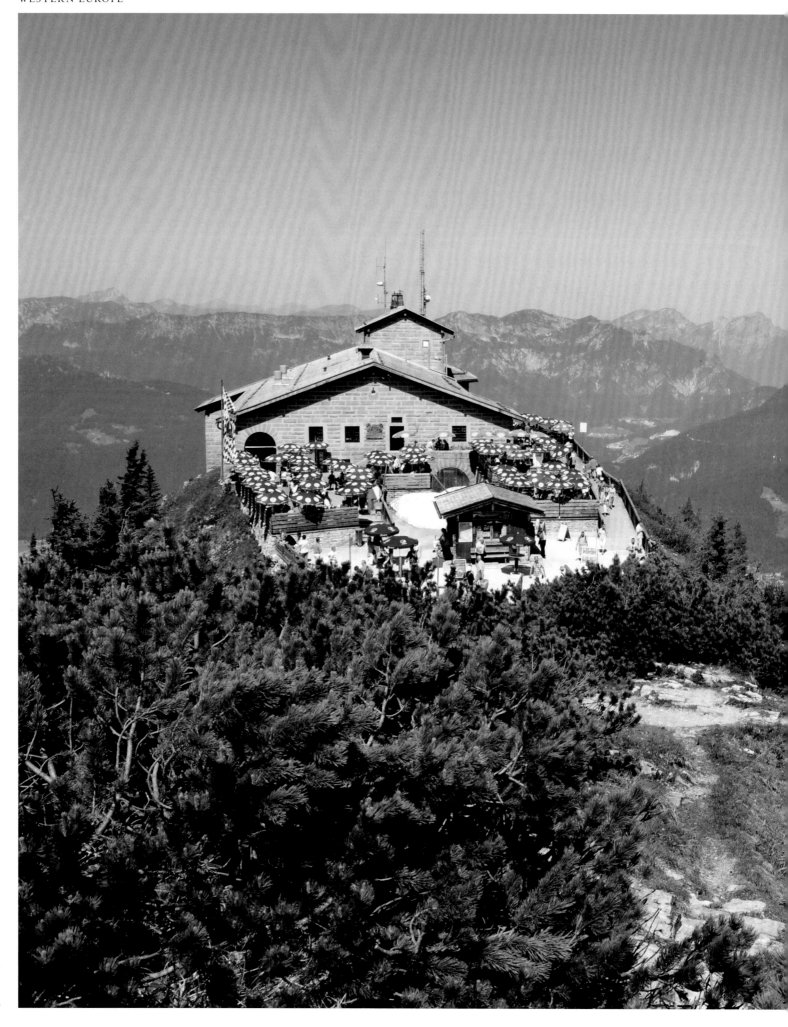

Kehlsteinhaus ('Eagle's Nest'),
southeast Germany
The *Kehlsteinhaus* was erected
on the summit of the Kehlstein,
a rocky outcrop that rises above
Obersalzberg near the town of
Berchtesgaden, in southeastern
Germany, to celebrate Hitler's 50th
birthday. It was used exclusively
by members of the Nazi Party for
government and social meetings,
including Hitler himself, on at least
14 occasions.

Today, it is open seasonally as
a restaurant offering spectacular
views of the mountains. It found
additional fame when depicted in
the HBO series *Band of Brothers*
in 2001, when members of the
US 101st Airborne Division were
shown exploring the buildings.

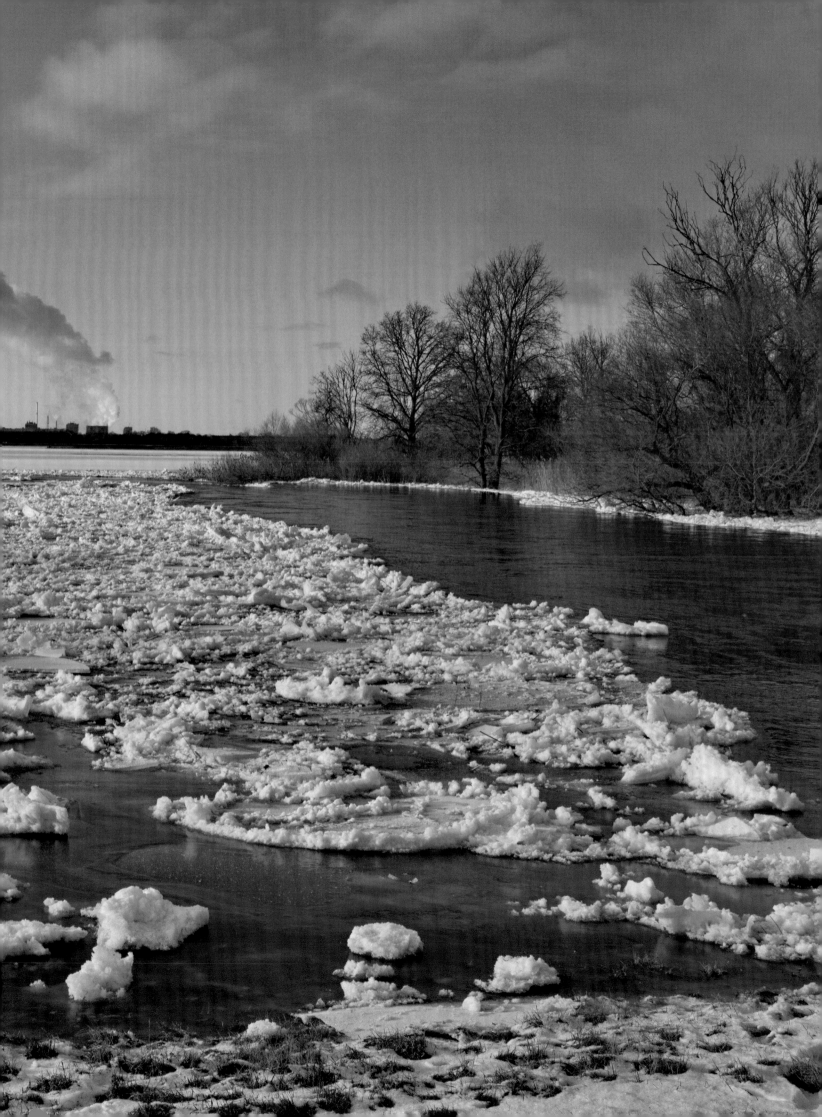

Eastern Europe

Without territorial gains and the capture of resources, Germany's ability to wage total war was sorely limited. The occupation of countries in the west would help. Norway's iron ore would be vital, as would France's industry, but a better solution lay to the east. Seizing Soviet oil, minerals and its fertile agricultural plains were always part of Hitler's thinking, but there was a problem. In Moscow on 23 August 1939, the German foreign minister Joachim von Ribbentrop and the soviet foreign Minister Vyacheslav Molotov had signed the Molotov–Ribbentrop Pact, which enabled those two powers to partition Poland between them. Thus, before he could think about breaking the non-aggression pact and attacking the Soviet Union, Hitler needed to first resolve the Polish situation.

On 1 September 1939, Germany launched a 'retaliatory' campaign into Poland. This was in reprisal for a phony attack staged by German troops disguised as Poles on a German-run radio station, and it was justified by Nazi propaganda that falsely accused Poland of persecuting ethnic Germans living in her cities. The surprise attack came via East Prussia in the north and Silesia and Slovakia in the south and consisted of more than 60 divisions and 2000 tanks, supported in the air by hundreds of bombers and fighters. Poland was slow to respond to this immense assault.

OPPOSITE:
Oder River, Poland
The Oder river forms part of the border between Poland and Germany. When Soviet forces crossed this obstacle westwards in January 1945 it was a defining moment of the war in the East. Though Hitler attempted to reorganize his near crippled forces, the end of the Third Reich was drawing close.

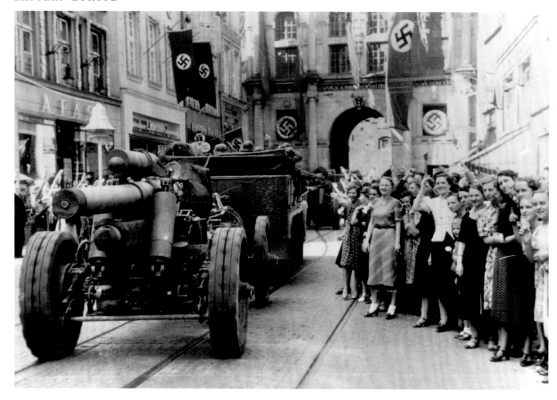

Poland had few armoured units and only around 300 aircraft – most of which the Luftwaffe shot down in the first few days. Despite fighting tenaciously in places like Westerplatte and inflicting heavy casualties on German forces, the Polish army soon found its forces fighting a two-front campaign when the Soviet Union invaded on 17 September. The Polish Army was quickly defeated and, in accordance with the terms of the Molotov–Ribbentrop Pact, Germany and the Soviet Union partitioned Poland on 29 September 1939 along the demarcation line of the Bug river.

ABOVE & RIGHT:
Gdansk, northern Poland
Friday 1 September 1939 is forever remembered as the day World War II began, and the costliest conflict in human history started here with the Nazis removing Gdansk's status as a free city and incorporating it into the Reich. Six years later the city was almost total destroyed by Soviet shelling, although the famous Golden Gate was rebuilt in 1957.

OPERATION BARBAROSSA

The enormity of Germany's thrust east is mind-boggling. Within days, the Operation Barbarossa front extended from the Gulf of Finland in the north almost 2900km (1800 miles) south to the Black Sea. Due to offensives in Greece and Yugoslavia the invasion had been delayed by more than a month, but on 22 June 1941 148 divisions, constituting around 80 per cent of the Wehrmacht, were committed. Four Panzer Groups formed the vanguard, with 3400 tanks supported by 2700 Luftwaffe aircraft. It was the largest invasion force of the war, involving 3.5 million German and other Axis troops.

Barbarossa was split over three army groups: Army Group North was to move through Latvia, Lithuania and Estonia and take Leningrad; Army Group South

**Gliwice Radio Tower,
southern Poland**

Standing at 111m (364ft), the
wooden transmitting tower at
the radio station in Gliwice was
a marvel of pre-war engineering.
On 31 August 1939, under
the orders of Gestapo chief
Heinrich Müller and his deputy
Reinhard Heydrich, a small
group of Germans dressed in
Polish uniforms seized the radio
station and broadcast a short
anti-German message in Polish.
By staging a fake act of sabotage
by anti-German rebels, the Nazis
were able to justify the invasion
of Poland, which began the very
next morning.

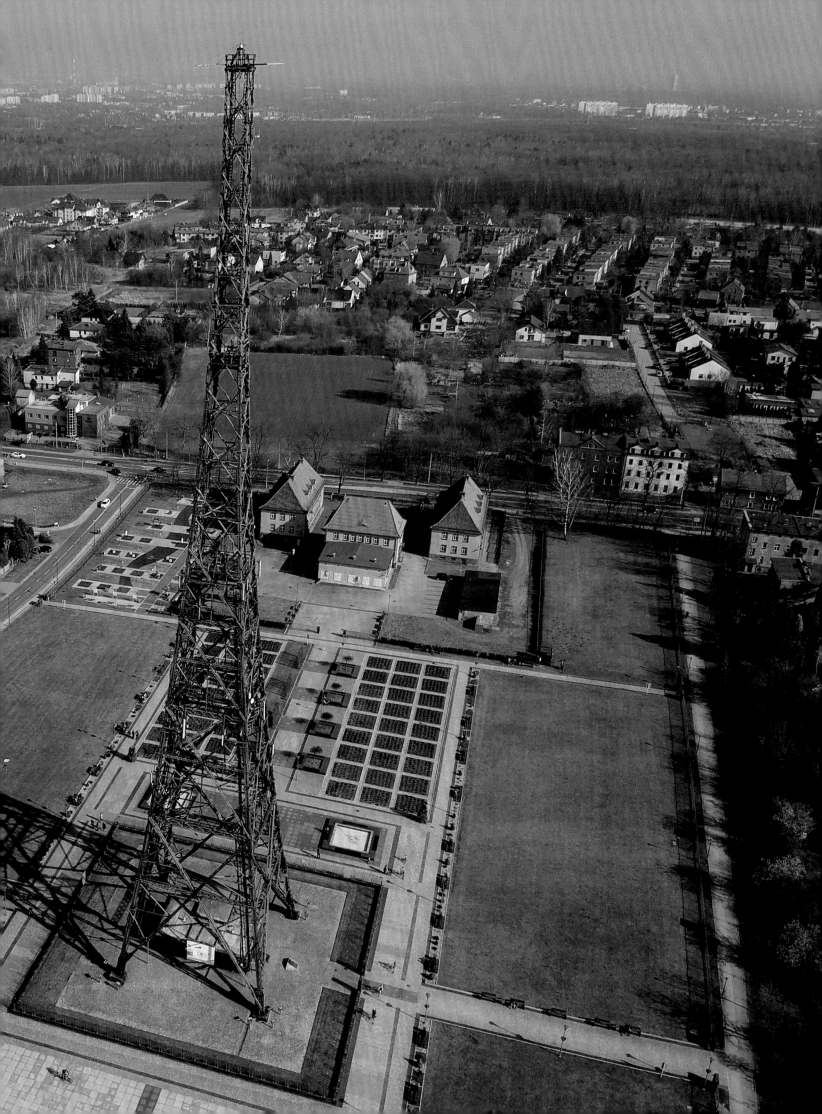

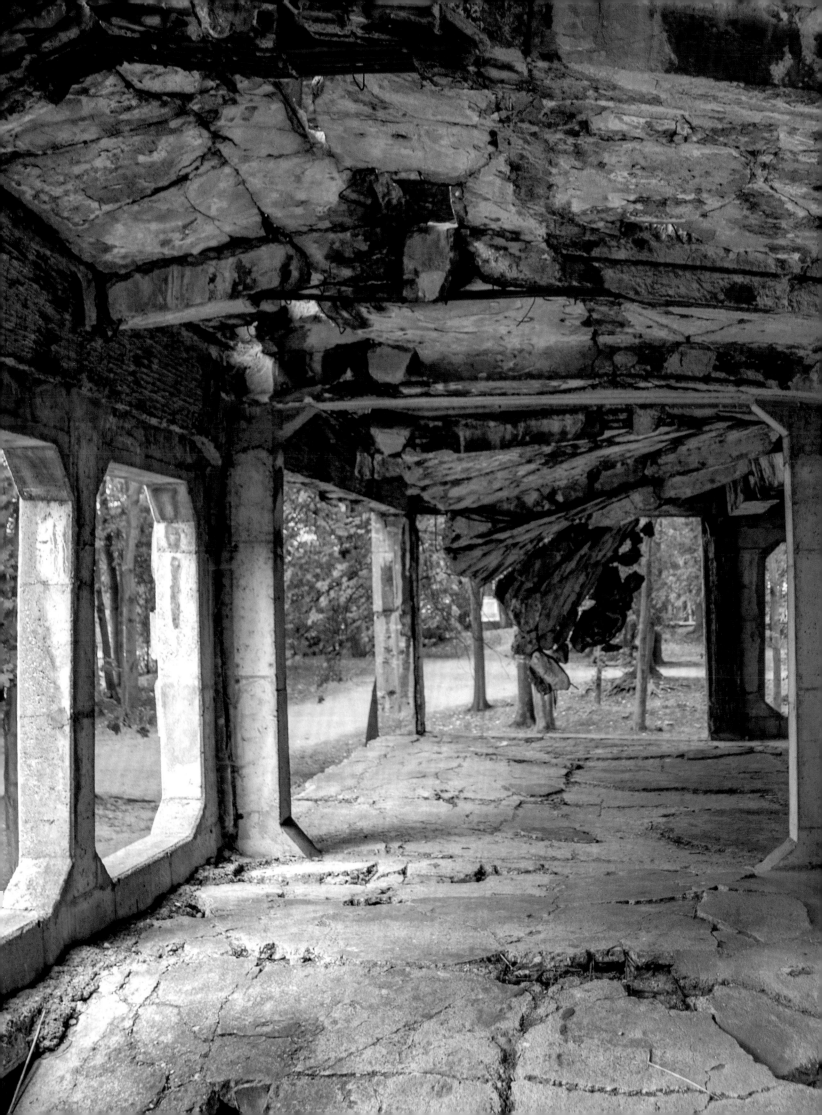

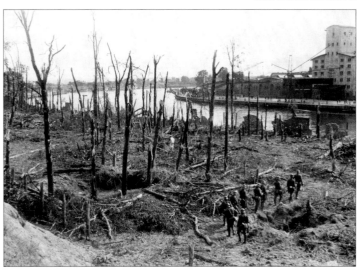

LEFT & ABOVE:

Ruins of Westerplatte barracks, Gdansk, Poland

The Battle of Westerplatte was the first engagement in the German invasion of Poland, heralding the start of the war in Eastern Europe. German forces attacked in strength on 1 September 1939 and the Polish garrison of the depot endured at least 13 assaults and heavy bombardments by the battleship Schleswig-Holstein, Stuka dive bombers and land-based artillery. For seven days the defenders held out against overwhelming odds. Eventually it was a lack of ammunition that forced the gallant commander, Major Sucharski, to surrender. The defence of the Westerplatte was an inspiration for the citizens of Poland and is still regarded as a symbol of resistance today. The three-storey barracks had been designed in such a way that the ceilings of the two upper floors would absorb the impact of bombs and shells protecting the defenders in the cellar below. This design worked well during the battle and most of the damage seen today is the result of post-war destruction, which included indoor detonations of unexploded shells and bombs.

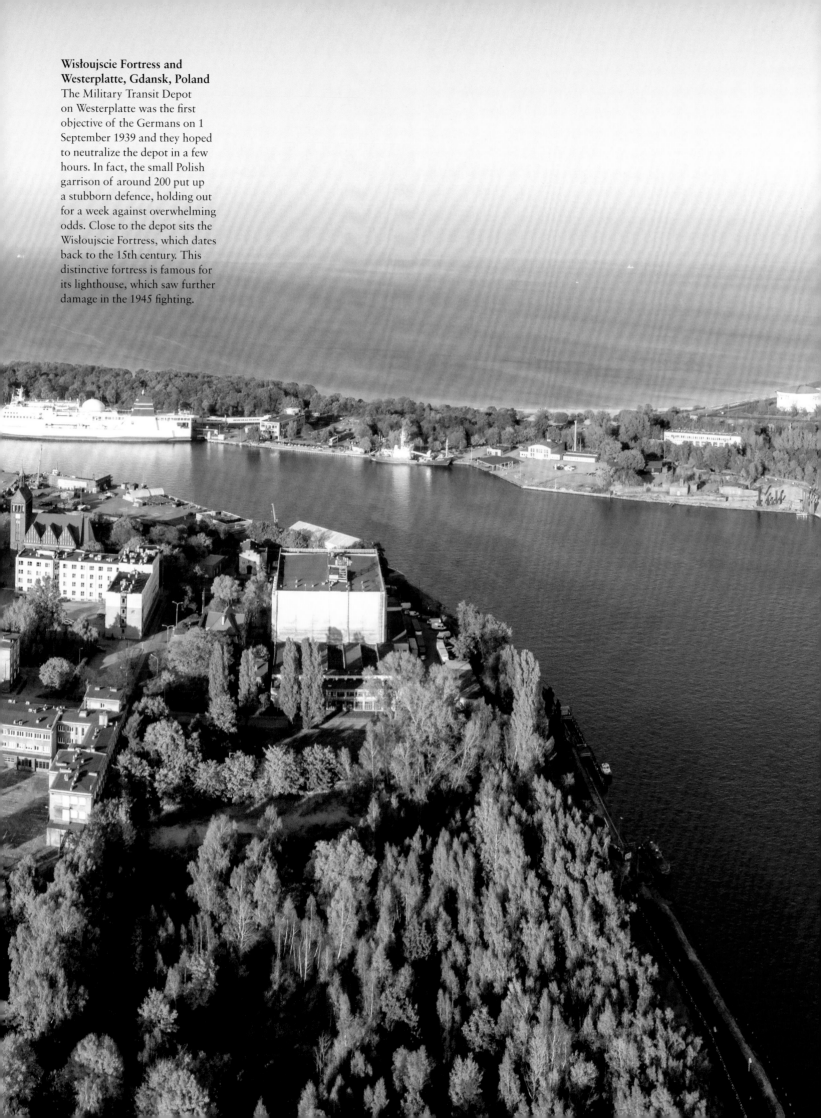

Wisłoujscie Fortress and Westerplatte, Gdansk, Poland
The Military Transit Depot on Westerplatte was the first objective of the Germans on 1 September 1939 and they hoped to neutralize the depot in a few hours. In fact, the small Polish garrison of around 200 put up a stubborn defence, holding out for a week against overwhelming odds. Close to the depot sits the Wisłoujscie Fortress, which dates back to the 15th century. This distinctive fortress is famous for its lighthouse, which saw further damage in the 1945 fighting.

would attack into Ukraine towards Kiev and the Donbas industrial region; and Army Group Centre's objective was Minsk and then the ultimate prize of Moscow. Hitler expected to achieve victory in approximately 10 weeks.

Opposing them, the Soviets had amassed around five million men and 23,000 tanks. But Stalin, believing that Hitler would not break the Molotov–Ribbentrop Pact so soon, had not prepared them for such a well-coordinated attack. The Germans consequently got off to a good start, with the Panzer groups swiftly moving towards their objectives, assisted by the Luftwaffe's efficient bombing of Soviet airfields, artillery positions and transport hubs. On the first day alone 1800 Soviet aircraft were destroyed, and on the ground many Russian units fell apart in disarray.

Over the next few weeks, all three Army Groups made huge gains, cities fell and huge tracts of Soviet land were taken. Soon, German Panzers were only 320km (200 miles) from Moscow. But, as summer turned to autumn and winter, a German logistics weakness became

apparent and across the massive front Soviet resistance grew.

THE BATTLE FOR MOSCOW

During the Barbarossa offensive, priorities frequently changed as the Germans tried to exploit perceived Soviet weaknesses. In addition, some battles were taking longer than anticipated, most notably those at Leningrad and Kiev, delaying Army Group Centre's advance on Moscow.

By 2 October 1941, when Hitler unleashed Operation Typhoon, his final drive on the Russian capital, German forces were already weakened, and the defending Red Army had

BELOW & OPPOSITE:
River Bug, Polish–Belarus border
Belarus had been occupied by Soviet forces since September 1939, but on 22 June 1941 the Germans launched Operation Barbarossa and attacked across the 201km (125 mile) part of the Bug that forms the border between Poland to the west and Ukraine and Belarus to the east. Often ignored by westerners in the study of the war, Belarus lost a quarter of its population in the conflict, including nearly all its intellectual elite. In total around 9200 villages and 1.2 million homes were destroyed.

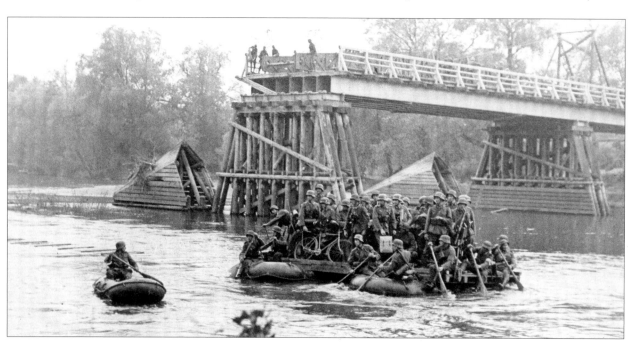

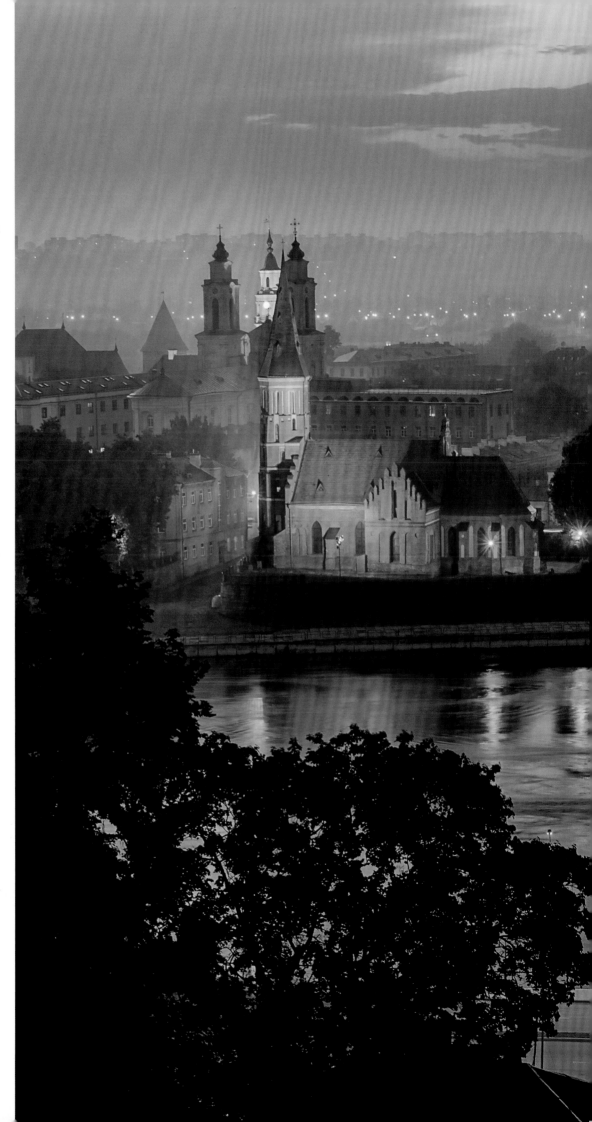

Vytautas the Great Bridge, Kaunas, southern Lithuania
This bridge crosses the Nemunas River connecting Aleksotas and Old Town in Kaunas. On 22 June 1941, the Germans began Operation Barbarossa, putting into action the Nazis' ideological goal of conquering the western Soviet Union to create *Lebensraum* ('living space') for its people.

The German Army Group North launched a strong advance into Lithuania, swiftly capturing the city of Kaunas. Supply shortages forced the attacking army to temporarily halt in the city. But during that time the commander of Army Group North, Wilhelm von Leeb, was able to plan the next breakthrough, and just two days later he had advanced another 129km (80 miles) and taken the strategic objective of Vilnius. In doing so his army had secured the northern flank and destroyed a good number of Soviet units.

Four months later, on 29 October, a massacre took place in Kaunus when *Einsatzkommandos* under the orders of the SS murdered more than 9000 Lithuanian Jews in a single day, nearly half of whom were children. This occurred at the Ninth Fort, a site where eventually a total of up to 50,000 Jews, mostly from Kaunas and the Kovno Ghetto, were systematically killed by Nazis and Lithuanian collaborators.

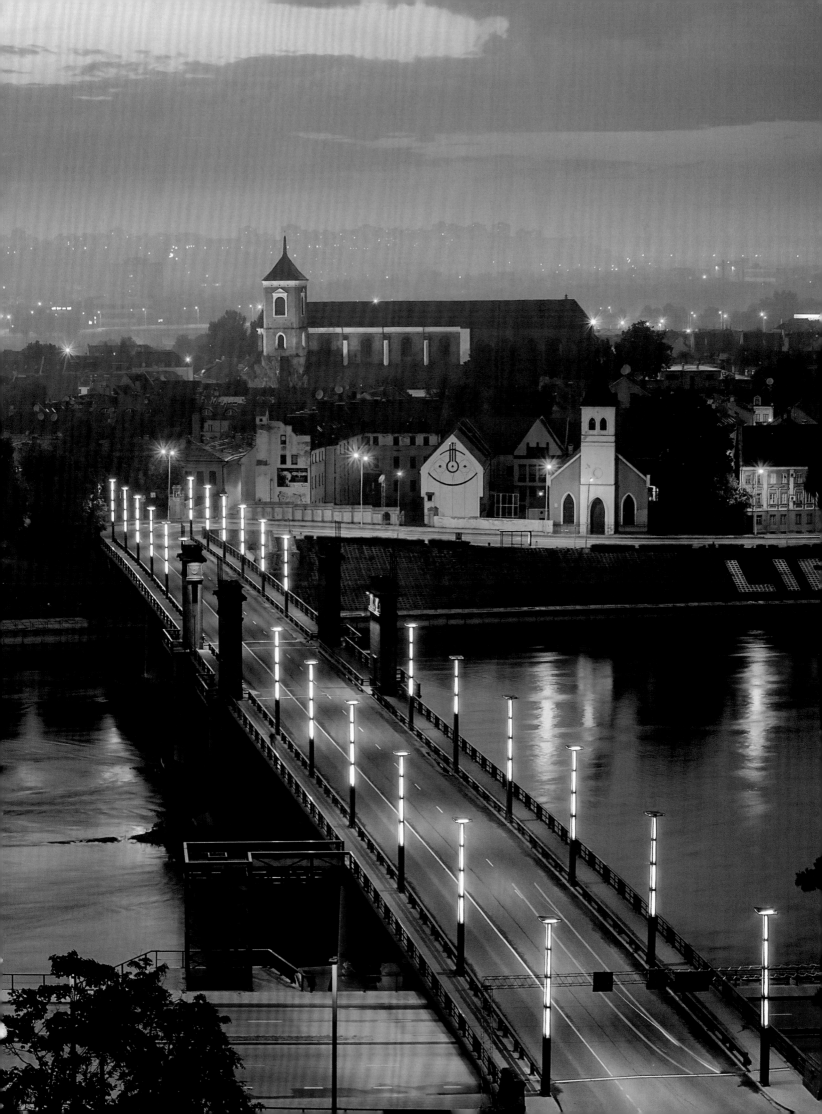

**Pripyat Marshes,
southern Belarus**
In June 1941 Heinz Guderians 2nd
Panzer Group was sent to clear
the Pripyat Marshes of Soviet
forces to secure the southern
flank of the drive on Minsk. The
ensuing campaign was difficult,
due to both the enormous size of
the marshlands and the initially
efficient delaying actions of
the retreating Soviet troops. A
breakthrough occurred when
Guderian's 24th Panzer Division
gained ground by attacking
the Soviet 75th Rifle Division
in Malkovichi, who fell back
eastwards to defend Minsk. The
Germans continued to advance
through the marshes with little
opposition. During the wider
campaign, the 2nd and 3rd Panzer
Groups had advanced over 483km
(300 miles) into the Soviet Union
and by 30 June had encircled four
Soviet Armies near Bialystok and
Minsk. The Red Army had lost
420,000 men against Wehrmacht
casualties of just a few thousand.

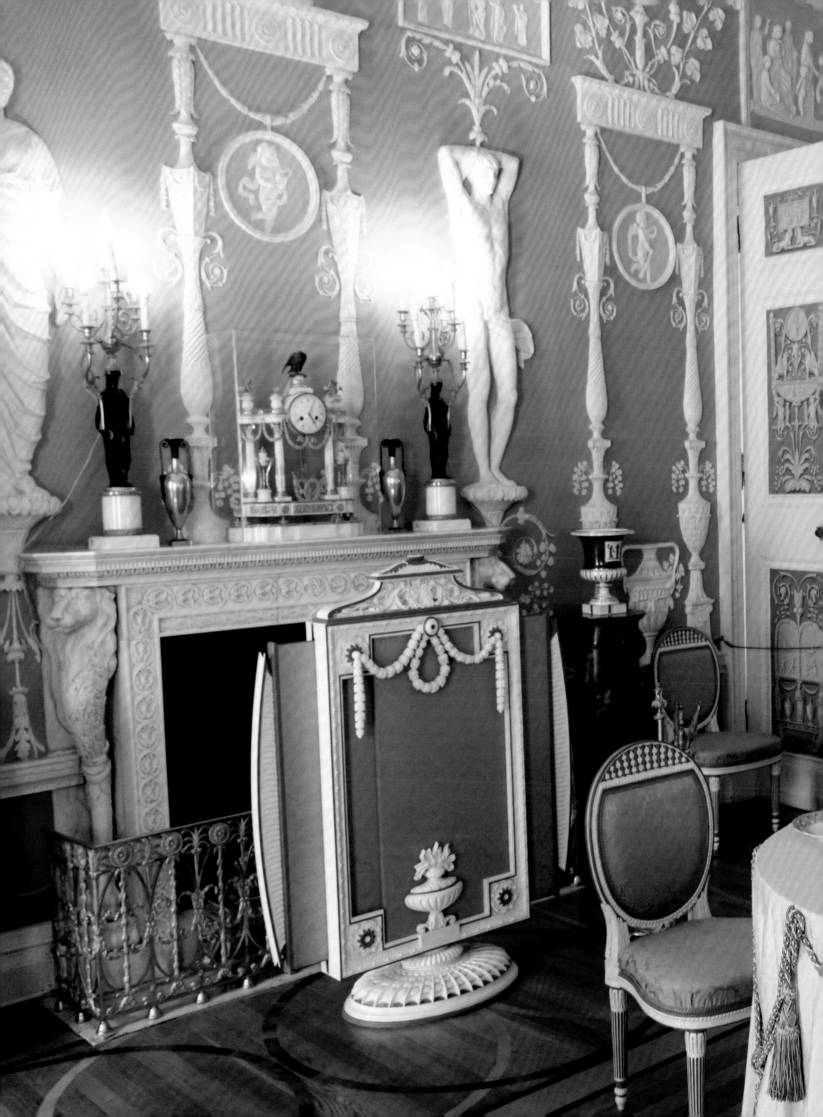

been reinforced with almost a million men, having used the time caused by the German delay to fortify the city. A multi-layered ring of defences had been thrown around the capital and all of its citizens had been mobilized.

Nevertheless, Typhoon stormed forward and German Panzers soon made gains near Vyazma, encircling four Soviet Armies. Rather than surrendering, the Red Army tenaciously continued the fight, slowing the German advance and forcing them to commit more men. Meanwhile, other Soviet troops fell back to the Mozhaysk line west of Moscow.

On 7 October the first snows fell but soon melted, turning the roads to mud. The Russians called this time of year Rasputitsa, or 'quagmire', season. It slowed the Germans but, trudging forward, they eventually reached the Mozhaysk defences on 10 October. That same day, Stalin recalled General Georgy Zhukov from Leningrad to take charge of Moscow's defence. He brought in additional troops from Siberia and the east – men accustomed to low winter temperatures. Battles raged across the Moscow front as the Germans continued to hammer at the Soviet line.

By November, the harsh winter had frozen the ground and brought the Rasputitsa season to an end, allowing German Panzers to renew their advance with a pincer attack. The northern pincer managed to get just 19km (12 miles) from its goal; German commanders could see the Kremlin through their binoculars. Another thrust along the Minsk road headed for the centre of Moscow and, on 2 December, a reconnaissance unit got within 8km (5 miles) of the city.

Three days later, however, the Soviets launched a counter-offensive of 58 divisions and the exhausted and demoralized Germans were forced to retreat. Hitler was furious and

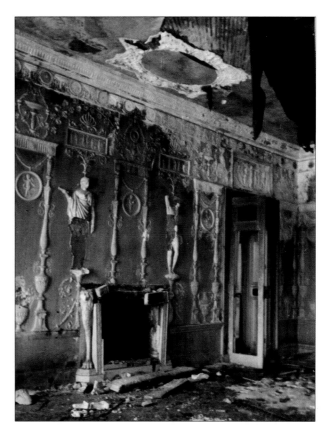

sacked several commanders, including Generals Hans Guderian and Fedor von Bock. Although Soviet troops had held Moscow and pushed the Germans back over 96km (60 miles) west, it was not a comprehensive victory. As the weather improved in late December and early January, the Luftwaffe renewed its bombing

OPPOSITE & ABOVE:
Catherine Palace, Tsarskoye Selo, Russia
Leningrad (since renamed St Petersburg) was the main target of Army Group North in Operation Barbarossa. This was motivated by the city's political status as the former capital of Russia and the symbolic capital of the 1917 revolution; it was also a key base of the Soviet Baltic Fleet. When the Germans finally retreated after an epic 872-day siege, the battle had claimed the lives of around one third of Leningrad's citizens. Catherine Palace sits 32km (20 miles) away in Tsarskoye Selo and had been a former residence of the Russian tsars. Seeking revenge after the siege, retreating German forces intentionally shelled the palace, leaving only an empty shell in their wake. They had looted treasures, disfigured art objects and torched many of the interiors. Restoration of the palace continues to this day, with parts of the famous Amber Room being returned from Germany in the 2000s.

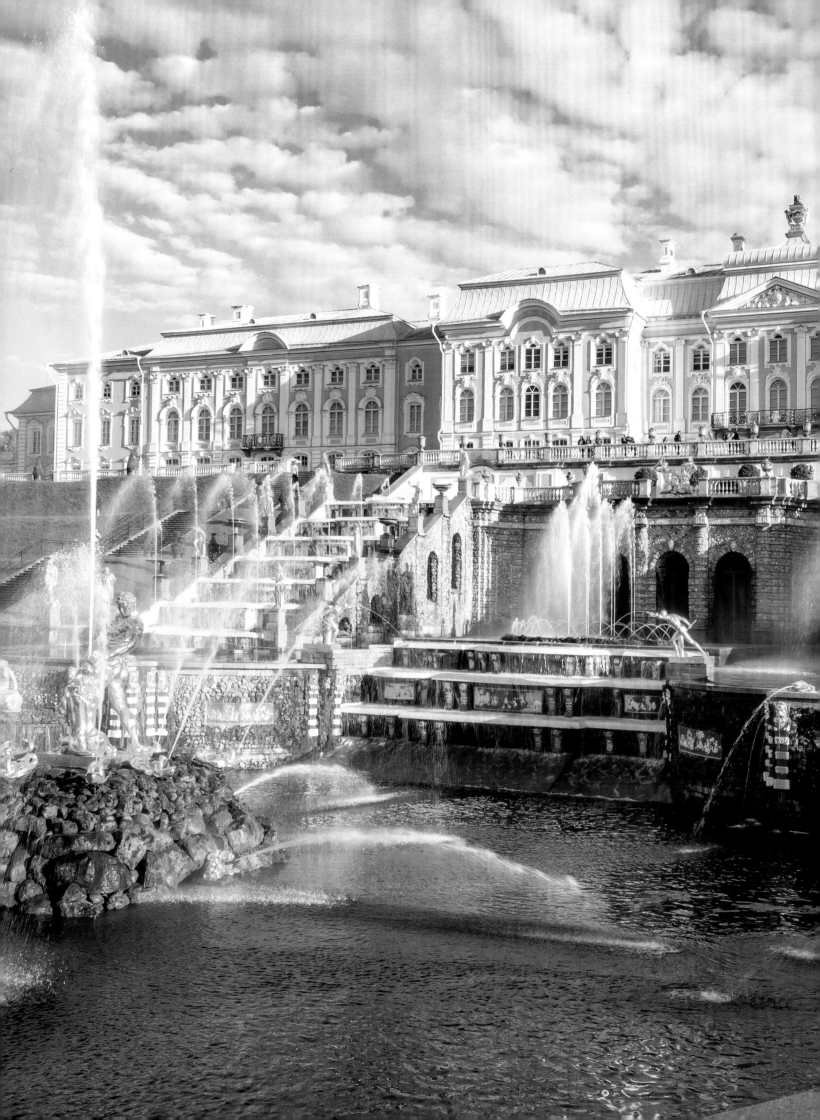

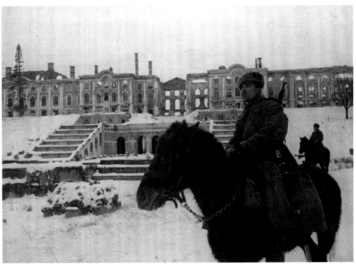

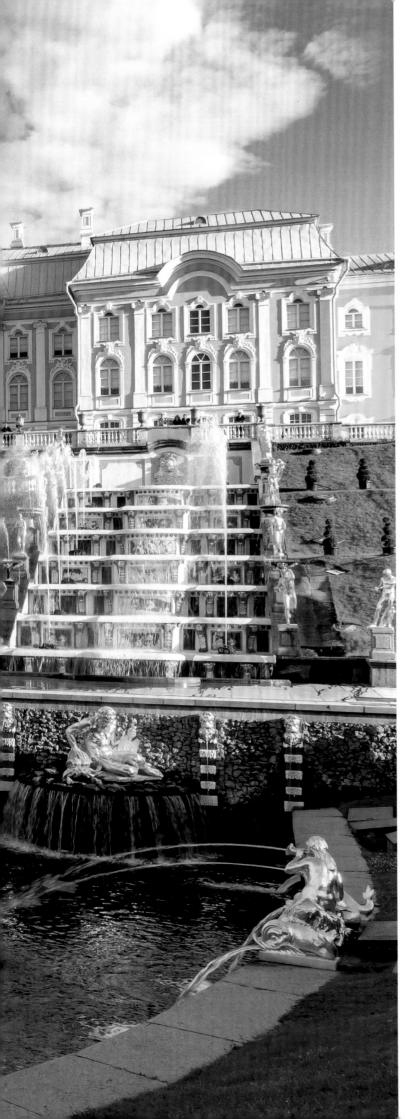

LEFT & ABOVE:

Peterhof Palace, southwest of St Petersburg, Russia

On 23 September 1941 German troops captured Peterhof, which was perhaps the most magnificent palace in Leningrad (now St Petersburg). Peter the Great had overseen its construction in 1715, wanting it to surpass Versailles in elegance and sophistication. In October a valiant but unsuccessful operation to retake Peterhof was attempted by 510 Soviet marines. The operation was beset with problems from the outset and most of the marines were quickly surrounded. Some had reached the Palace Gardens, when the defenders released several dozen German Shepherd dogs into the grounds. The dogs quickly found their prey and some marines were bitten and mauled to death, the remainder being captured.

Peterhof remained under almost constant bombardment until the end of the siege in January 1944. Much of the palace had been reduced to rubble, the park and fountains destroyed, and the trees burned. Restoration of the gardens began the following spring and of the palace soon after the war, with work continuing for decades – the Lion Cascade Fountain (*pictured*), for example, was only reopened in 2000.

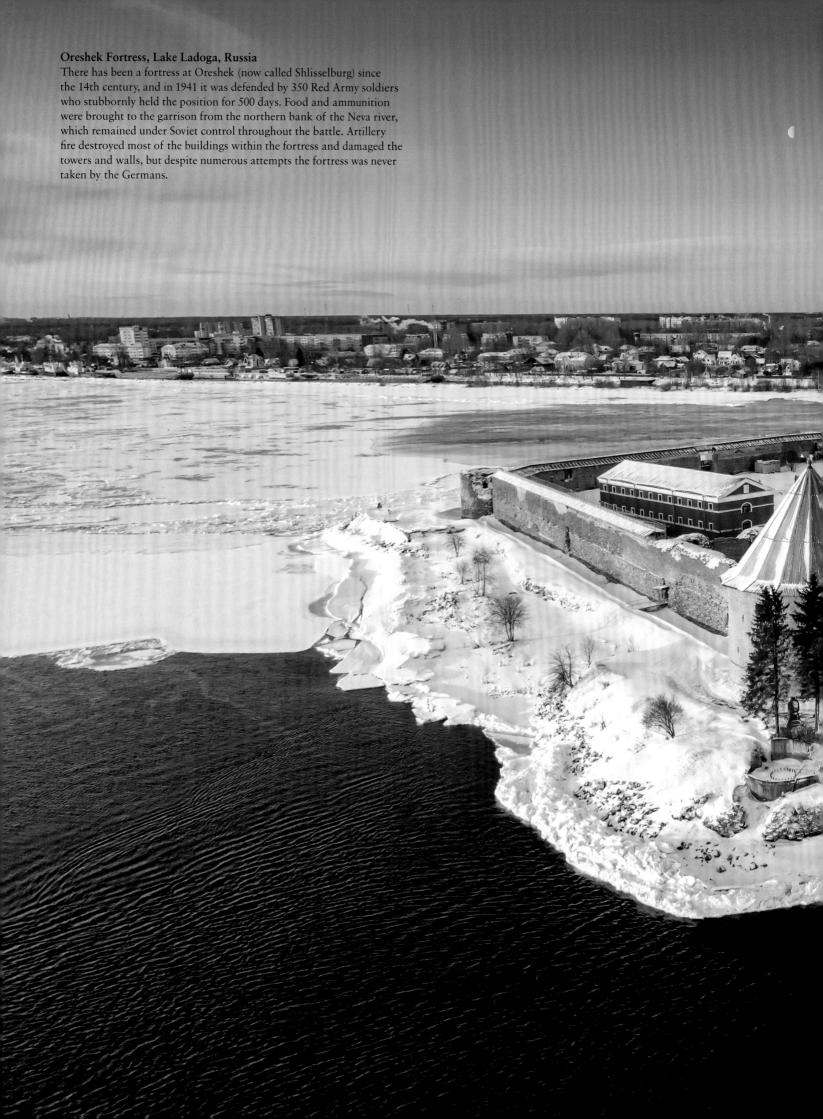

Oreshek Fortress, Lake Ladoga, Russia
There has been a fortress at Oreshek (now called Shlisselburg) since the 14th century, and in 1941 it was defended by 350 Red Army soldiers who stubbornly held the position for 500 days. Food and ammunition were brought to the garrison from the northern bank of the Neva river, which remained under Soviet control throughout the battle. Artillery fire destroyed most of the buildings within the fortress and damaged the towers and walls, but despite numerous attempts the fortress was never taken by the Germans.

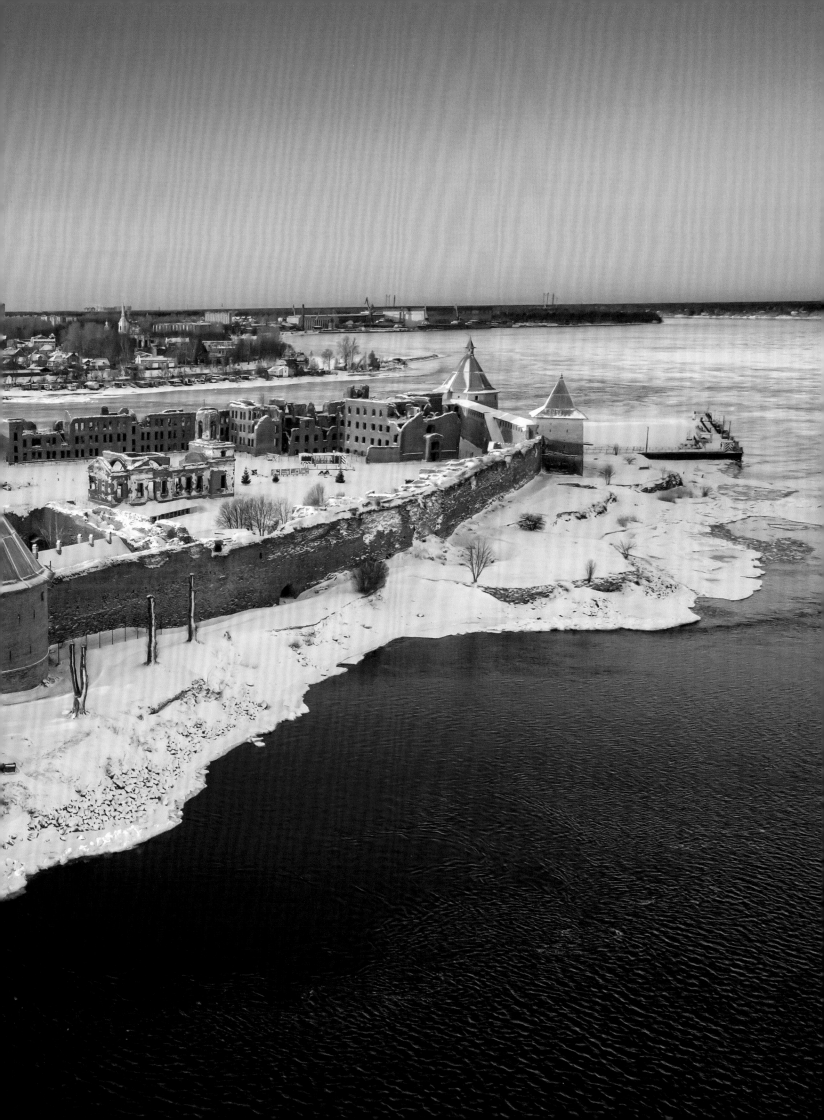

campaign to support ground forces and the Red Army counter-offensive came to an end. The decisive battle that would turn the tide on the Eastern Front was to occur 965km (600 miles) southeast on the Volga River.

SIEGE OF STALINGRAD

Stalingrad had been named after the Soviet Union's beloved leader Joseph Stalin, and holding this strategically important city on the banks of the Volga was symbolically important to every Russian man, woman and child. In August 1942, the Germans launched a major offensive into southern Russia that aimed to capture the Caucasus oilfields and to eliminate any remaining Soviet resistance in their path.

The initial advance went well, and the German Sixth Army under General Friedrich von Paulus moved on Stalingrad, which the Luftwaffe mercilessly pounded from the sky. But Stalin had ordered every citizen and soldier in the city to hold it 'at all costs', leading to a gruelling battle that lasted months.

Typified by fierce close-quarter combat in the factories and streets and even in the sewage tunnels below, it became one of the bloodiest battles in the history of war, with an

estimated two million casualties – including many civilians. In November, as the battle in Stalingrad raged, General Georgy Zhukov amassed new forces around the city, launching Operation Uranus to encircle and trap von Paulus's army. Forbidden to break out by Hitler, the exhausted remnants of the Sixth Army, running severely short of supplies and having endured a bitter Russian winter, finally surrendered in February 1943. The Germans lost a total of 500,000 men during the Stalingrad campaign, including 91,000 taken prisoner, many of whom would die in captivity.

THE HOLOCAUST

Often, the study of the Holocaust is kept separate from the military campaigns of the war, but they are inextricably linked. Hitler's attack on the Soviet Union for Lebensraum ('living space') necessitated the removal and eventual eradication of the Soviet, Polish, Jewish and Slavic peoples that lived there, and racial purification was central to German thinking in most of their operations. It should not be forgotten that the first use of Zyklon-B gas at Auschwitz was on Red Army officers captured in Barbarossa, and that even as the battles for France, Italy and other countries raged the Nazis never let up on their determination to murder the Jewish population of Europe, along with intellectuals, homosexuals, the disabled, Romany gypsies and many other groups.

The Holocaust was not limited to the concentration and death camps. A third of all victims were murdered by bullets, long before the first gas chambers were built. As German troops launched Barbarossa, with them came the *Einsatzgruppen* – the Death Squads – and all military branches were complicit in murder operations: the SS, Wehrmacht and the

OPPOSITE:
Pavlov's House, Stalingrad (now Volgograd), Russia
In the early stages of the battle of Stalingrad German forces controlled around 90 per cent of the city, the Soviets holding a small pocket near the Volga River. The strategic benefit of one apartment block there was that it sat on a crossroads, giving the defenders a clear line of sight in three directions.

In late September 1942, between 30 and 50 soldiers of the 42nd Guards Regiment, 13th Guards Rifle Division, occupied the building and from there relayed vital information back to Soviet headquarters. The man who led the initial assault was Sergeant Yakov Pavlov, but it was probably under Lieutenant Ivan Afanasiyev's leadership that the building held on. On 25 November 1942 the defenders were finally relieved, and Pavlov and some of his men were awarded the highest award in the Red Army, the 'Hero of the Soviet Union' medal.

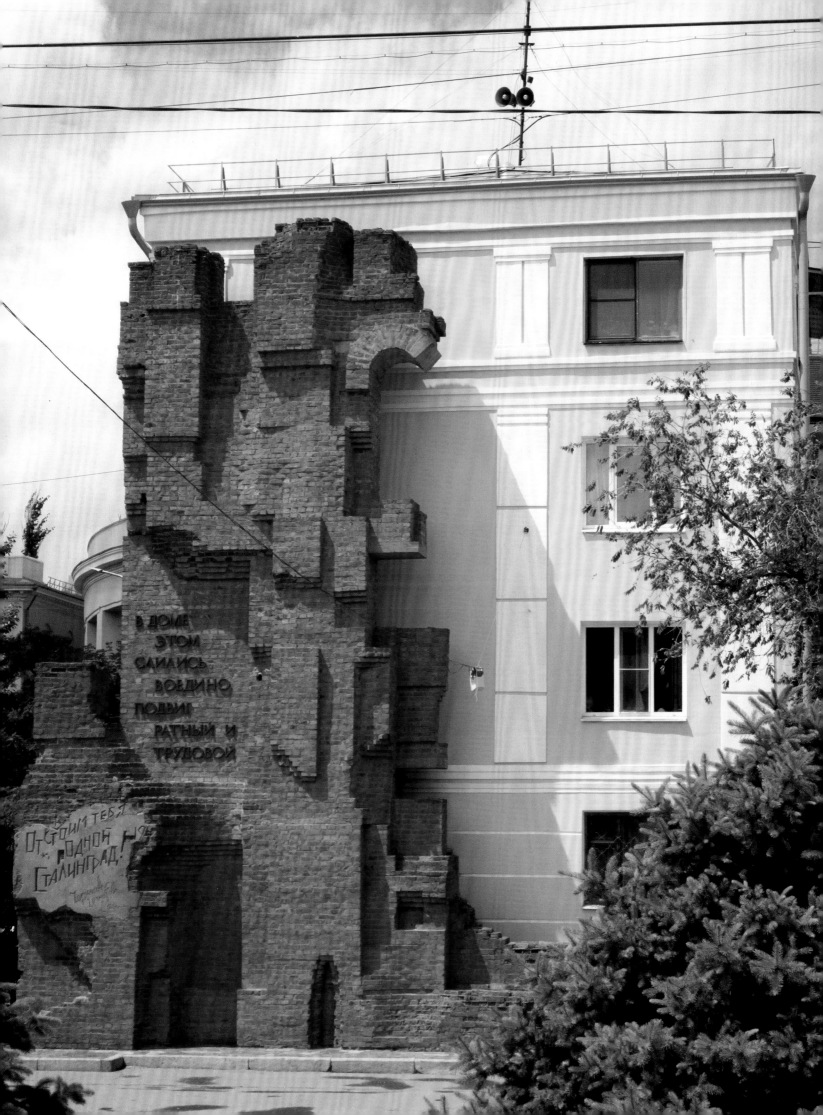

В ДОМЕ
ЭТОМ
СЛИЛИСЬ
ВОЕДИНО
ПОДВИГ
РАТНЫЙ И
ТРУДОВОЙ

ОТСТОИМ ТЕБЯ
РОДНОЙ
СТАЛИНГРАД!

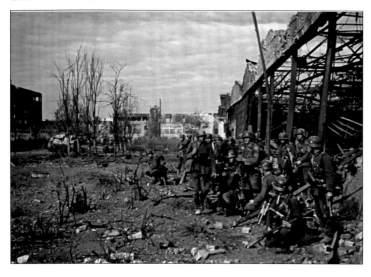

ABOVE:

Factory district, Volgograd, Russia

A colour photograph shows German forces during an assault on a
warehouse in Stalingrad in 1942. Note that a number of the German
soldiers are armed with Russian small arms, which were prized for their
reliability and accuracy.

OPPOSITE:

Old Steam Mill, Volgograd, Russia

The Gerhardt steam mill became a bastion of the Red Army's defence
of the Volga River and its bullet peppered façade makes it the most
well-known symbol of the battle. Virtually cut off for 58 days, it
withstood shelling, aerial bombing and countless German attacks. In
front of the mill stands a replica of the informally named 'Barmaley'
fountain. Its official name is the Children's Khorovod and it depicts six
children dancing the *khorovod* ('round dance') around a crocodile in
a scene derived from the fairy tale poem Barmaley, written in 1925 by
Korney Chukovsky.

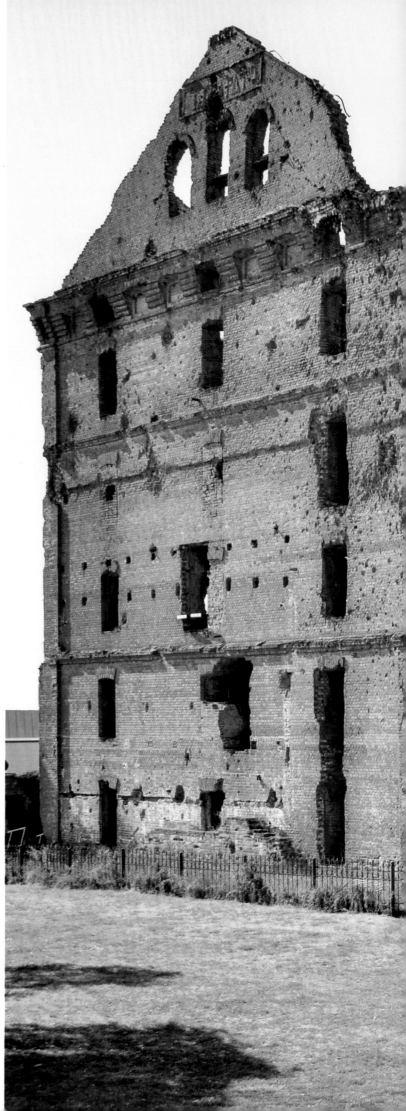

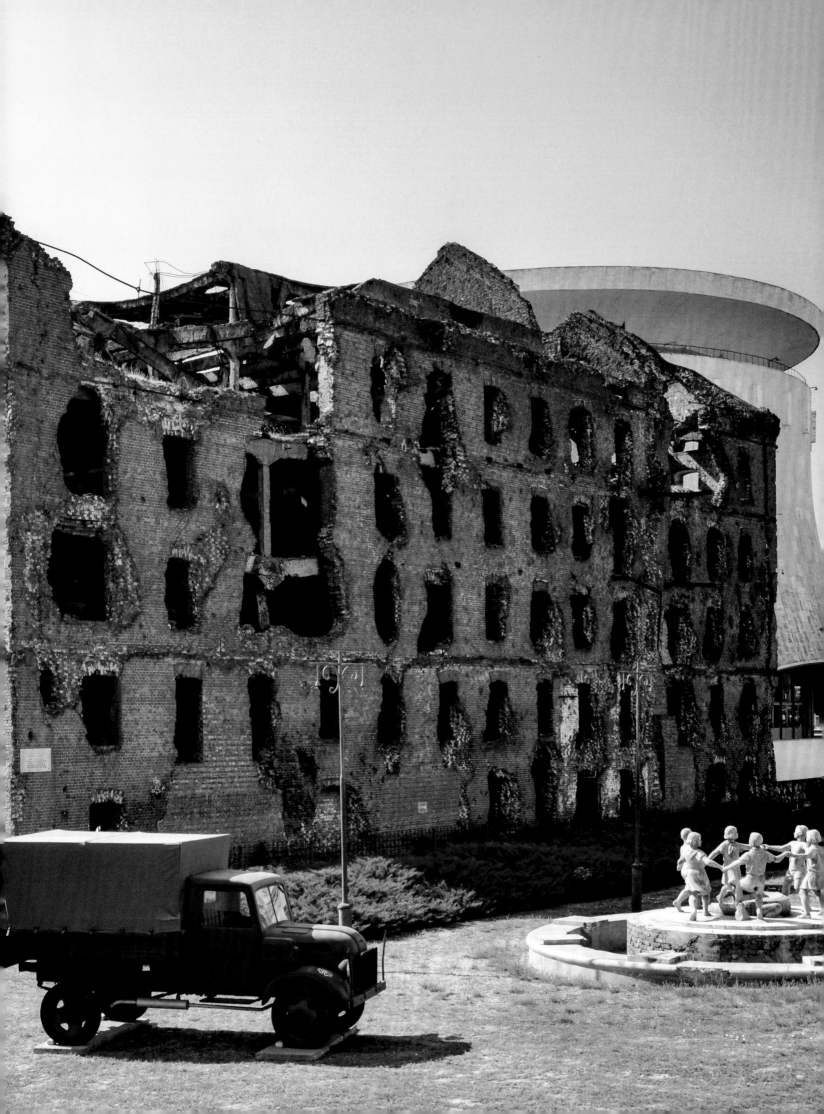

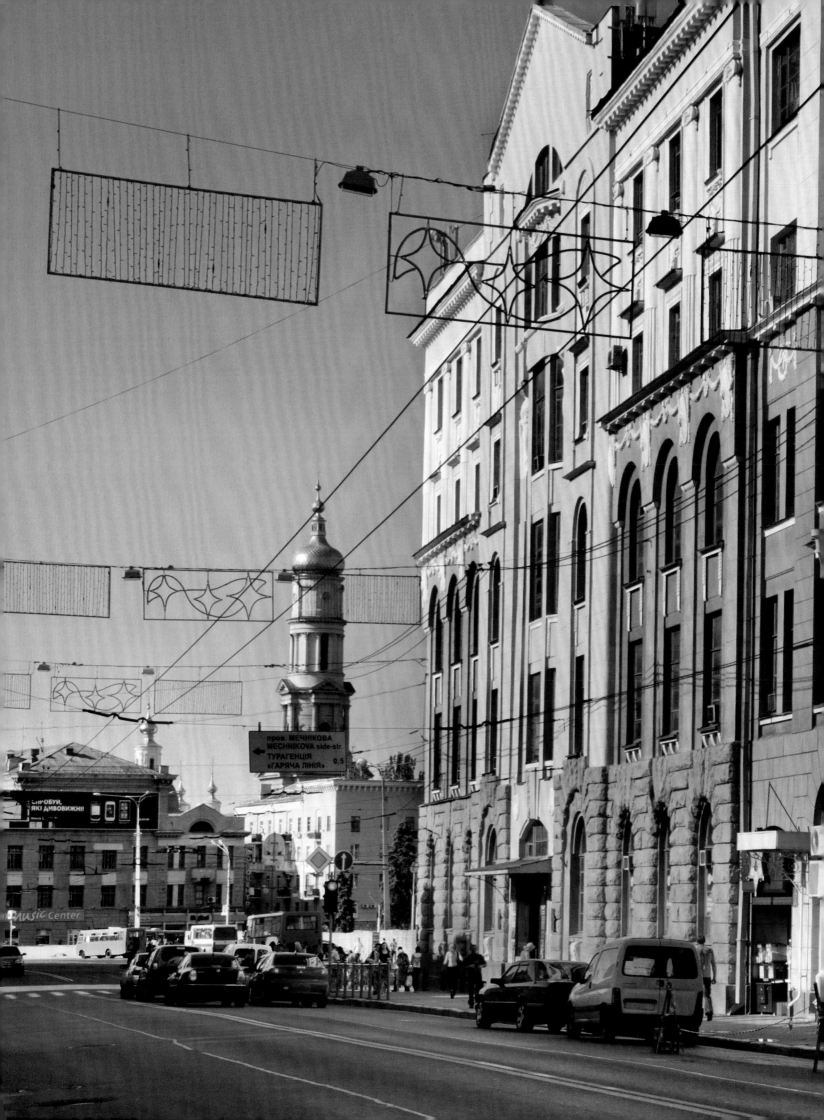

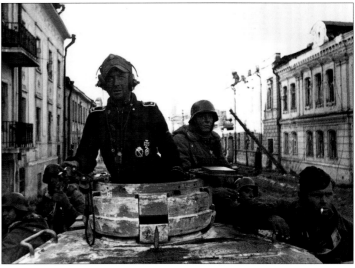

LEFT & ABOVE:

Sumska Street, Kharkiv, Ukraine
Kharkiv is the second-largest city in Ukraine and had the distinction of being fought over four times during the war. By October 1941 Operation Barbarossa was beginning to stall. The rainy season had slowed down the advance along the Dnepr Front, causing Hitler and his generals to shift their focus to the secondary objective of the industrial centre of Kharkiv. As the Germans moved in for the attack, the Soviets had time to evacuate the factory equipment to the Urals, which later became the heart of armour production, including the T-34 tank.

The German LV Corps took the city on 24 October 1941, leading to a winter of hardship for the citizens when the occupiers confiscated much of the city's food stocks for its troops; this resulted in mass starvation and death. In May 1942 the Red Army tried unsuccessfully to retake the city at a point in the campaign where it had not yet mastered offensive operations.

The following year, on 16 February 1943, the Soviets briefly reclaimed the city before the Germans fought back and drove thm out once again a month later. (The photograph above shows SS panzergrenadiers riding aboard a German tank during the fighting in March 1943.)

The Red Army finally liberated the city on 23 August 1943 as part of the wider Belgorod-Kharkiv offensive. At 2AM that day, troops of the 183rd and 89th Rifle Divisions pushed into the city centre from different sides, meeting in Dzerzhinsky Square, which was adjacent to Sumska Street. Soviet troops hoisted a red banner over the city – 70 per cent of which lay in ruins.

Kriegsmarine. Even the much-vaunted Luftwaffe, with its reputation even today for chivalry in the skies, took part in atrocities in Poland and elsewhere.

KURSK OFFENSIVE

Hitler's bold plan to conduct a decisive offensive against the Russians in the Kursk salient was beset by delays as he waited for sufficient Tiger and Panther tanks to become available for his armoured forces. Finally, the 5 July start date for Operation Citadel had arrived. Three Panzer and five infantry divisions from Army Group North led the assault, and managed to gain 10km (six miles). After taking more ground on the second day, the Germans came to a standstill, having suffered significant losses. Army Group South initially encountered problems caused by bad weather, but by nightfall on 5 July had managed to advance around 11km (seven miles).

By 11 July, 2nd SS Panzer Corps had reached Prokhorovka, a small village most notable for its railway junction. It would swiftly become the location of the largest tank battle in history. On 10 July, General Vatutin, commander of the Voronezh Front, had carried out an assessment of German intentions, and concluded that they would attack at Prokhorovka. Vatutin promptly redeployed Rotmistrov's Fifth Guards Tank Army to the area as reinforcements. The Fifth Guards Tank Army counterattacked. The end result was an enormous battle on 12 July, in which more than 1000 tanks participated. After 36 hours'

Victory Memorial, Prokhorovka, Russia
This 52m (170ft) tower was built on the battlefield of Prokhorovka, around 90km (54 miles) southeast of Kursk, its bell ringing every 20 minutes to commemorate the fallen. The Battle of Kursk, from 5 July to 23 August 1943, was a massive German assault by around 50 divisions (900,000 troops) on the Soviet salient. Aware in advance of the offensive, the Soviets had well-entrenched anti-tank guns and minefields, which inflicted a heavy toll on the German tanks and vehicles.

At the height of the battle, on 12 July, the Red Army counterattacked in what became the largest tank battle in history. Kursk marked the end of German offensive actions on the Eastern Front and paved the way for the great Soviet offensives of 1944.

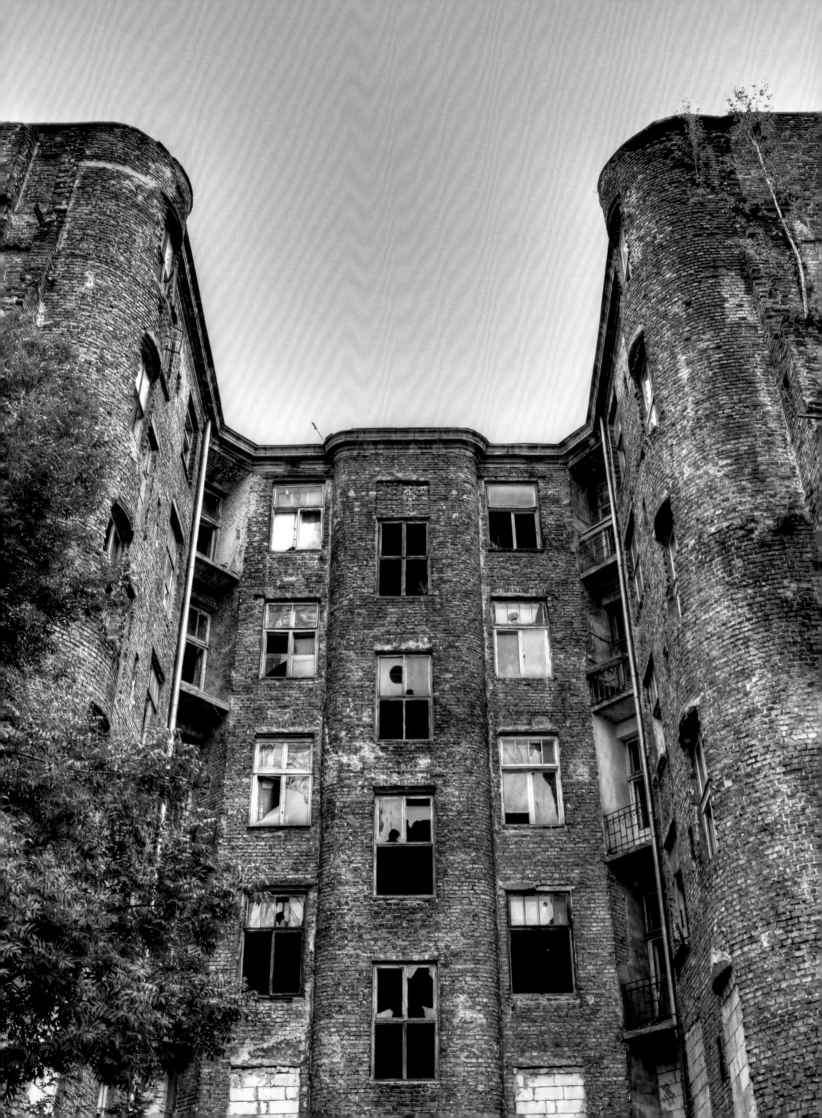

fighting, the Germans were brought to a halt. Although they had destroyed more tanks than they had lost, they had lost the initiative and the offensive stalled.

SOVIET SUMMER OFFENSIVE

Operation Bagration was the code name for the vast Soviet summer offensive of 1944, which eventually led to the complete destruction of German Army Group Centre, which had been halted near Moscow more than two years earlier. Bagration has been largely overshadowed by the Normandy invasion in France which occurred at the same time, and it is covered elsewhere in this book, but it was instrumental in keeping German forces looking both east and west, their now-limited resources being split over two fronts.

The summer offensive was essentially one of grinding attrition. The Red Army, rebuilt and equipped with its own superb tanks like the T-34/85, also had lend-lease equipment from the USA and used its considerable strength to crush the now-reduced German forces in a catastrophic defeat of unbelievable proportions. The Red Army had experienced earlier victories, but had not been able to deliver the one deadly blow that would bring the war to an end.

Operation Bagration was conceived by the Red Army's best general, Konstantin Rokossovsky, and it commenced on 22 June 1944 – three years to the day after the Germans had launched Barbarossa. The plan was to simultaneously breach the German line at six points along an 800km (500 mile) front with four million Soviet troops, 62,000 artillery pieces, 7500 tanks and 7100 aircraft. The German Army, although reduced to less than a million men, was experienced and motivated. They were losing but would fight

to the last breath, generally preferring to die in combat than be taken prisoner. One of the key objectives of Bagration was the city of Minsk in Belarus. Taking Minsk would set the stage for the Red Army's advance west into Poland and Germany and north into the Baltic. The Soviet 5th Tank Army pushed deep into the rear of Army Group Centre around Minsk, preventing a German retreat and cutting supply lines.

Maintaining a rate of advance of 48km (30 miles) per day, the 5th Guards soon captured the vital German communication centre of Orsha, and promptly encircled Minsk, where nearly 100,000 German soldiers were trapped. Within just 23 days over the entire front the Red Army had advanced between 400 and 560km (250 and 350 miles). German losses were 381,000 killed and 158,480 captured, far greater than the losses at Stalingrad, and the Germans were soon to be fighting a desperate battle for survival on their own soil.

THE END OF THE REICH

The battle for Berlin that followed Bagration brought the fighting in Europe to an end. But to

OPPOSITE:
Jewish ghetto, Warsaw, Poland
Two months after the fall of Poland and the capture of Warsaw, on 16 November 1940 the Germans created a ghetto to house the city's Jews. It was enclosed by a permanently guarded 19km-long (12 mile), 3m-high (10ft) wall topped with barbed wire. At its peak the population within the Warsaw Ghetto, increased by Jews brought in from other towns, was estimated to be more than 400,000 Jews – all living in an area of just 3.4km² (1.3 miles²).

On 19 April 1943 an uprising began in the ghetto when German troops and police entered to round-up its remaining inhabitants. Armed resistance broke out in retaliation, leading to the largest uprising by Jews of the whole war. Within a month the Germans had totally crushed the uprising and any surviving ghetto residents were deported to concentration camps and killing centres. Just a few buildings remain today due to the near total destruction of Warsaw by 1945.

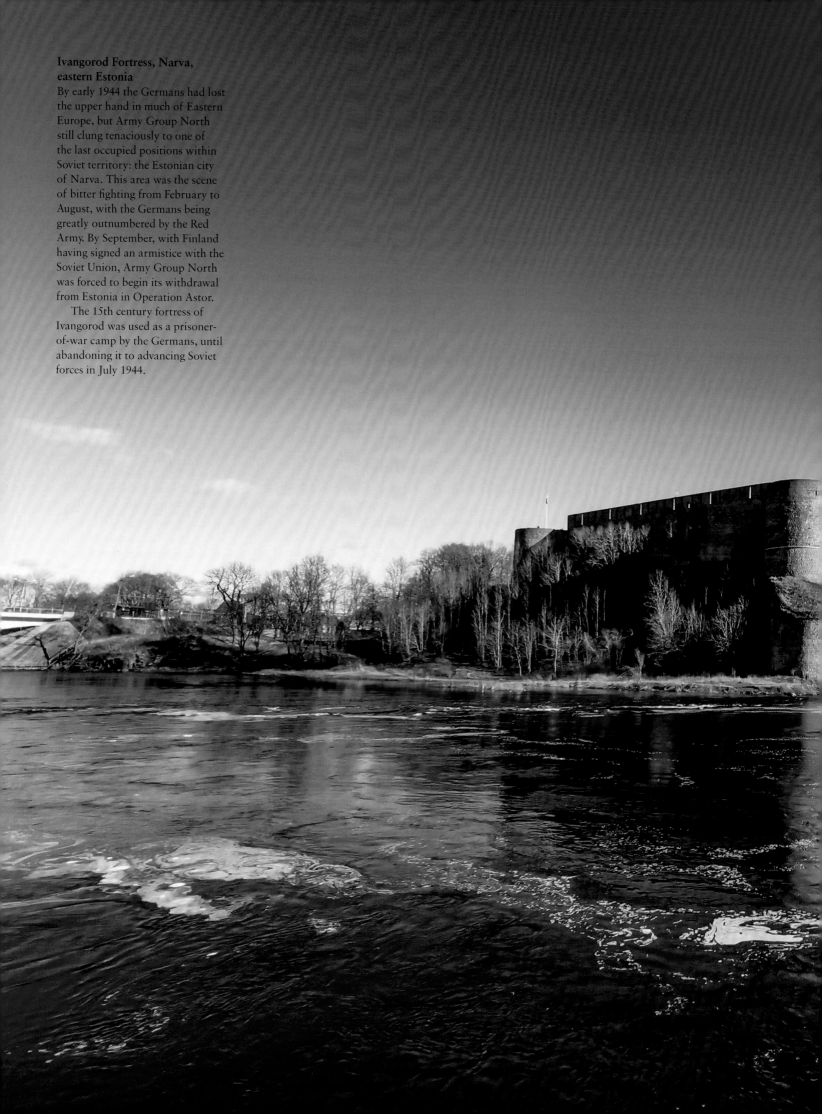

Ivangorod Fortress, Narva, eastern Estonia

By early 1944 the Germans had lost the upper hand in much of Eastern Europe, but Army Group North still clung tenaciously to one of the last occupied positions within Soviet territory: the Estonian city of Narva. This area was the scene of bitter fighting from February to August, with the Germans being greatly outnumbered by the Red Army. By September, with Finland having signed an armistice with the Soviet Union, Army Group North was forced to begin its withdrawal from Estonia in Operation Astor.

The 15th century fortress of Ivangorod was used as a prisoner-of-war camp by the Germans, until abandoning it to advancing Soviet forces in July 1944.

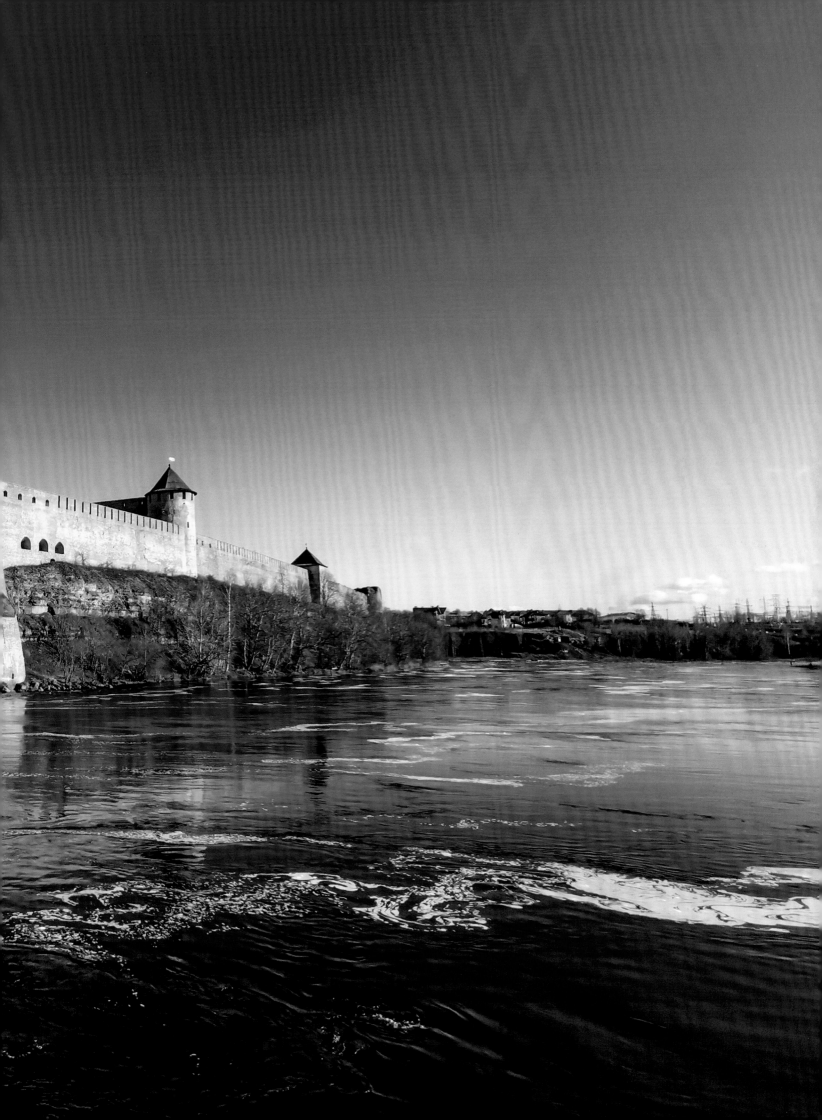

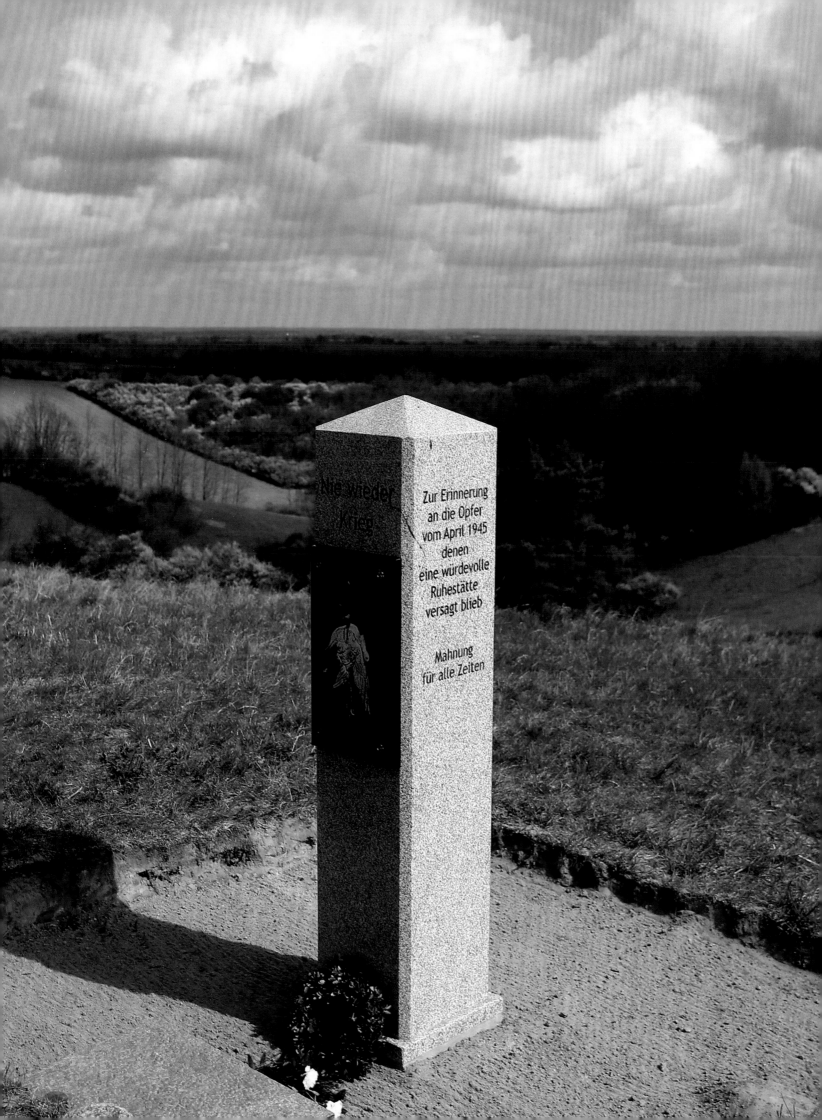

conclude this chapter it's important to address the war crimes trials that followed. In August 1945, Britain, France, the Soviet Union and the United States signed the London Agreement and Charter (also called the Nuremberg Charter), which established an International Military Tribunal (IMT) in Nuremberg to try major Nazi war criminals. The crimes they were indicted for included murder, extermination, enslavement and deportation on political, racial or religious grounds.

The most famous of the trials was that of 22 leading German officials beginning on 20 November 1945. The IMT reached its verdict on 1 October 1946, acquitting three and convicting 19 of the defendants. Of those convicted, 12 were sentenced to death, among them Reich Marshall Hermann Göring, Alfred Rosenberg, Hans Frank and Julius Streicher.

The IMT sentenced three defendants to life imprisonment and four to prison terms ranging from 10 to 20 years. Between December 1946 and April 1949, US prosecutors tried a further 177 persons and gained convictions on 97 defendants. It is a chilling fact, though, that the majority of the perpetrators of the most hideous crimes against humanity were never brought to justice.

LEFT & OVERLEAF:
Seelow Heights, Germany
Pictured opposite, a small memorial stands on a hilltop to commemorate victims of the final stages of the battle for the Seelow Heights on 17 April 1945, just 80km (50 miles) east of Berlin.

The photograph overleaf offers a view towards the south of the Oderbruch slopes. When Marshal Georgy Zhukov's 1st Belorussian Front attacked the German defensive line near the town of Seelow, a carefully crafted German plan caught the over-confident Soviet general off guard, leading to a fraught and chaotic three-day battle. Although the Red Army did fight on to victory, the German 9th Army was imbued with renewed confidence, resulting in three more weeks of combat on the approach to Berlin.

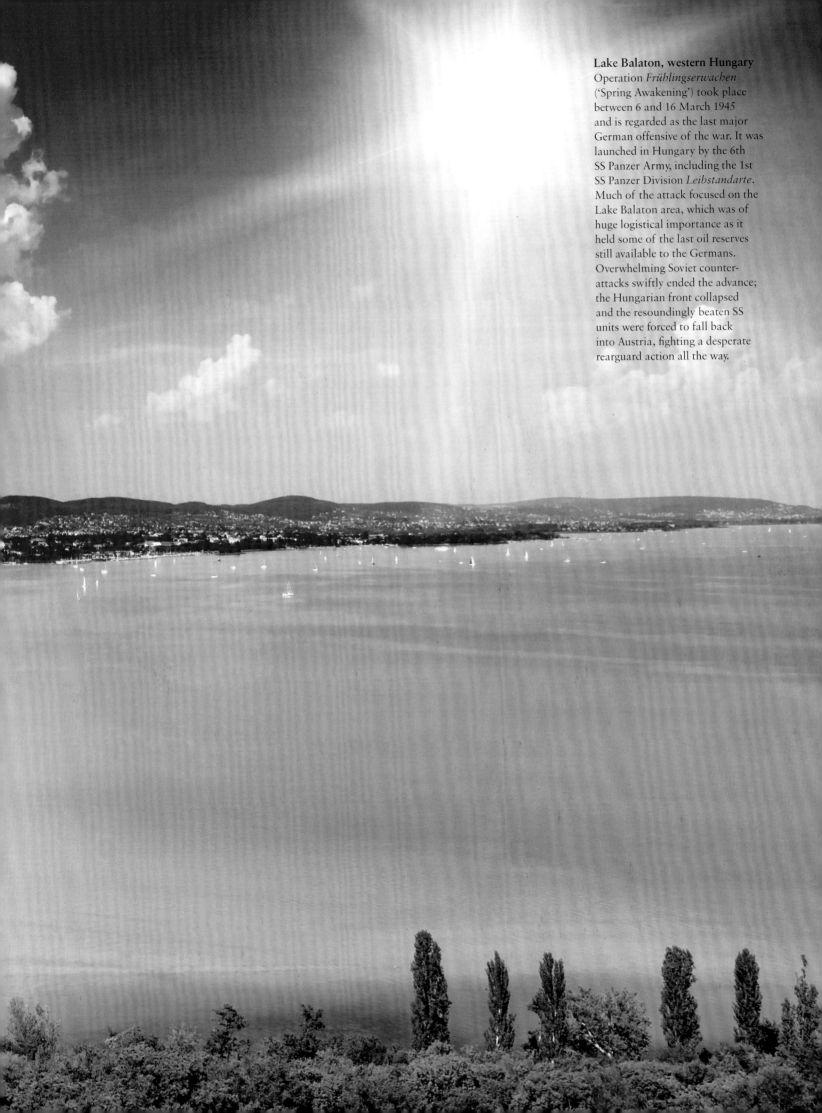

Lake Balaton, western Hungary
Operation *Frühlingserwachen* ('Spring Awakening') took place between 6 and 16 March 1945 and is regarded as the last major German offensive of the war. It was launched in Hungary by the 6th SS Panzer Army, including the 1st SS Panzer Division *Leibstandarte*. Much of the attack focused on the Lake Balaton area, which was of huge logistical importance as it held some of the last oil reserves still available to the Germans. Overwhelming Soviet counter-attacks swiftly ended the advance; the Hungarian front collapsed and the resoundingly beaten SS units were forced to fall back into Austria, fighting a desperate rearguard action all the way.

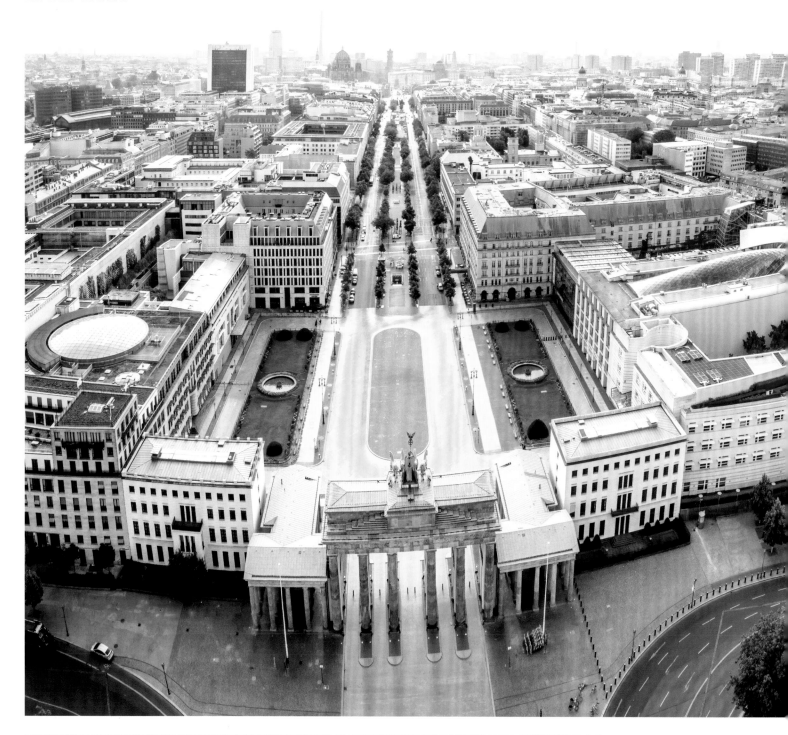

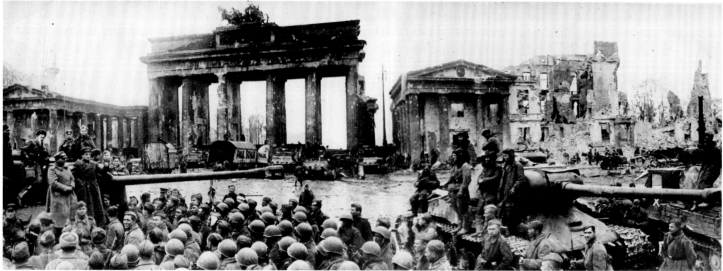

ABOVE & OPPOSITE:

Brandenburg Gate, Berlin, Germany

The photograph opposite shows victorious Soviet troops and tanks in front of the Brandenburg Gate, May 1945. Although the city of Berlin had been severely damaged in the fighting, the gate had survived nearly intact. Red Army journalists and photographers took numerous photos in the area and these images came to symbolize the great victory over the Nazis by the combined forces of the Soviet Union.

OVERLEAF:

Friedrichstrasse, Berlin, Germany

By 23 April 1945 three vast Soviet Army Groups had surrounded Berlin and the area east of the River Elbe where the last remaining German forces were holding out. That day the first Red Army soldiers began to penetrate the suburbs of the city, but within four days Berlin was completely cut off and its fall was inevitable. SS and *Volkssturm* defenders made desperate attempts to hold off the encroaching Soviet forces and fighting continued until 2 May, when the commander of the Berlin Defence Area, General Helmuth Weidling, surrendered to the commander of the Soviet 8th Guards Army, Lieutenant-General Vasily Chuikov.

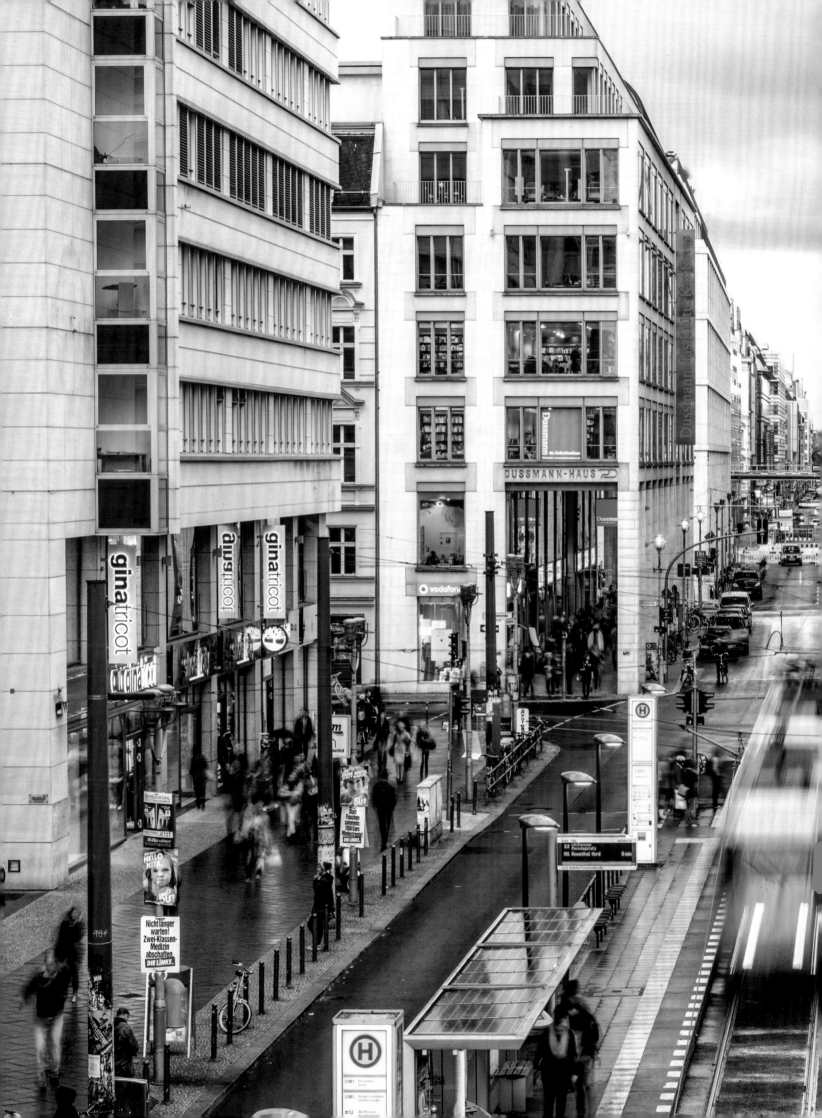

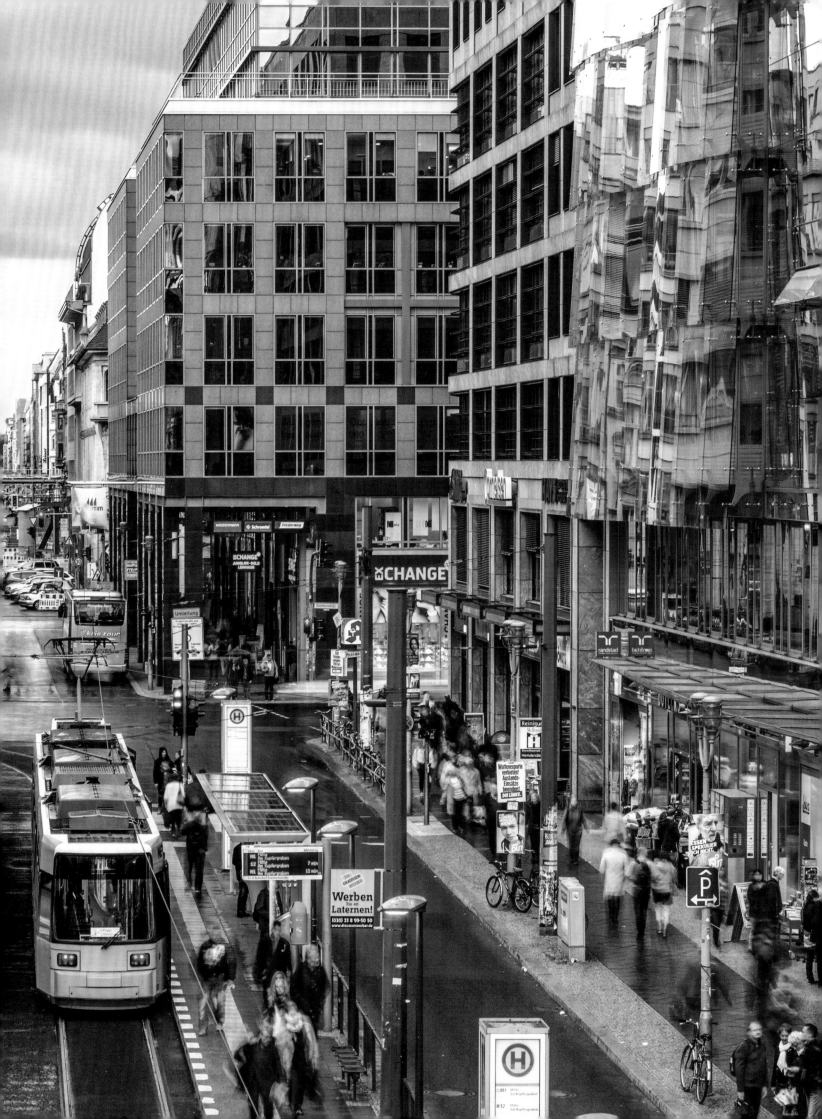

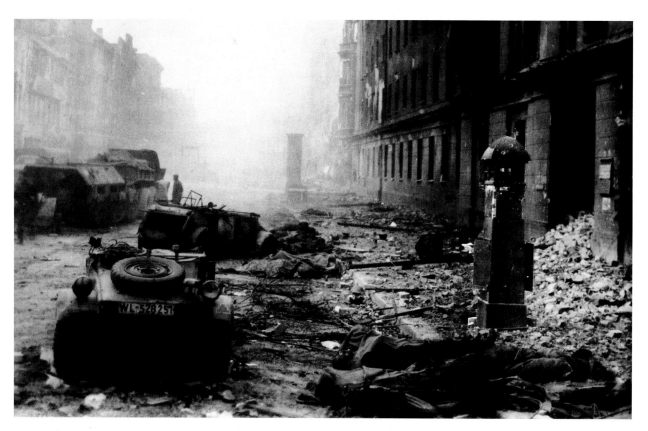

ABOVE:

Friedrichstrasse, Berlin, Germany, April 1945
The Third Reich had fallen in Berlin, but also across Germany. On the night of 2 May, General von Manteuffel, commander of the 3rd Panzer Army, along with General von Tippelskirch, commander of the 21st Army, surrendered to American forces.

Von Saucken's 2nd Army, fighting northeast of Berlin in the Vistula Delta, surrendered to the Soviets on 9 May. German troops were taken prisoner by the tens of thousands and the streets of cities like Berlin were littered with vehicles and the dead. Here, knocked out kübelwagons and halftracks lie in the smoking ruins of Friedrichstrasse.

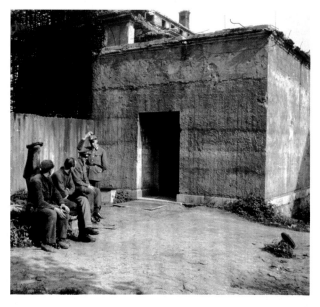

LEFT & OPPOSITE:

Führerbunker, Berlin, Germany
On 30 April 1945 as the streets of Berlin echoed to the sound of gunfire, Adolf Hitler was holed up in his Führerbunker. An air-raid shelter and headquarters located near the Reich Chancellery, the Führerbunker is where his dream for the 'Thousand-Year Reich' came to an end. Hitler and his wife of one day, Eva Braun, committed suicide by gunshot, having first swallowed cyanide capsules. In accordance with his prior written and verbal instructions, later that day their remains were carried up the concrete stairs through the bunker's emergency exit, doused in petrol and set alight in the Reich Chancellery garden outside the bunker. The location of the bunker remained unmarked until 2006, when information panels were installed.

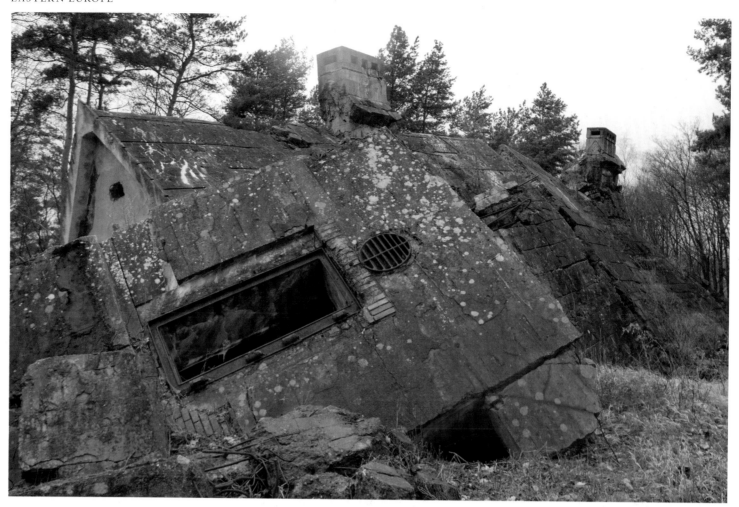

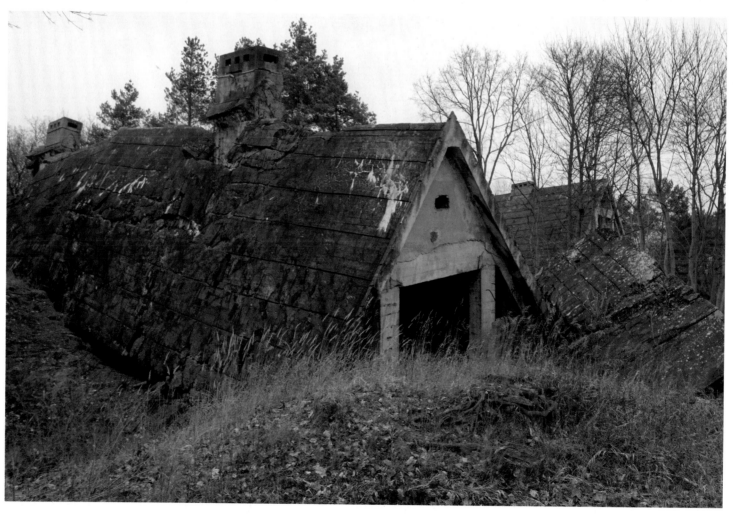

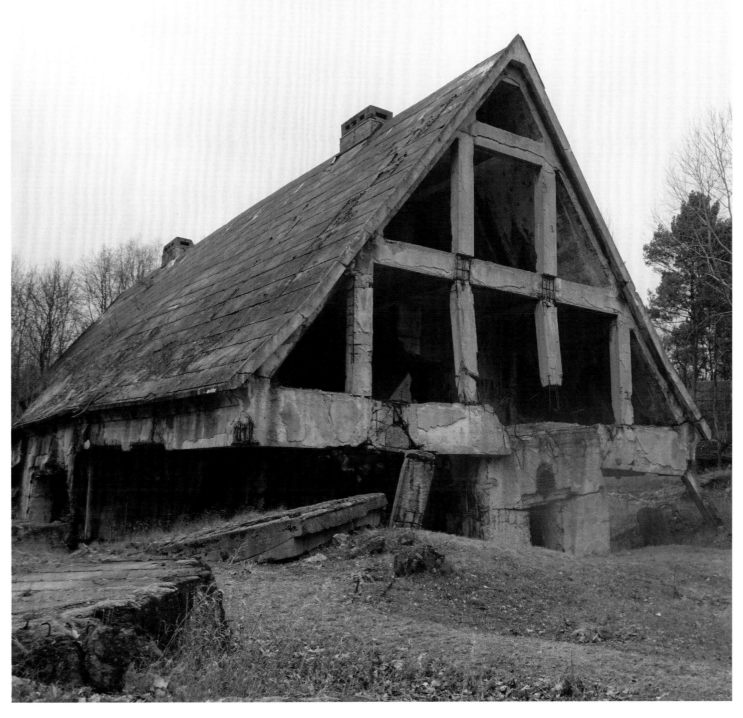

ALL PHOTOGRAPHS:
Zossen-Wünsdorf, Germany
In 1937, the construction of top-secret bunkers began in the Brandenburg town of Wünsdorf. They were to become the headquarters of the Wehrmacht, from where it could direct operations in the forthcoming war. The 'Maybach I' complex at Zossen-Wünsdorf consisted of numerous concrete structures around a central section of 12 bunkers. These had one level above ground and two below, and to conceal their purpose they were built to look like ordinary civilian houses, with slate roofs and plastered walls. Fake painted windows were added and armoured steel doors were decorated with wood to look like regular doors. Underground, the 'houses' were linked by a large network of tunnels and rooms. These tunnels were fitted with facilities such as running water, machine rooms and air filters to survive an attack or bombing. Parts of the site were destroyed by Russian forces in 1945 but many of the bunkers remain, albeit in ruins.

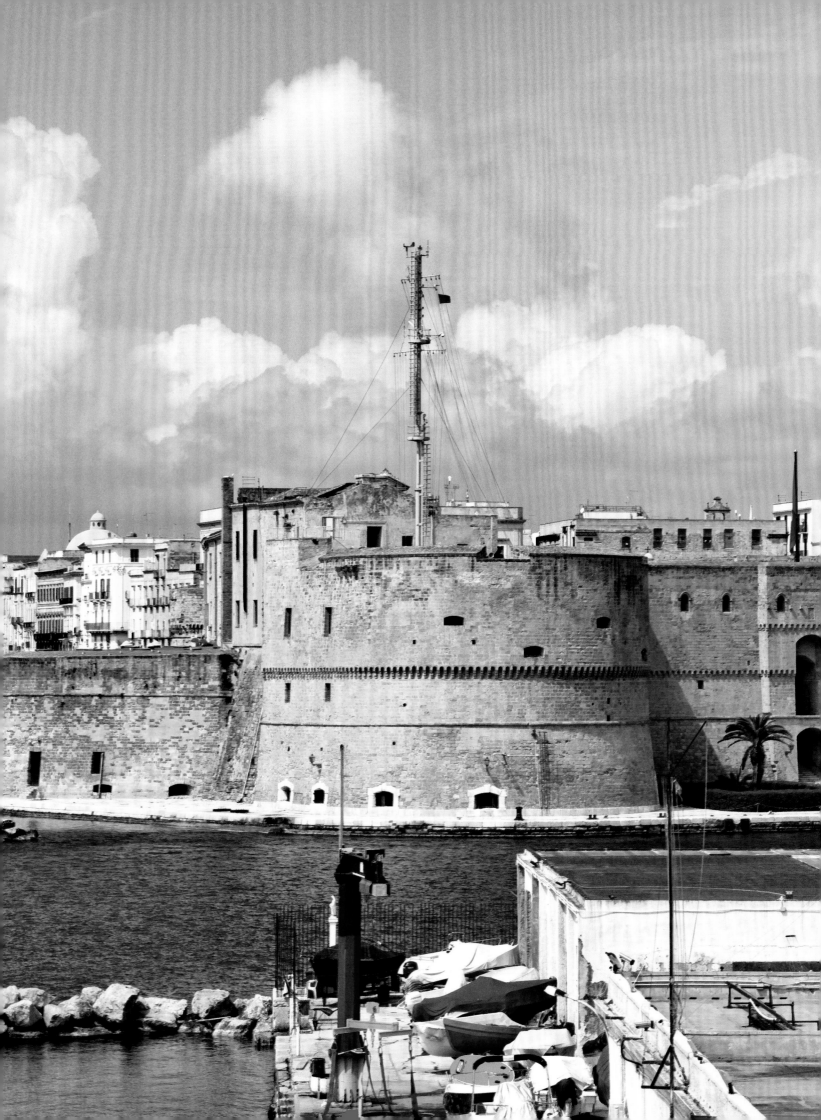

The Mediterranean

The battle for the Mediterranean encompassed naval and air engagements, from Gibraltar in the west to the Suez Canal in the east, 4000km (2500 miles) away. To the south, great battles were fought in Morocco, Algeria, Tunisia, Libya, Sudan, Egypt, Syria and Iraq, and to the north in France, Italy and Greece. Islands within the Mediterranean also proved vital, and Malta, Crete and Sicily were fiercely contested.

At sea, the battle was fought between the Italian Royal Navy, supported by other Axis nations, and the British Royal Navy, together with forces from Australia, the Netherlands, Greece and Poland, with American naval and air units joining the fray in 1942. Only the Pacific theatre saw more conventional naval engagements, and by the time the Allies signed the Armistice with Italy in 1943 some 493,962 tonnes (544,500 tons) of shipping from both sides lay at the bottom of the Mediterranean. This included 76 Allied warships, 83 Italian warships and around 200 submarines. The Mediterranean war was one of logistics, with each side battling to cut the other's supply lines while maintaining their own.

OPPOSITE:

Taranto, Italy
The entrance to the harbour at Taranto has been protected by a fortified position since the 3rd century BCE. The Castello Aragonese was built for Ferdinand II of Aragon in 1496, and in World War II ships of the Regia Marina passed the castle to reach the Ionian Sea and the Mediterranean beyond.

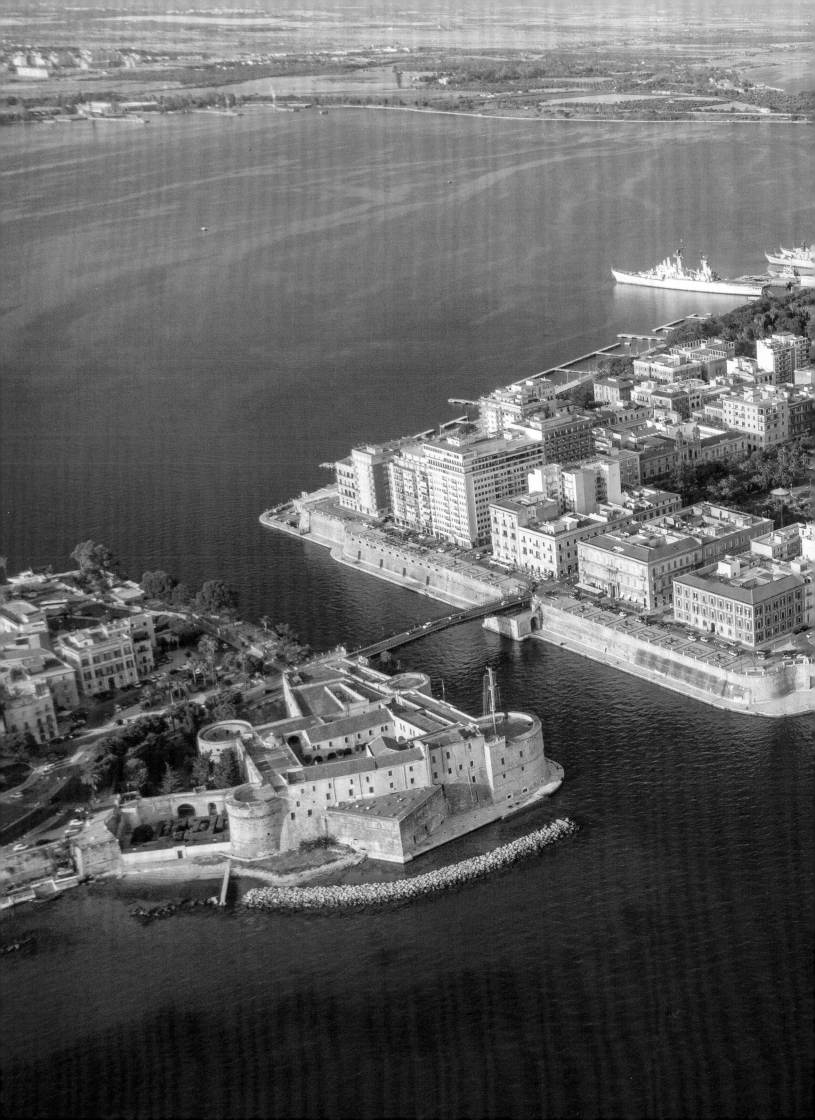

CRETE AND MALTA

After Greece fell to the Germans in April 1941, they quickly moved to attack Crete and on 20 May launched Operation Mercury, an airborne invasion of the island. German paratroopers and glider-borne soldiers landed at Maleme, Retimo, and Heraklion airfields and the naval base at Suda Bay. They were engaged by 40,000 British, Dominion and Greek defenders commanded by a New Zealander, General Bernard Freyberg VC.

In one of the first significant uses of Ultra signals intelligence, derived from Bletchley Park codebreakers, he had been made aware an attack was imminent and, with support from the Royal Navy off-shore, he hoped for a morale-boosting victory. Because the Germans were unable to mount a surprise offensive they suffered appalling casualties on the first day and did not capture any of their objectives.

But the Germans fought on and soon seized the airfield at Maleme, enabling them to fly in more troops, including a specialized mountain unit. The bloody battle ebbed and flowed for nine days, but the Germans

LEFT & ABOVE:
Taranto, Italy
On the night of 11 November 1940, the Royal Navy launched a bold aerial strike of 21 Fairey Swordfish torpedo-bombers from HMS *Illustrious* on the Italian Navy in Taranto. Many had believed the 12m-(40ft-) deep harbour was too shallow for such an attack; however, using modified torpedoes from low altitude they succeeded in disabling or damaging three battleships, one cruiser and two destroyers.

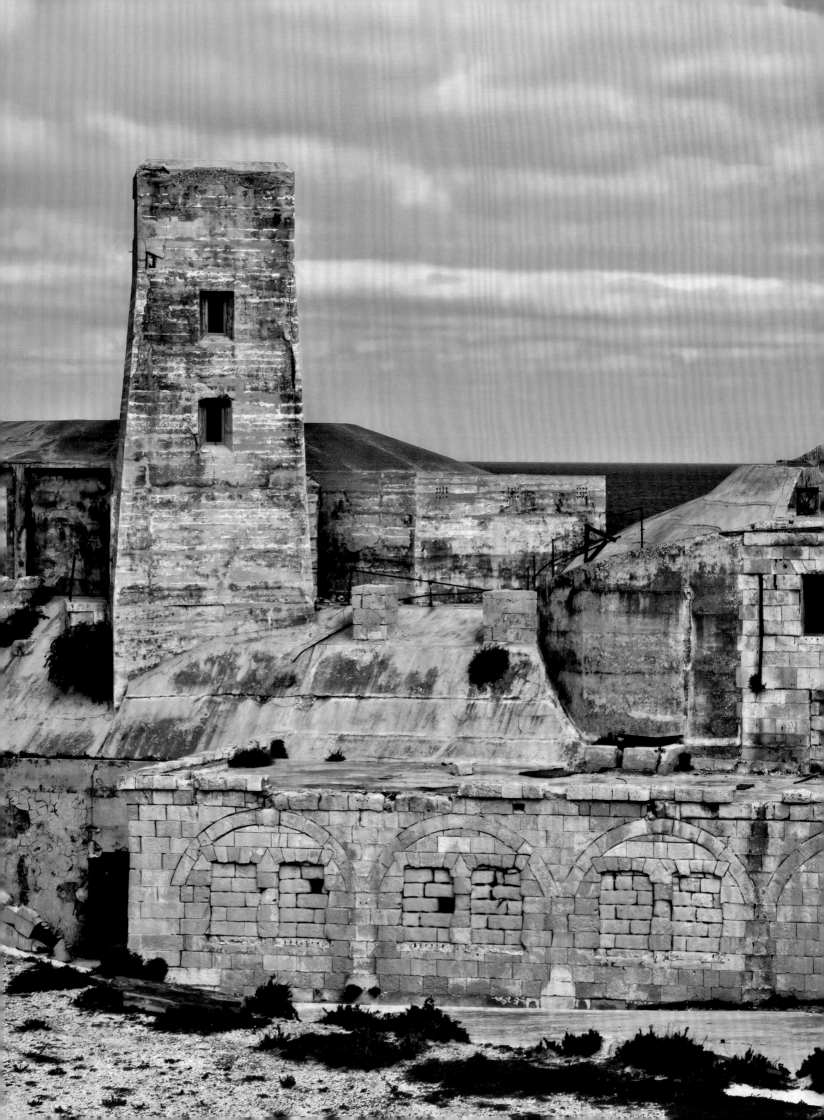

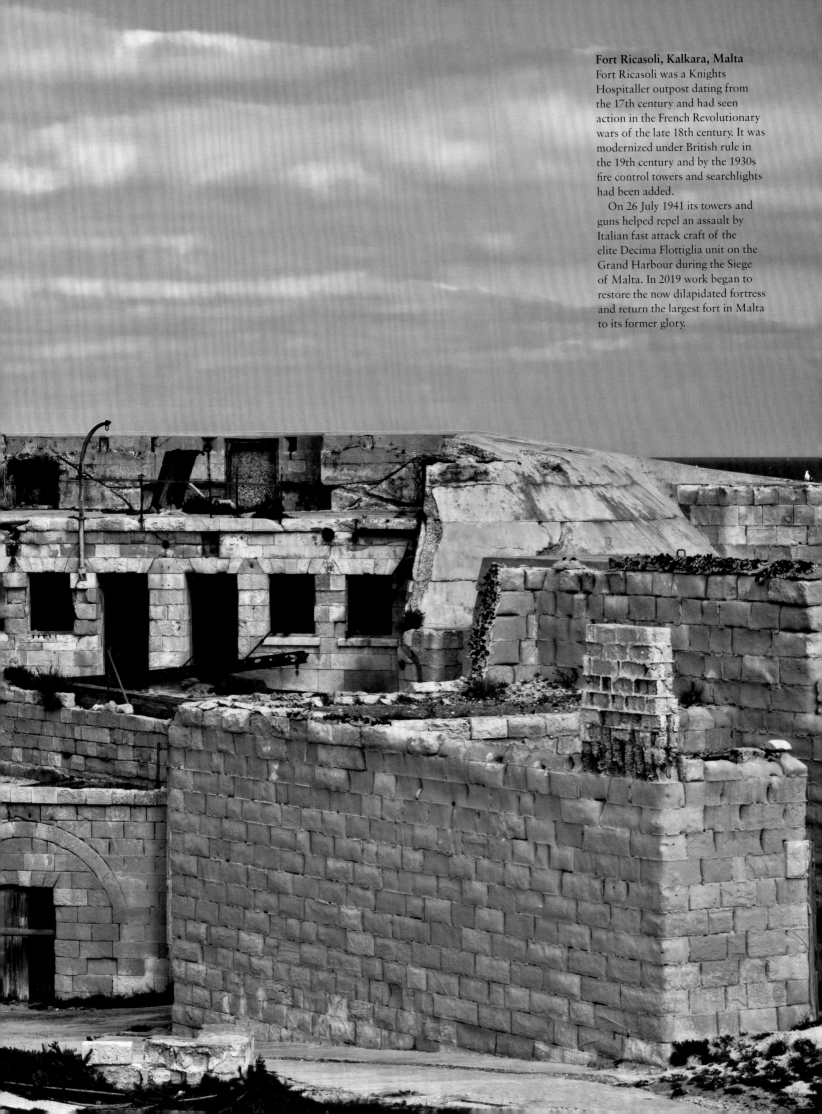

Fort Ricasoli, Kalkara, Malta
Fort Ricasoli was a Knights Hospitaller outpost dating from the 17th century and had seen action in the French Revolutionary wars of the late 18th century. It was modernized under British rule in the 19th century and by the 1930s fire control towers and searchlights had been added.

On 26 July 1941 its towers and guns helped repel an assault by Italian fast attack craft of the elite Decima Flottiglia unit on the Grand Harbour during the Siege of Malta. In 2019 work began to restore the now dilapidated fortress and return the largest fort in Malta to its former glory.

Preveli, Crete

While Commonwealth troops ate breakfast on 20 May 1941, scores of German transport aircraft suddenly appeared overhead, filling the sky with parachutes as thousands of German *fallschirmjäger* (paratroops) descended as part of Operation Mercury to capture Crete.

Over nine days a fierce battle raged over the rugged mountains, including at Preveli, where Abbott Lagouvardos from the local monastery helped supply and shelter Commonwealth soldiers. One group of Australians and Lagouvardos himself were later rescued by submarine from Preveli Beach.

prevailed and on 27 May the Allies decided to withdraw. The surviving troops made their way to the south coast, where around half were evacuated by the Royal Navy. The remainder were taken prisoner.

Throughout the first half of the Mediterranean campaign the island of Malta endured relentless attacks by the Luftwaffe and the Italian Air Force. Axis commanders knew that the island stronghold was essential to the Allied war effort, as it provided a naval and air base from which to disrupt the Germans' supply lines to North Africa. In June 1941 the Luftwaffe had to withdraw some of its aircraft from the Mediterranean to support Operation Barbarossa and Royal Air Force aircraft and Royal Navy submarines were able to renew their strikes on Axis shipping and inflict crippling losses. This success was short-lived though, as the Luftwaffe returned in December, restored its supply routes and laid siege to Malta. This led to a terrible shortage of food, oil and equipment for the island's defenders and Maltese people alike. On 15 April 1942, King George VI awarded the people of Malta the George Cross in recognition of their continued and heroic struggle during this period. The turning point of the siege was Operation Pedestal, a convoy that reached Malta in August 1942. Although it had suffered heavy losses, its arrival brought enough supplies to continue the fight. Further convoys in November and December helped to finally break the siege. With Malta secured, the Allies were able to use it as a base from which to plan future amphibious landings in North Africa, Sicily and Italy.

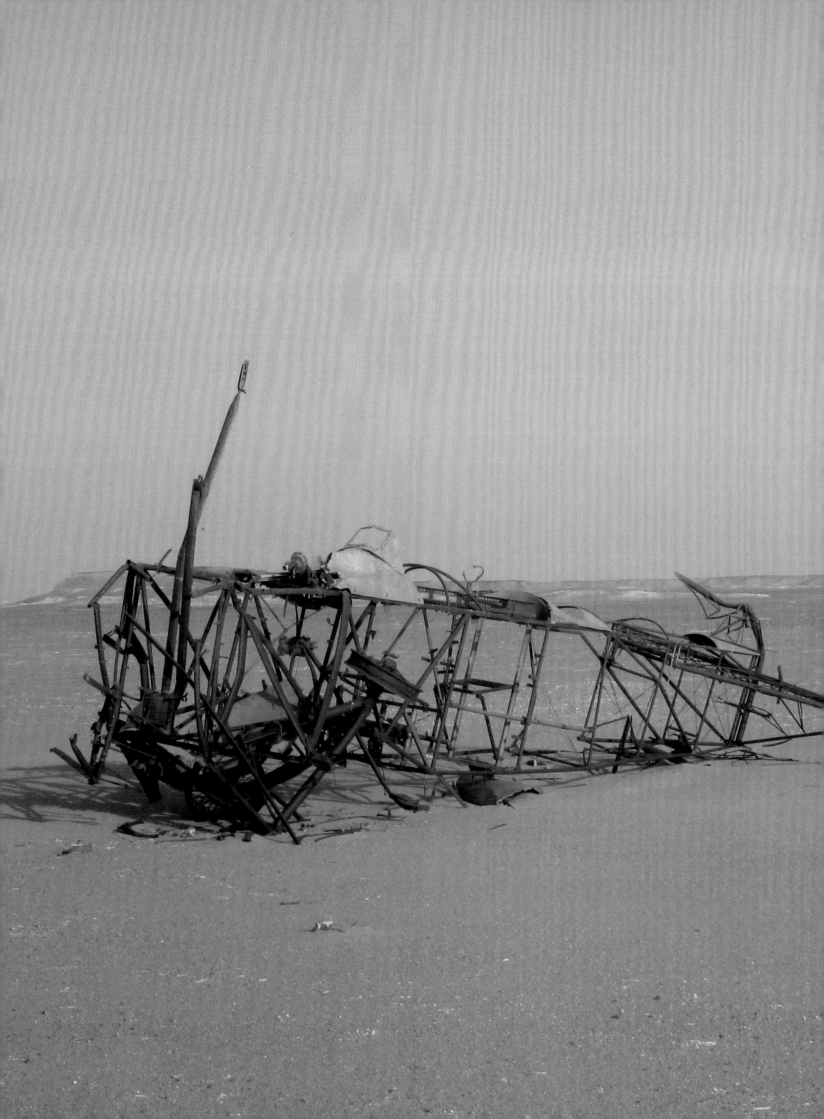

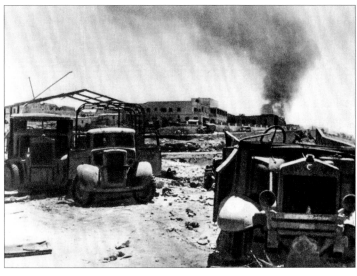

LEFT & ABOVE:

Tobruk, Libya

The first battle for Tobruk occurred in January 1941 during Operation Compass, when Commonwealth forces captured the town from the Italians. Holding Tobruk's deep-water port was vital for the Allies' defence of Egypt and the Suez Canal, as it forced the Axis to bring their supplies overland from the port of Tripoli to the front, across 1600km (1000 miles) of desert.

In April 1941, General Erwin Rommel made the capture of Tobruk the main objective of his first offensive. During his swift advance the British were forced to retreat east, leaving the garrison of 14,000 (mostly Australian) troops cut off in Tobruk – thus beginning the famous siege, which was only broken on 10 December 1941 during Operation Crusader, when British armoured units linked up with the defenders.

Tobruk eventually fell to the Germans in June 1942 during Rommel's second offensive. This time the defensive force was weaker, as large numbers of mines and barbed wire had been lifted and moved to the Gazala–Bir Hakeim line west of Tobruk. Rommel took 33,000 prisoners in Tobruk, along with fuel, vehicles and ammunition, and was promoted to Field Marshal for the victory.

OVERLEAF:

Bir Hakeim, Libya

The Battle of Bir Hakeim was fought near an oasis in the Libyan desert southwest of Tobruk, during the Battle of Gazala in May 1942. The 1st Free French Brigade under Général Marie-Pierre Kœnig defended the position against strong attacks by the much larger forces of Rommel.

The delay imposed on the Axis offensive at Bir Hakeim influenced the cancellation of Operation Herkules, the Axis invasion of Malta. German General Friedrich von Mellenthin wrote of the French stand: 'In the whole course of the desert war, we never encountered a more heroic and well-sustained defence.'

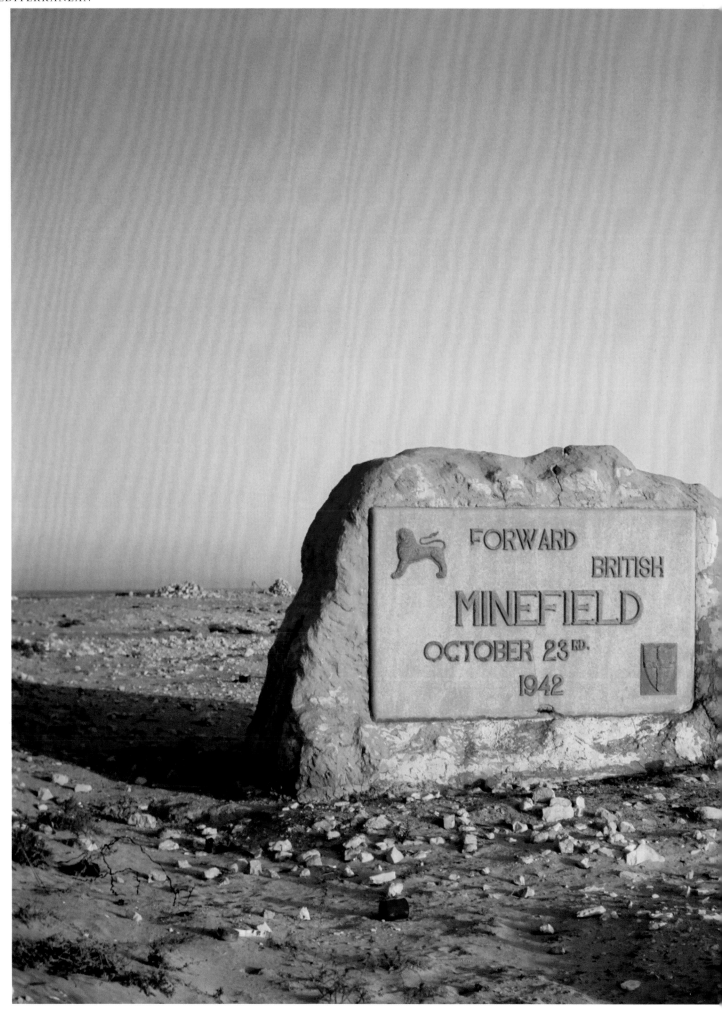

FIGHTING IN THE DESERT

The desert war began in 1940 and continued unabated for three years, with the two sides pushing each other back and forth across North Africa. At stake were the vast oil reserves of the Middle East and control of the Suez Canal, the vital route for transporting men and material to Southeast Asia. Four days after the Italian declaration of war on 10 June 1940, British armoured units crossed the border from Egypt into Libya and captured the Italian fort at Capuzzo.

This was followed by an Italian counter-strike into Egypt and the capture of Sidi Barrani in September. British and Commonwealth forces fought back in December with Operation Compass, where many Italian units were destroyed and 130,000 troops captured. Hitler's response to this embarrassing loss was to send in the newly formed Afrika Korps, led by General Erwin Rommel. For two years a fluctuating series of epic battles then ensued. But a turning point was reached at El Alamein in late 1942, when General Bernard

LEFT & OVERLEAF:
El Alamein, northwest Egypt
Before the second battle of El Alamein three million landmines had been sown in great swathes across the Egyptian desert. Field Marshal Erwin Rommel referred to them as 'Devil's Gardens' and most remain today, and are increasingly unstable and dangerous. In the pre-dawn of 24 October 1942, British infantry and engineers began Operation Lightfoot, the painstaking and deadly task of clearing two corridors through the mines through which Montgomery's armoured units were to advance.

The second battle of El Alamein was one of attrition, labelled 'crumbling' by Montgomery. The British Eighth Army was to maintain constant pressure on the enemy and hold against the inevitable counter-attacks. The cleared but congested minefield corridors caused delays and the Eighth Army was tested in a maelstrom of heat, shellfire and terror, but victory was secured. Remnants of the fighting still litter the battlefield (*see overleaf*), much of it remaining relatively rust-free because of the lack of moisture.

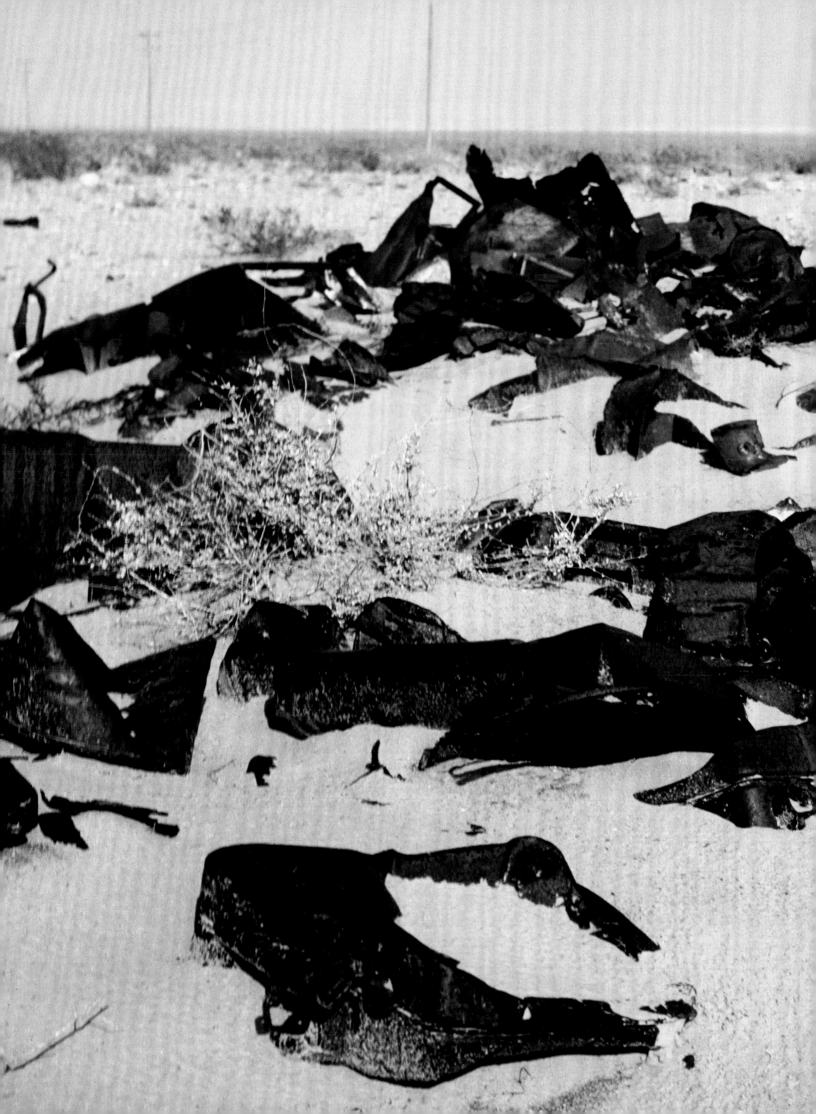

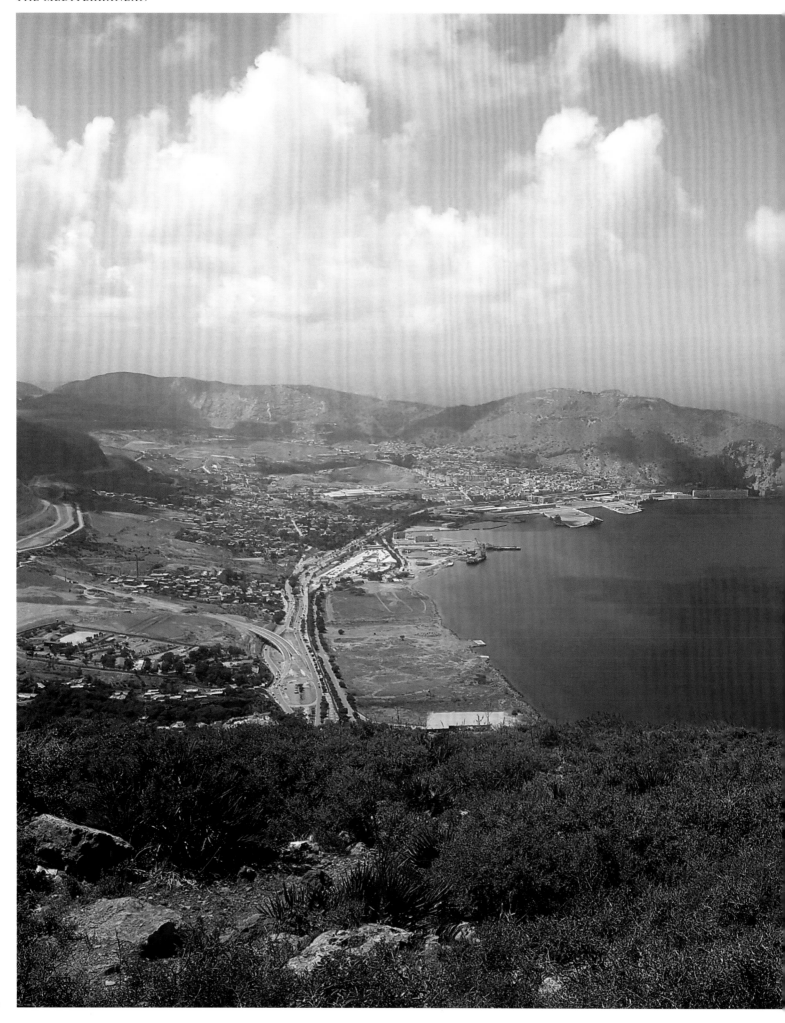

Montgomery's British Eighth Army broke out and pushed Axis forces all the way back to Tunisia.

OPERATIONS TORCH AND HUSKY

Operation Torch was the Allied invasion of French Morocco and Algeria on 8 November 1942. Commanded by General Dwight Eisenhower, its primary objective was to secure bridgeheads for the opening of a new front to the rear of Axis forces still battling the British around El Alamein. It also aimed to relieve pressure on the Soviet Union by stretching Axis forces across multiple fronts. Torch would need to overcome strong Vichy French opposition, which just a day earlier had thwarted an attempted coup d'état against its command in Morocco. This would stiffen Vichy resistance, especially at the key port of Oran. Despite

LEFT:

Oran, Algeria

The Algerian port of Oran was under Vichy-French control in 1942 and the Allies expected limited resistance when they landed on 8 November during Operation Torch. In fact, the 14,000-strong garrison, bolstered by 193mm (7.6in) and 240mm (9.4in) coastal guns, put up a valiant defence, not surrendering for two days. In the meantime, they also managed to destroy the harbour facilities and disable the ships at the docks.

OVERLEAF:

Kasserine Pass, Tunisia

The Battle of Kasserine was actually a series of battles fought around a deep pass through the Grand Dorsal chain of the Atlas Mountains in Tunisia. On 19 February 1943, two Panzer divisions and the Italian Centauro Armoured division launched an attack through the pass, inflicting such damage that the Allies turned westward in retreat for 80km (50 miles). This marked the first large-scale meeting of American and German forces of the war.

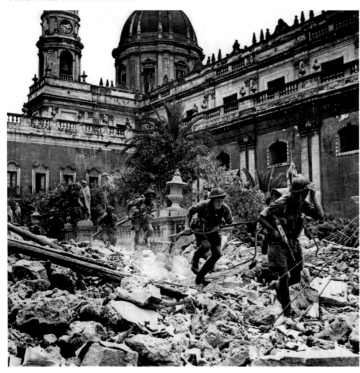

ABOVE & RIGHT:

Catania, Sicily

Sitting in the shadow of Mount Etna, Catania was a key objective of the British advance north to Messina in Operation Husky, which began on 10 July 1943. When Commonwealth troops entered the city on 5 August they had endured weeks of fighting, the heaviest of which had been at Primosole Bridge across the Simeto River, south of the city.

This had been the objective of Operation Fustian, when the British 1st Parachute Brigade of the 1st Airborne Division, with glider-borne forces in support, was tasked with seizing the bridge until relieved by infantry and armour of XIII Corps from the beaches. Tenacious counter-attacks by German paratroopers and armour delayed this approach for days, and when Catania finally fell it was of great relief to all.

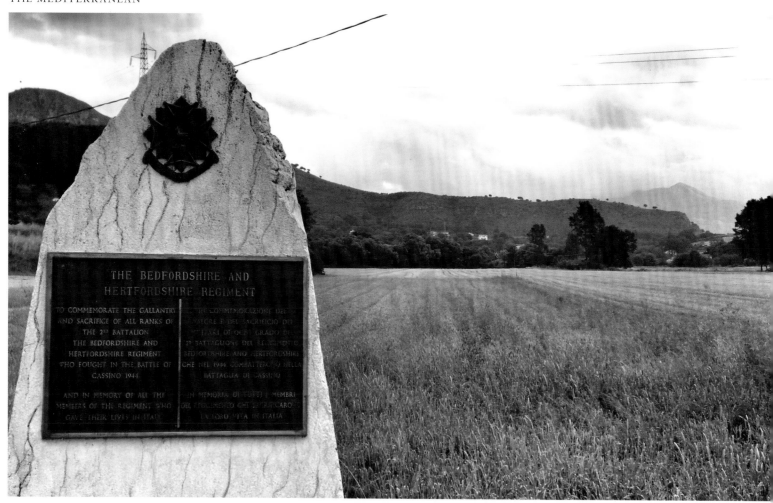

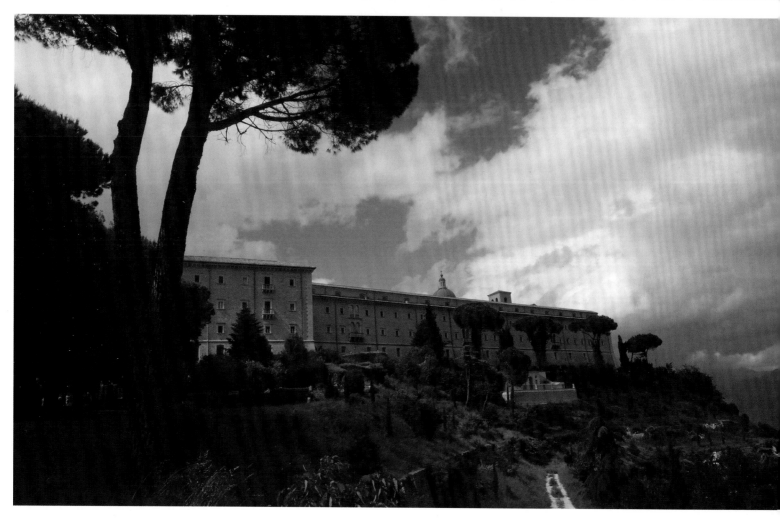

heavy losses, the landings were successful and the Allies pushed on through Tunisia.

Difficult and costly battles followed at places like Kasserine and Longstop Hill, but by May 1943 all resistance in North Africa had ended and the Allies had captured 250,000 Axis troops. Eisenhower was now ready for his next move – the elimination of fascist forces on the Italian mainland. But first he had to deal with Sicily.

Sicily had been the obvious route to Italy from the south since the Punic Wars beginning in 264 BCE, and on 10 July 1943 the Allies launched Operation Husky – a huge amphibious assault of 3000 ships and 150,000 troops. A two-pronged attack by Montgomery's British and Canadian Eighth Army from the southeast and Patton's US Seventh Army from the south would envelop north towards Messina. The Axis defenders commanded by Field Marshal Albert Kesselring used the island's rugged terrain to carry out an effective delaying operation. But the Allies, though plagued by logistical problems and the clashing egos of its commanders, pressed on.

On 17 August, when the Allies finally closed in on Messina, they found very few defenders there. Kesselring had understood the force moving steadfastly forwards would soon overwhelm his own and five days earlier had evacuated 100,000 German and Italian troops across the strait to mainland Italy in order to continue the fight there. In 38 days of fighting the Allies had sustained almost 25,000 American, British and Canadian casualties, but the battle for Sicily was over.

INVASION OF ITALY

There were huge potential advantages to be gained by knocking Italy out of the war. Neutral Turkey might join the Allies and

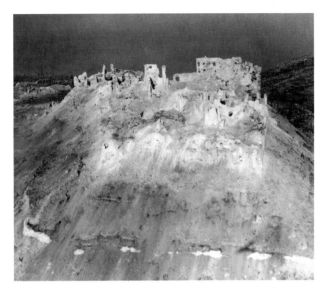

support Allied operations in Yugoslavia, a second route into Nazi Germany via Austria would be open and the Allies would gain airfields closer to Germany. The Germans would also be forced to bring in units from the Eastern Front and from France, where the Allies would land in the summer of 1944. Although the Allied landings at Salerno and later at Anzio did eventually lead to victory, the campaign took much longer than intended. This was no 'soft underbelly', a phrase Churchill had used to describe an attack from the Mediterranean; instead, the Allies found themselves attacking what the American General Mark Clark called 'a tough old gut'.

OPPOSITE & ABOVE:

Monte Cassino, Frosinone, Italy
Monte Cassino had been founded in 529 CE by Benedict of Nursia as the first monastery of his new Benedictine order and was perched high on a mountain above the town of Cassino. To Italians it had been a symbol of wisdom, contemplation and peace. In 1944 it became a symbol of the brutal and devastating attritional nature of the Italian campaign.

Today, when visitors travel through the vineyards and olive groves of Frosinone they discover memorials to an astonishing array of nations who fought in the battle: Britain, Canada, Poland, the USA, New Zealand, India, Free France and South Africa – for it took that many Nations to defeat Axis forces in the Battle of Monte Cassino.

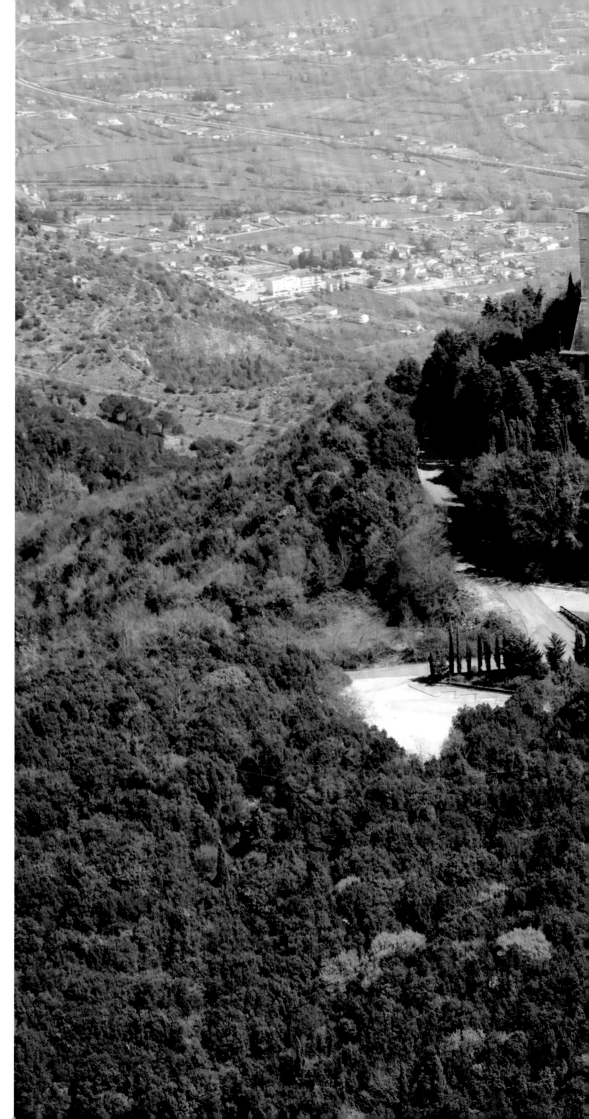

Monte Cassino, Italy

Monte Cassino was in the 'Winter Line' sector, a series of German and Italian military positions, commanded by Field Marshal Albert Kesselring, and Allied forces falsely assumed Germans were using the abbey there as an observation post. From 17 January 1944 to 18 May 1944, a series of four offensives attempted to break through Monte Cassino. As each attack up the steep slopes failed it led to a tremendous decline in morale. The US Fifth Army Commander Mark Clark recalled that the battle of Cassino was 'the most gruelling, the most harrowing, and in one aspect the most tragic, of any phase of the war in Italy'.

On 15 February 1944 the Abbey at Monte Cassino was virtually destroyed by Allied bombing, killing many of the locals who had taken refuge there. A month later the town was also razed to the ground. During the course of the whole battle over 2000 civilians, one-tenth of the town's population of 20,000, were killed. The Abbey was rebuilt after the war and is a popular tourist attraction today.

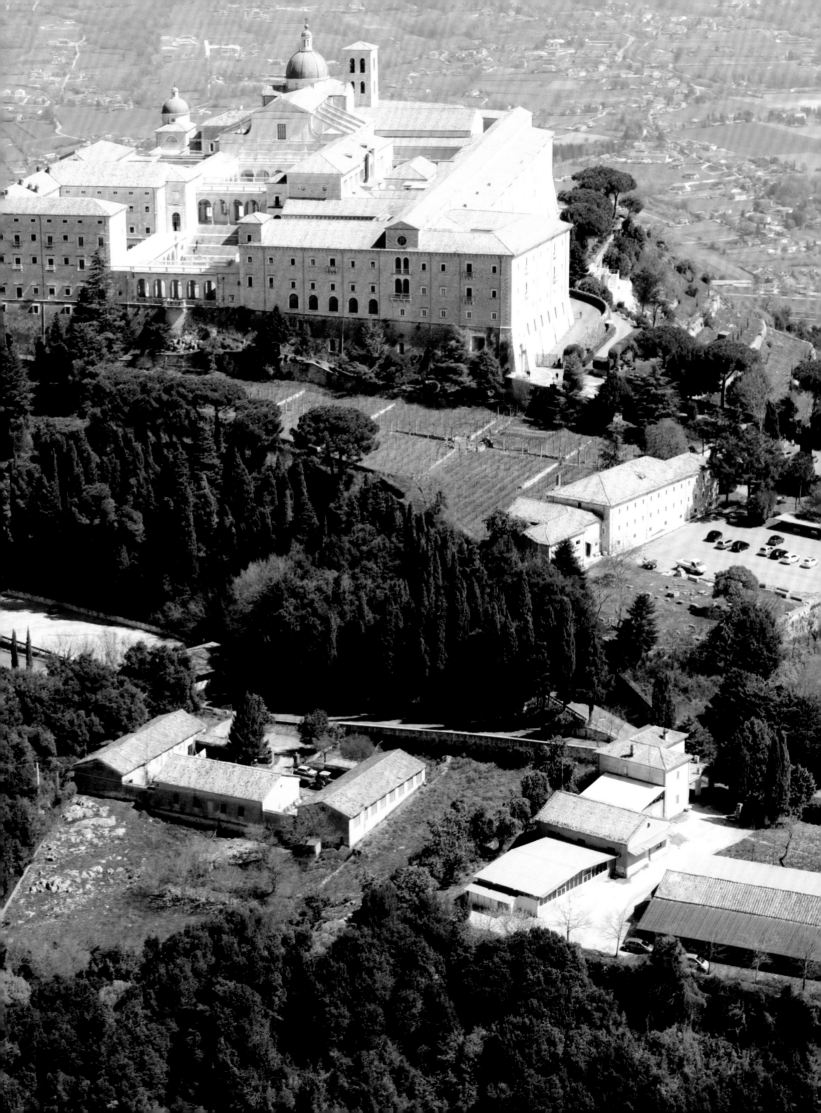

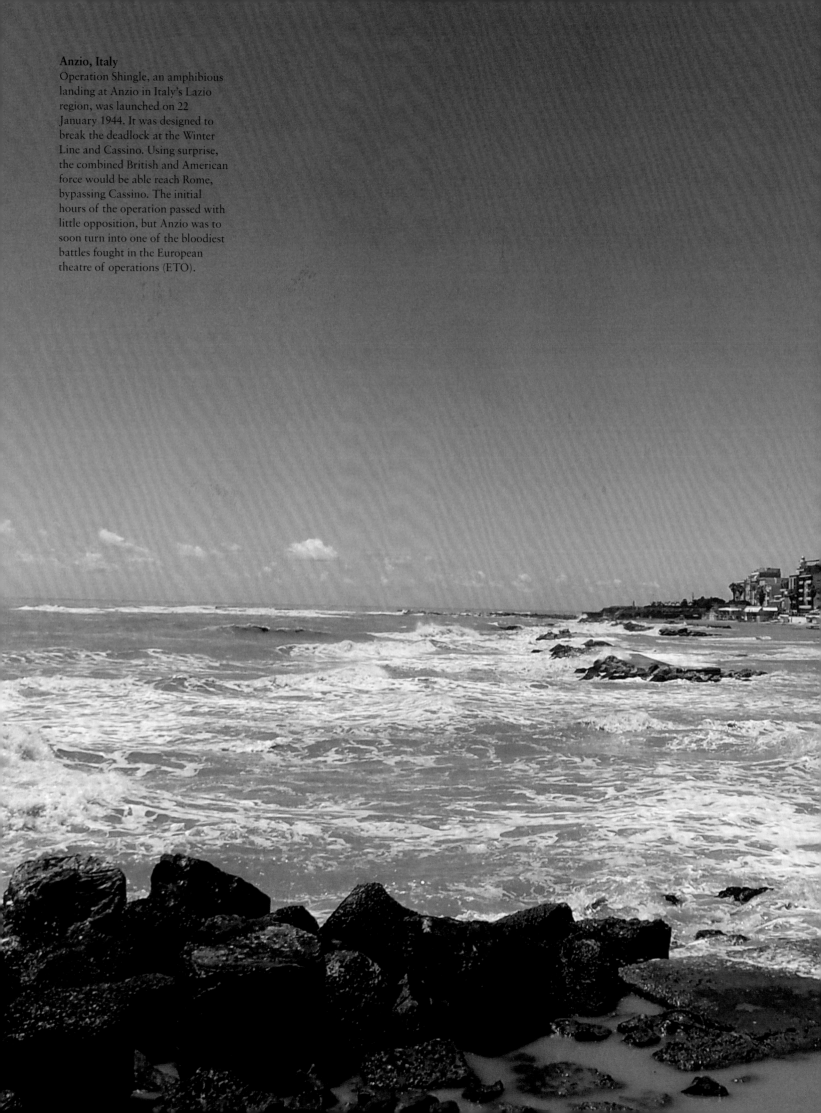

Anzio, Italy
Operation Shingle, an amphibious landing at Anzio in Italy's Lazio region, was launched on 22 January 1944. It was designed to break the deadlock at the Winter Line and Cassino. Using surprise, the combined British and American force would be able reach Rome, bypassing Cassino. The initial hours of the operation passed with little opposition, but Anzio was to soon turn into one of the bloodiest battles fought in the European theatre of operations (ETO).

Asia and the Pacific

The sweeping battles on the Eastern Front occurred over an almost incomprehensibly enormous area, leaving millions dead. Entire cities and thousands of villages were destroyed in the wake of advancing and retreating armies. The war in the Pacific was fought over a similarly expansive area but differed from the Eastern Front in several ways, all of which were hugely influential to the strategy and planning of both sides.

The first point to consider is that the Pacific is the largest ocean on the planet, and a considerable percentage of each side's efforts was dedicated to the transportation of supplies. These routes spanned thousands of miles and were not just for bullets, bombs and bandages. In some places even drinking water had to be brought in from bases far behind the advance. The next factor to consider is the relentlessly horrific conditions human beings found themselves thrust into throughout the campaign. Soldiers fought on uninhabited islands where disease, malnutrition and poisonous insects were rife, and deaths by landslides, swamps and river crossings were common. But the most horrifying aspect of the Pacific War was probably the fanaticism shown by Japanese forces. From the surprise attacks of 1941 to the massacres in Manila and the death by suicide of thousands of civilians who hurled themselves from clifftops on Okinawa in 1945, they fought with a bloodlust seldom seen in the history of warfare.

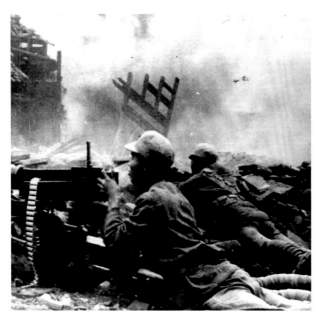

ABOVE & OPPOSITE:
Taiping Street, Changsha, Hunan Province, China
The First Battle of Changsha (one of four attempts by the Japanese to capture the city) commenced on 17 September 1939, becoming the first major battle in Asia to fall within the accepted dates of World War II. On 19 September the Japanese launched poison gas on Chinese forces along the Xiangjiang River; this was one of the very few times that chemical weapons were used in combat in the entire war.

On 29 September, after 12 days of hard fighting, Japanese forces had reached the outskirts of Changsha; however, with losses of up to 40,000 killed and wounded, their situation was dire. Recognizing that the exhausted Japanese had supply issues, and angry about the previous use of gas, the Chinese struck back with vengeance. The Japanese fled and Changsha represented the first major defeat of the Japanese Army in a major Chinese city since the start of the Second Sino-Japanese War in 1937.

JAPANESE EXPANSION

Japan had relied almost entirely on imports since its industrialization. The invasions of Manchuria in 1931 and China in 1937 had fuelled an imperial appetite for dominance on the world stage. But this did little to address the pressing need for oil and raw materials. On 27 September 1940, Japan signed the Tripartite Pact with Germany and Italy, becoming part of the Axis alliance. This led to the United States

The Bund, Huangpu river, Shanghai, China

This image shows the landscape of Lujiazui, the Bund of Huangpu District and the Hongkou District in Shanghai, China. The Battle of Shanghai was the first of many engagements fought between the National Revolutionary Army of the Republic of China and the Imperial Japanese Army in the early stages of the Sino-Japanese War. The battle has been described by historians as 'Stalingrad on the Yangtze', which goes some way to conveying its savage and bitter nature. The battle was fought on the ground, in the air and on the sea between August and November 1937, and eventually involved over a million combatants, as both armies continually reinforced their troops to make up for their heavy losses. It ended when Japanese forces began to threaten Chinese forces on the border, forcing the Chinese army to withdraw towards the west.

to Japan were the petroleum-rich Dutch East Indies and the tin mines and rubber plantations of Malaya.

The risky Japanese strategy would need to be one of aggressive surprise attack. If Japan could deal a fatal blow quickly enough, expand its empire and seize the resources it depended on before the Allies could respond, it might just achieve victory. Then Japan could sit back behind a strongly defended perimeter and hope that the world would simply accept its gains and sue for peace. The Japanese conquest was initially an overwhelming success, striking what appeared to be the fatal blow it desperately needed. Japanese forces soon defeated American, British, Australian, Dutch and local forces, which often underestimated Japanese resilience and determination.

By the middle of 1942 the Japanese empire stretched from Attu near Alaska in the north to New Guinea in the south. In the west, the empire began at the India-Burma border and continued to the Gilbert Islands in the east.

PEARL HARBOR AND THE PHILIPPINES

Pearl Harbor was a United States Naval base in Hawaii and was the scene of a shocking pre-dawn surprise attack by the Imperial Japanese Navy on 7 December 1941. Waves of fighters, dive-bombers and torpedo-bombers launched from carriers descended on the base, destroying or damaging eight battleships and 10 other vessels, as well as more than 300 aircraft. More than 2400 American military personnel and civilians were killed in the attack, and another 1100 were wounded. Just 24 hours after this 'Day of Infamy' President Franklin Roosevelt

imposing economic sanctions, which it hoped would curb Japanese aggression and prompt the country's withdrawal from Manchuria and China. Unwilling to lose face by bowing to international pressure, and unable to achieve self-sufficiency to solve its resource shortages, Japan decided instead to attack the United States and Commonwealth forces in Asia and seize the resources it needed. Particularly vital

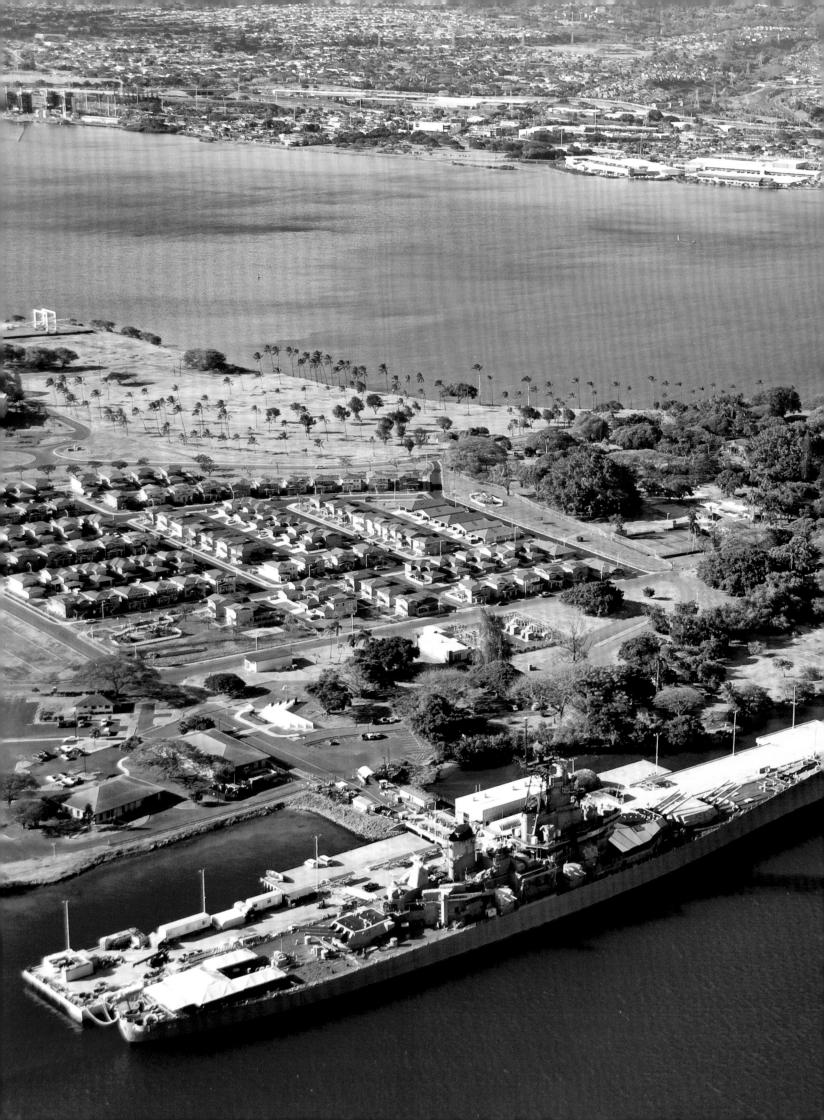

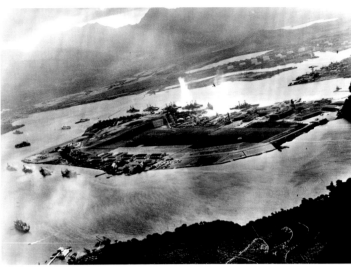

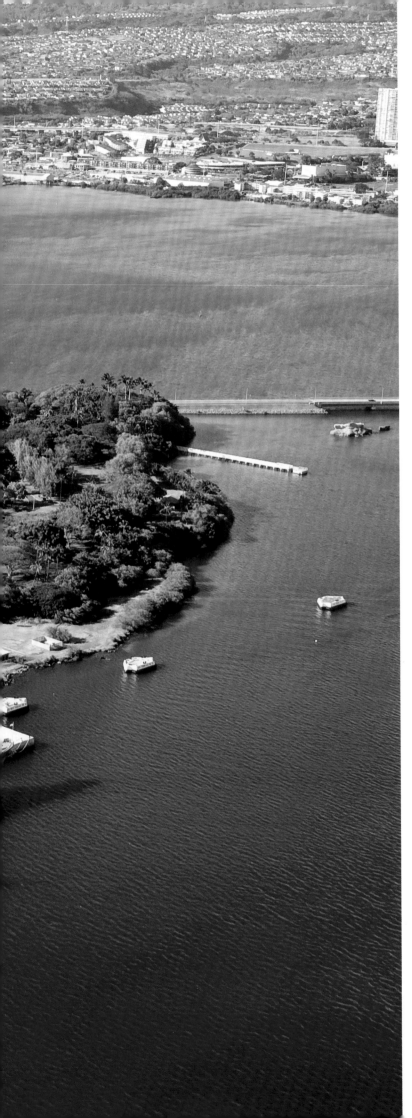

LEFT & ABOVE:

Battleship *Missouri* Memorial, Pearl Harbor, Hawaii

The 56,200 tonne (58,000 ton) USS *Missouri* (nicknamed 'The Mighty Mo') was the last American battleship ever built and the last to be decommissioned. Although now permanently anchored in Pearl Harbor, she had no involvement in the events of 7 December 1941, being launched in June 1944. She fought with distinction in the battles of Iwo Jima and Okinawa and later took part in the Korean War. She was decommissioned in 1955 into the USN reserve fleet, but was reactivated and modernized in 1984 and provided fire support during Operation Desert Storm in 1991.

Missouri's most famous role in history occurred on 2 September 1945 when General Douglas MacArthur oversaw the unconditional surrender of the Japanese to the Allies; the instrument of surrender was signed on her deck, officially ending World War II.

OVERLEAF:

USS *Arizona* Memorial, Pearl Harbor, Hawaii

The USS *Arizona* Memorial marks the final resting place of 1102 of the 1177 sailors and US Marines killed onboard during the attack on 7 December 1941. The memorial, built in 1962, sits over the sunken hull of the battleship without touching it. The battleship's remains were declared a National Historic Landmark in 1989, and oil leaking from the hull can still be seen rising from the wreckage to the water's surface. This oil is sometimes referred to as 'the tears of the *Arizona*'.

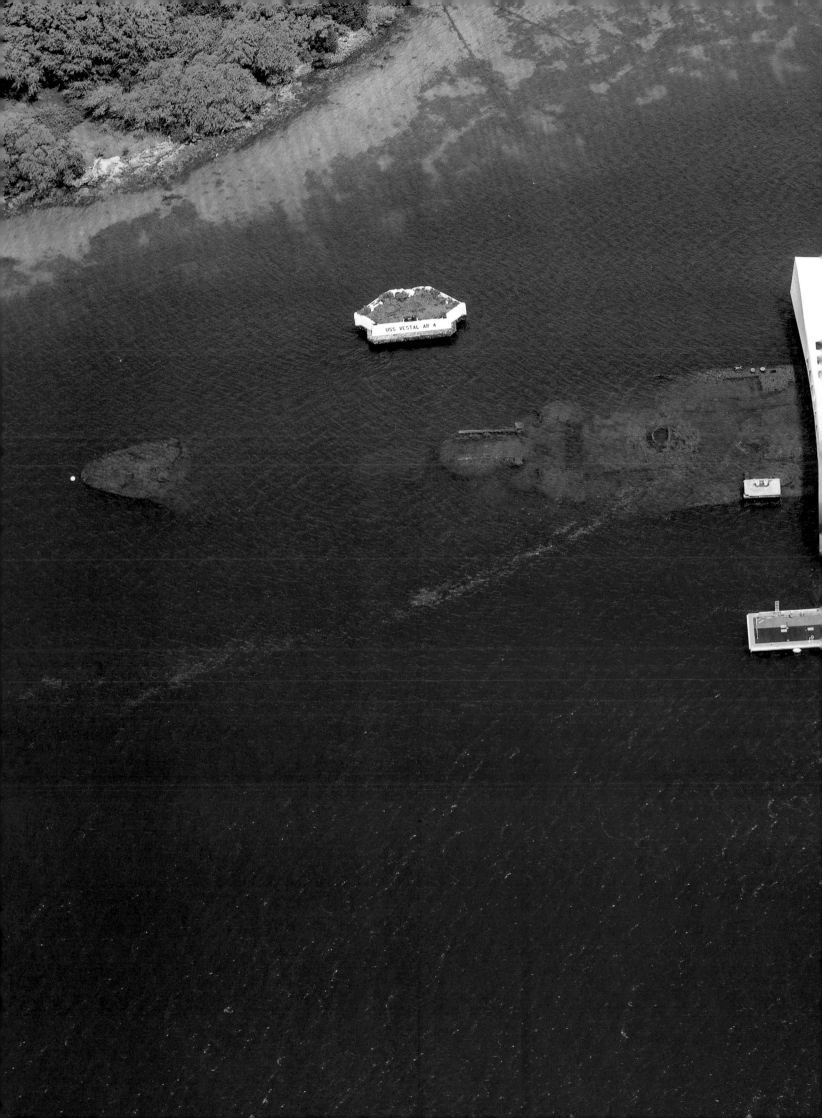

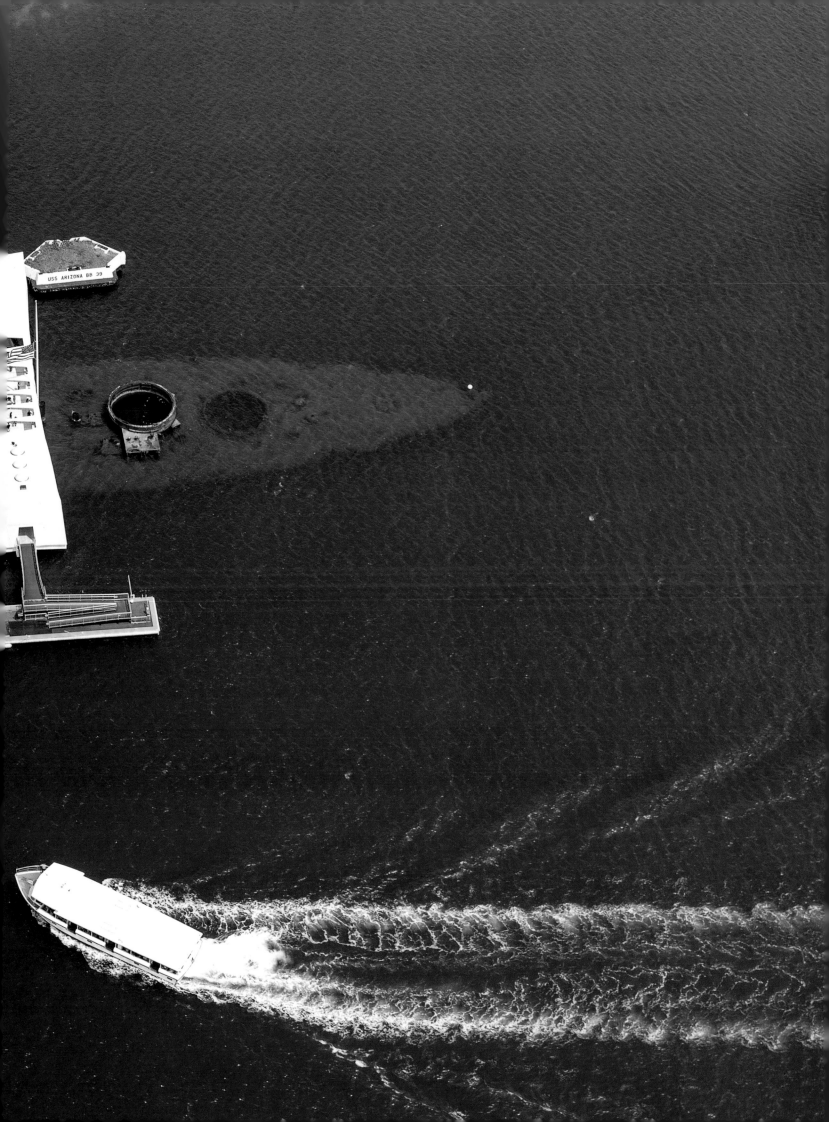

asked the United States Congress to declare war on Japan.

Swift capture of its objectives was crucial to Japan's expansion plan, and it progressed with astonishing speed. Throughout December, key locations across the Pacific fell like dominoes: Guam on the 10th, Wake Island on 22nd and Hong Kong on 26th. The assault on the Philippines began on 8 December 1941, just 10 hours after the attack on Pearl Harbor. Initial aerial bombardment was followed by the landing of ground troops. Defending troops were under the command of General Douglas MacArthur, whose home was in Manila – his son having been born there in 1938. His naval forces unavailable, the aircraft of his command destroyed and reinforcement of his ground forces virtually impossible, MacArthur's situation was dire.

Under the weight of superior numbers, his defending forces withdrew to the Bataan Peninsula and to the island of Corregidor.

OPPOSITE:
Corregidor Island, Manila, Philippines
These barracks were built in 1941 and were used for the billeting of American personnel, including General Douglas MacArthur. The building is less than a third of a mile in length but is commonly referred to as the 'Mile-Long Barracks'. Corregidor fell to the Japanese on 6 May 1942 and was the last major engagement in the Japanese conquest of the Philippines. MacArthur had already departed on the night of 12 March, traveling by patrol torpedo (PT) boat to Mindanao, from where his party then flew to Australia on a B-17 Flying Fortress. On 16 February 1945 the 503rd Parachute Infantry Regiment jumped into Corregidor as part of the Allied operation to retake the island fortress, and the area around Mile-Long Barracks once again saw heavy fighting before the island was liberated on 26 February.

Manila, declared an open city to prevent its total obliteration, was occupied by the Japanese on 2 January 1942. By May, all resistance in the Philippines had come to an end and 80,000 American and local prisoners captured by the Japanese were forced to undertake the infamous 'Bataan Death March' to a prison camp 113km (70 miles) away. As many as 10,000 men, weakened by disease and starvation and treated mercilessly by the guards, died on the march.

Over the three long years of brutal Japanese occupation, an effective resistance by 250,000 local guerrillas persisted; before the Allies returned in 1945, Japanese units fully controlled only 12 of the 48 provinces in the Philippines. In 1942 MacArthur had famously promised to the world that 'I shall return' and, after a costly campaign of island-hopping, Allied forces under his command landed on the island of Leyte on 20 October 1944. Further landings followed on the islands of Mindoro and Luzon ahead of the final push on Manila and the fulfilment of his promise.

Convinced the Japanese would abandon the city as he had done, MacArthur envisaged a glorious victory parade through its streets, but the Japanese defenders had other plans. Determined to fight to the death, they had barricaded road junctions, converted buildings into strongholds and booby-trapped shops, homes and even dead bodies. The 29-day battle to liberate Manila resulted in the cataclysmic annihilation of a city already ravaged by starvation. The rampage that ensued was typified by rape, torture, murder and wanton destruction. By its conclusion, an estimated 100,000 civilians had lost their lives in a massacre as heinous as any in human history.

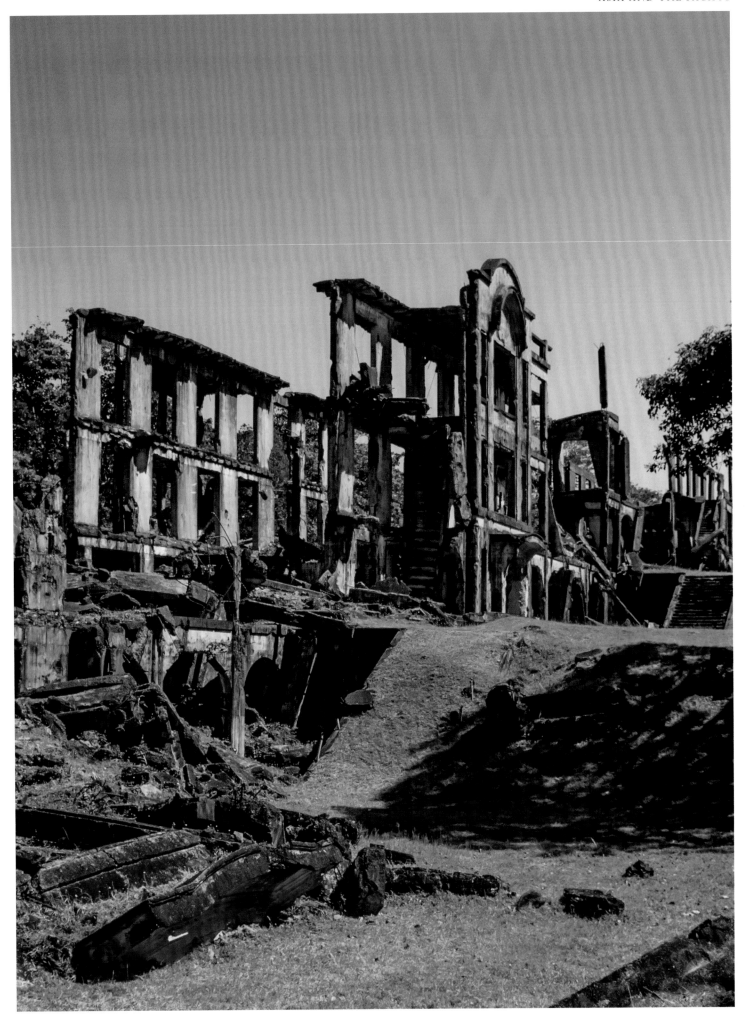

LEFT & ABOVE:

Johor–Singapore Causeway, Straits of Johor, Malaysia
Beginning on 8 December 1941, the Japanese assault through peninsular Malaya had been relentless. By 31 January 1942 Allied forces under the command of General Arthur Percival were falling back across the 1.07km-long (²/₃ mile) causeway consisting of a combined railway and road bridge linking the city of Johor across the straits to the district of Woodlands in Singapore (*pictured left*). British forces attempted to slow the Japanese advance by blowing the causeway and two explosions detonated: one wrecking a lift-bridge over the lock and the second creating a 21m-wide (70ft) gap. It delayed the Japanese only until they constructed a girder bridge over the gap (*pictured above*), following successful amphibious landings further along the coast, which had allowed them to secure a bridgehead. After this the Japanese tanks and troops were able to move on into Singapore, which fell on 15 February 1942.

Today, the causeway is still in use and is one of the busiest border crossings in the world, with 350,000 daily travellers.

MALAYA AND SINGAPORE

As the American public reeled from the lethal attack in Hawaii, nearly 11,000km (6000 nautical miles) east, the Japanese Army made a simultaneous amphibious landing in northern Malaya. Although outnumbered by the Australian, Indian, Malay and British defenders, the Japanese made swift progress down the peninsula. They frequently outflanked defending forces, who believed that the jungle was impassable, and concentrated

ABOVE:

Bukit Chandu ('Opium Hill'), near Pasir Panjang, Singapore

On 12 February 1942, 13,000 Japanese troops made an amphibious landing near Sarimbun and began advancing south towards the city of Singapore via Pasir Panjang ('Long Beach' in Malay), capturing Tengah Airfield en route.

Just 1400 soldiers of the 1st Malaya Infantry Brigade and British 5th Battalion Bedfordshire and Hertfordshire Regiment stood in their way, and their valiant defensive action over the next two days at Bukit Chandu has gone down in legend.

RIGHT:

Kent Ridge Park, Singapore

The summit of the hill is where 159 survivors of the Malay Regiment led by Lieutenant Adnan bin Saidi fought off attacks by the Japanese 18th Division.

The position was only overrun after an extended period of bitter hand-to-hand combat when the defenders' ammunition ran out. Many survivors were massacred in the aftermath, including Adnan bin Saidi. Having fought on with just a sword and then his bare hands, bin Saidi was tied upside-down to a cherry tree and bayoneted to death.

their defences around the roads. Japanese air and sea power proved equally influential in the Malayan campaign and the army made good use of bicycles and light tanks. By mid-January, the Japanese had reached Johor across the strait from the ultimate prize of Singapore. Although the Australian 8th Infantry Division fought valiantly at Gemas around the Gemencheh Bridge and other locations, the Japanese advance was relentless and soon Singapore itself was in peril.

Britain had controlled a naval dockyard in Singapore for generations and used it as its primary base from which to protect its empire in Southeast Asia. It was central to Commonwealth planning. The 'Singapore Strategy' was dependent on a rescue fleet being despatched from Europe if crisis loomed, a strategy that many viewed as fatally flawed. Ultimately, when the powerful Japanese attack came in December 1941, Britain could spare few ships for Singapore, dealing as it was with other crises in Europe and the Mediterranean.

Only two vessels had arrived by October 1941, HMS *Prince of Wales* and HMS *Repulse*. With no carrier support, both were sunk on 10 December. When the exhausted Commonwealth ground forces withdrew from Johor onto Singapore in January 1942, they knew their situation was probably hopeless. When the Japanese attacked a few days later, the British commander General Percival had spread his force too thinly and with little in reserve. Under persistent ground attack, relentless bombing from the air and deadly artillery barrages, the defenders were pushed back into an ever-decreasing perimeter around Singapore city.

Some epic defensive actions by Malay, British and Australian troops at places like Bukit Chandu and Kent Ridge Park were made, but the overall situation was untenable. At 8.30pm on 15 February more than 130,000 Allied troops surrendered to the Japanese, significant numbers of whom would die as prisoners over the next months and years. The one million civilians in the city would remain under Japanese occupation for the remainder of the war. During this dreadful time of starvation and brutality, the Japanese massacred many of Singapore's Chinese population as well as others who opposed their occupation. Winston Churchill called the fall of Singapore 'the worst disaster' in British history.

MIDWAY AND GUADALCANAL

On 20 May 1942 a simple radio message about broken water evaporator units was sent from Midway, a tiny atoll in the middle of the Pacific Ocean. This seemingly innocent transmission was in fact a ruse. When Japanese Naval Intelligence listeners intercepted the message and reported to their commanders that 'AF' had fresh-water problems, their American counterparts confirmed their suspicions: 'AF' was the Japanese codename for Midway. Allied code-breakers had been deciphering references

OPPOSITE & OVERLEAF:
Kokoda Trail, Papua New Guinea
The Kokoda Trail (or Kokoda Track) is a single-file foot jungle path that runs over 96km (65 miles) through the Owen Stanley Range in Papua New Guinea. After the fall of Singapore, focus moved to New Guinea and Japanese forces launched an attack on 21 July 1942 over the Owen Stanley Range, with the aim of capturing Port Moresby in the south – a vital harbour for the Japanese, especially as part of their campaign to threaten Australia. An earlier attempt to take Port Moresby by a seaborne landing had been disrupted by the Battle of the Coral Sea. What followed was a desperate and vicious seven-month campaign for the trail, which saw 600 Australian soldiers killed and 1600 wounded, and more than 10,000 Japanese fatalities. It is now a place of pilgrimage for Australians and the photo overleaf shows visitors hiking the trail.

ALL PHOTOGRAPHS:

Midway Atoll, Midway Islands, Pacific Ocean

One of the most important battles of World War II is named after the tiny 6.2km² (2.4 mile²) Midway Atoll. On 4 June 1942 the Japanese attack on this vital island comprised four aircraft carriers, seven battleships, 150 support ships, 248 carrier aircraft and 15 submarines. The US force committed to defend the atoll was made up of three aircraft carriers, 50 support ships, 233 carrier aircraft, 127 land-based aircraft on Midway and eight submarines. USMC flyer Major Lofton R. Henderson was killed in the battle and had the honour of three airfields being named after him: one each on Midway's Sand and Eastern Islands and a third on Guadacanal in the Solomon Islands. The historic seaplane hangar was designed by the famous industrial architect Albert Kahn, and was first shelled during air attacks on the same day as Pearl Harbor: 7 December 1941. It was set ablaze during the air attacks on Midway on 4 June 1942.

Partially rebuilt following the battle, Sand Island served as base for American PBY Catalina seacraft.

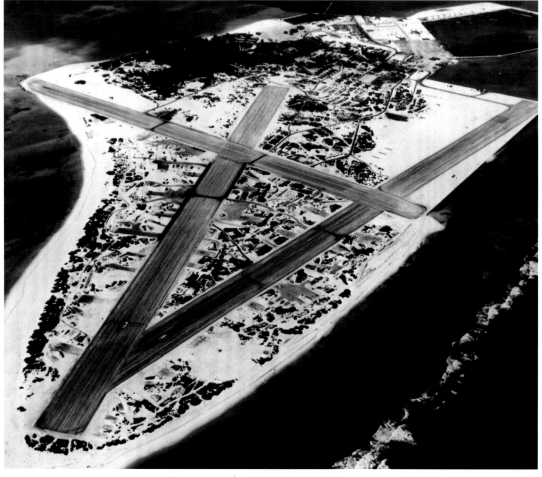

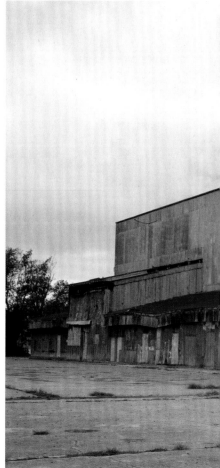

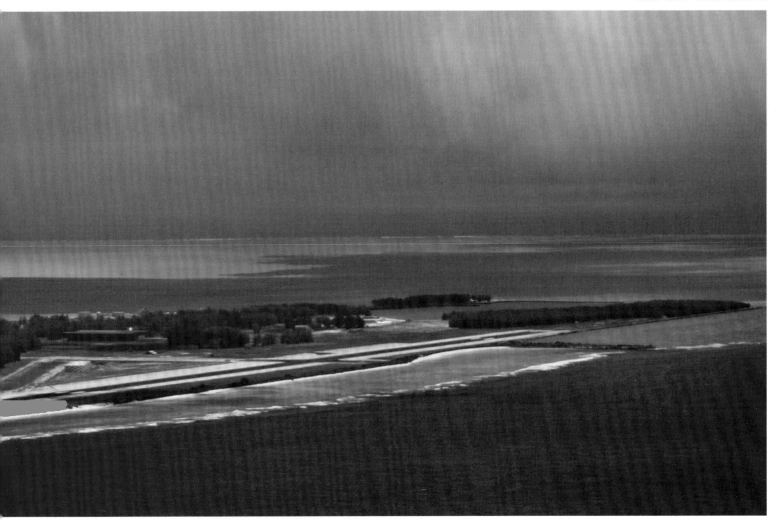

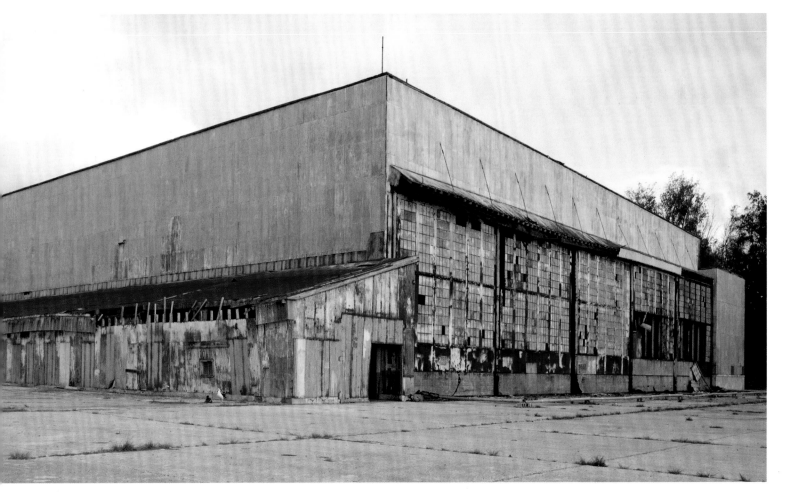

to 'AF' for some time and knew that the Japanese were mounting a huge offensive, but now they knew where and when. Positioning themselves masterfully, the US carrier force drew in the Japanese carriers and what followed between 4 and 7 June was undeniably the defining naval battle of the war. It was fought almost exclusively in the air and at its conclusion four Japanese carriers were sunk for the loss of one American. After a resounding victory and just six months after Pearl Harbor, Allied forces were able to go on the offensive.

Equally important to turning the tide in the Pacific was the Battle for Guadalcanal. On 7 August 1942, American forces, predominantly United States Marines, landed on the island of Guadalcanal in the Solomon Islands. Centring around the Henderson Field airstrip, the next seven months saw an almost continual series of ferociously contested, land, air and sea battles. The Japanese saw the Guadalcanal and associated New Guinea battles as one greater campaign; once the Japanese lost control of Guadalcanal and their key bases at Buna-Gona on New Guinea, the Allies had gained important air bases, which would help propel them towards the Japanese home islands.

NEW GUINEA

The New Guinea campaign lasted from January 1942 until the end of the war and was fought over remote and mountainous jungle where the oppressive climate exhausted both attacker and defender alike. The first strikes were the Japanese landings in New Ireland and then Rabaul in New Britain, from where they launched a seaborne attack on Port Moresby on the south coast of New Guinea in May.

Bunker, Sand Island, Midway Atoll
Midway had been fortified by the Americans in the years leading up to World War II with some 22 guns having been installed into six batteries. The remains of a few of these concrete bunkers and gun positions can still be seen around the atoll. Although Midway was attacked by air from carrier-based Japanese aircraft, the force of 5000 ground troops was never launched and the beach defences saw no ground action.

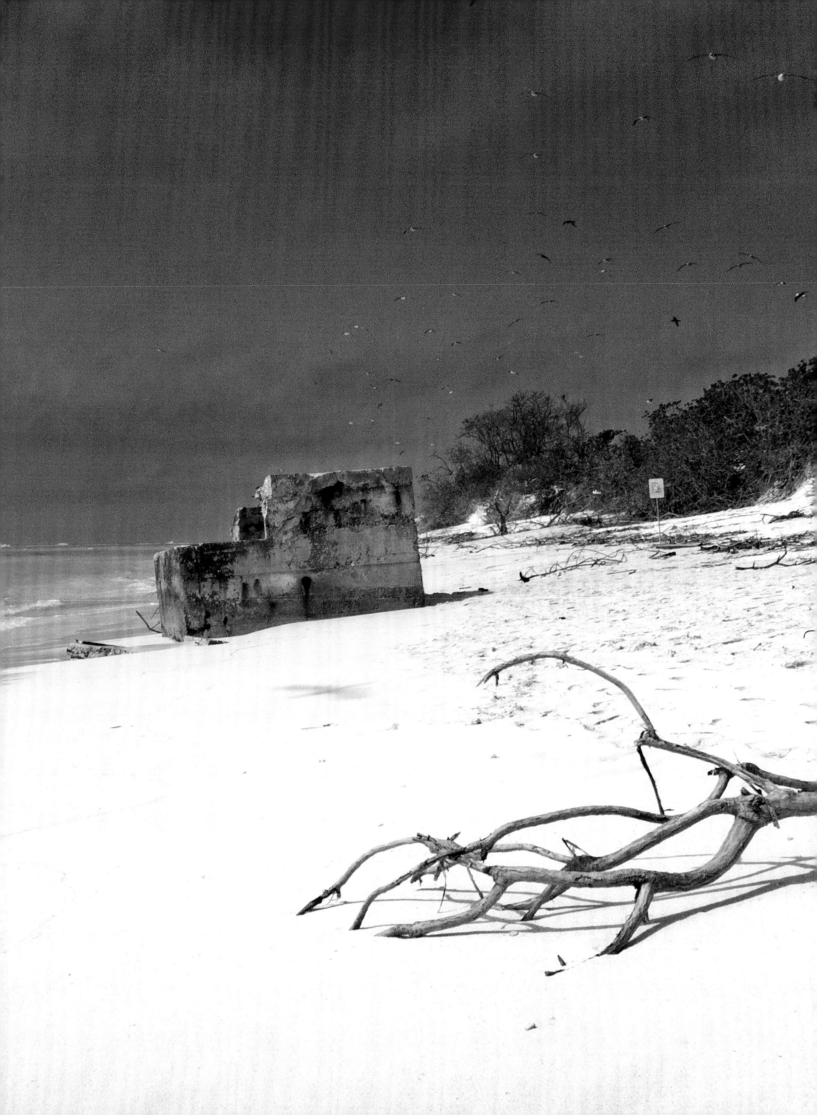

BOTH PHOTOGRAPHS:

***Kinugawa Maru*, Ironbottom Sound, Guadalcanal, Solomon Islands**

The *Kinugawa Maru* was an Imperial Japanese Navy transport ship on supply runs (known today as the 'Tokyo Express') in the Guadalcanal Campaign. On 15 November, she and three other ships were offloading their cargo when accurate fire from US Marine shore batteries opened up, setting two of the ships on fire. Airstrikes were soon called in from Henderson Field, and the destroyer USS *Meade* moved in from Ironbottom Sound and raked the vessels with shellfire. Later, aircraft from the USS *Enterprise* joined the attack and the captain of the *Kinugawa Maru* elected to run his heavily-damaged and burning ship aground, with the crew and the remaining soldiers onboard jumping and wading to Tassafaronga Beach. That evening, an American fighter put a bomb into her stern cargo hold and the Kinugawa Maru sank. Today, she is a popular dive site.

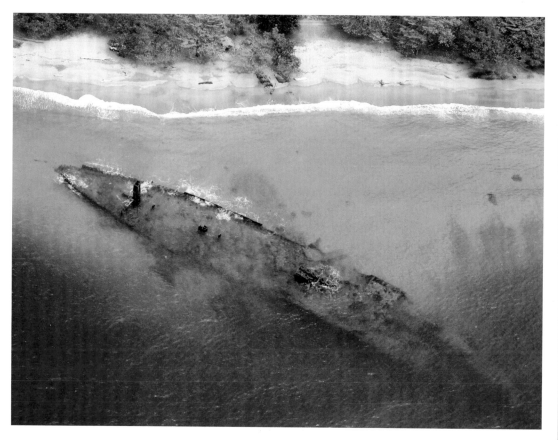

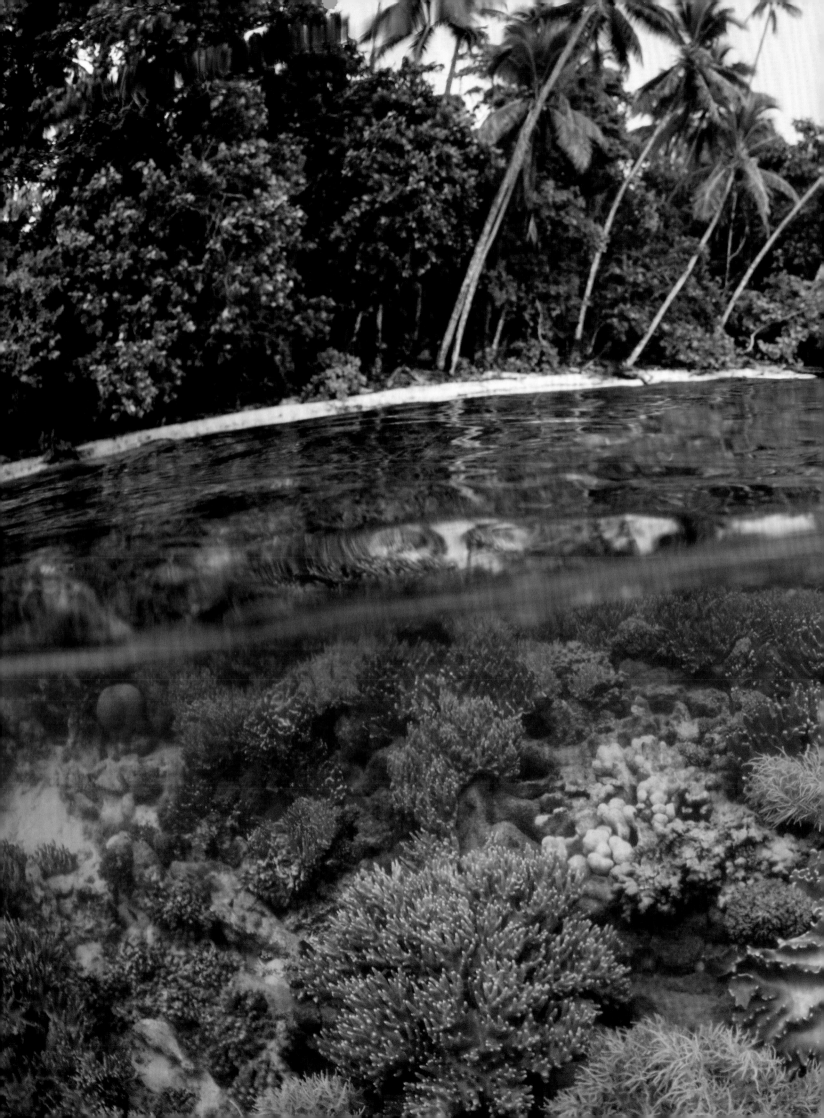

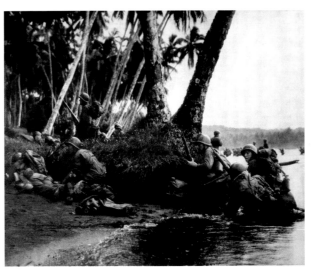

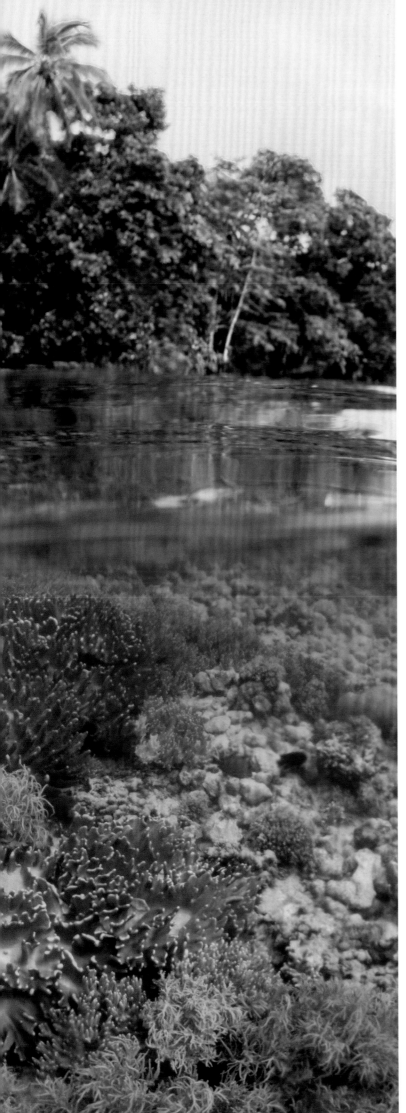

LEFT & ABOVE:

Rendova, Solomon Islands

The landings on Rendova Island on 30 June 1943 were part of the New Georgia Campaign. Attacking at the break of day in a heavy rainstorm, the first Americans ashore huddle behind tree trunks and any other cover they can find.

Unlike Guadalcanal, where the battle lasted six months, the Japanese garrison of 300 was quickly overwhelmed on Rendova, although Japanese air attacks persisted for several days. Within days, from a base on the northern tip of Rendova island PT boats conducted nightly operations, both to harass the busy Japanese barge traffic that was resupplying the garrisons in New Georgia and to patrol the Ferguson and Blackett Straits. Most famously, future US president John F. Kennedy saw action in this area as a lieutenant (junior grade) and skippered *PT-109*.

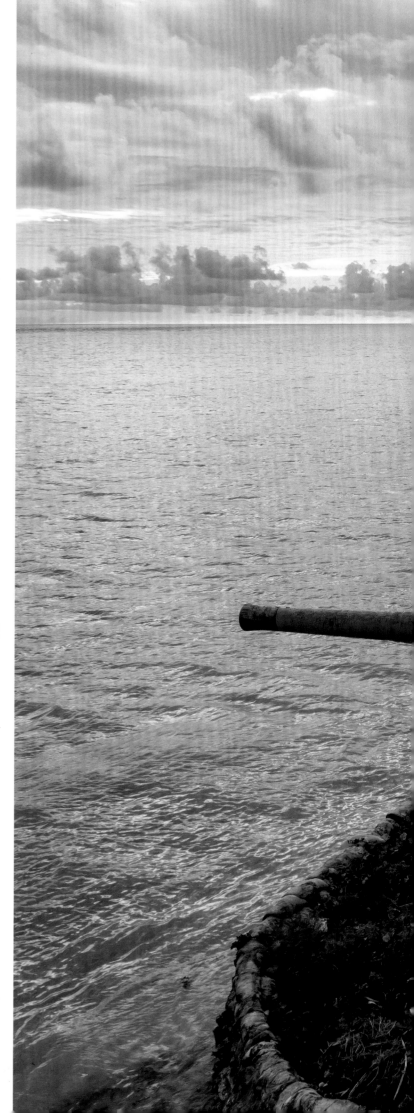

This plan was disrupted by the Battle of the Coral Sea, when US carrier-based aircraft and the Australian Navy were successful in forcing the Japanese armada back to Rabaul. Then, having suffered the devastating defeat at the Battle of Midway, the Japanese gave up trying to take Port Moresby from the sea and instead made a landing in June near Buna on the northeast coast. From this beachhead they launched an overland advance across the razor-edged ridges of the Owen Stanley Range, leading to the pivotal Kokoda Track and Milne Bay campaigns where the Japanese advance failed miserably.

General MacArthur was now determined to retake New Guinea and use it as a stepping-stone on his very personal quest to liberate the Philippines to the northwest. His rollback began on 16 November 1942, with the battle for Buna-Gona. For nearly two more blood-soaked years the war raged on in New Guinea and Bougainville, and as many as 90 per cent of all Japanese casualties were from non-combat causes such as disease and starvation.

ISLAND HOPPING

With the battle for Guadalcanal over and the New Guinea campaign evolving, American commanders hatched an ingenious plan: to bypass the most heavily fortified Japanese-

Japanese defences, Betio, Tarawa Atoll
One historian and former US Marine wrote that, 'Tarawa was the most heavily defended atoll that ever would be invaded by Allied forces in the Pacific.' The Japanese were equally sure of its defences and Admiral Shibasaki reportedly bragged that the Americans wouldn't take Tarawa with a million men in 100 years. Measuring just 3.2km (2 miles) long and 0.8km (0.5 miles) wide, the island of Betio was defended by a garrison of 4500 men, with coastal, anti-tank and machine guns installed in around 100 concrete bunkers and criss-crossed with an extensive trench system. Natural reefs ringed the island and barbed wire and mines augmented the defence. The photograph shows 14cm (5.5in) Japanese naval guns.

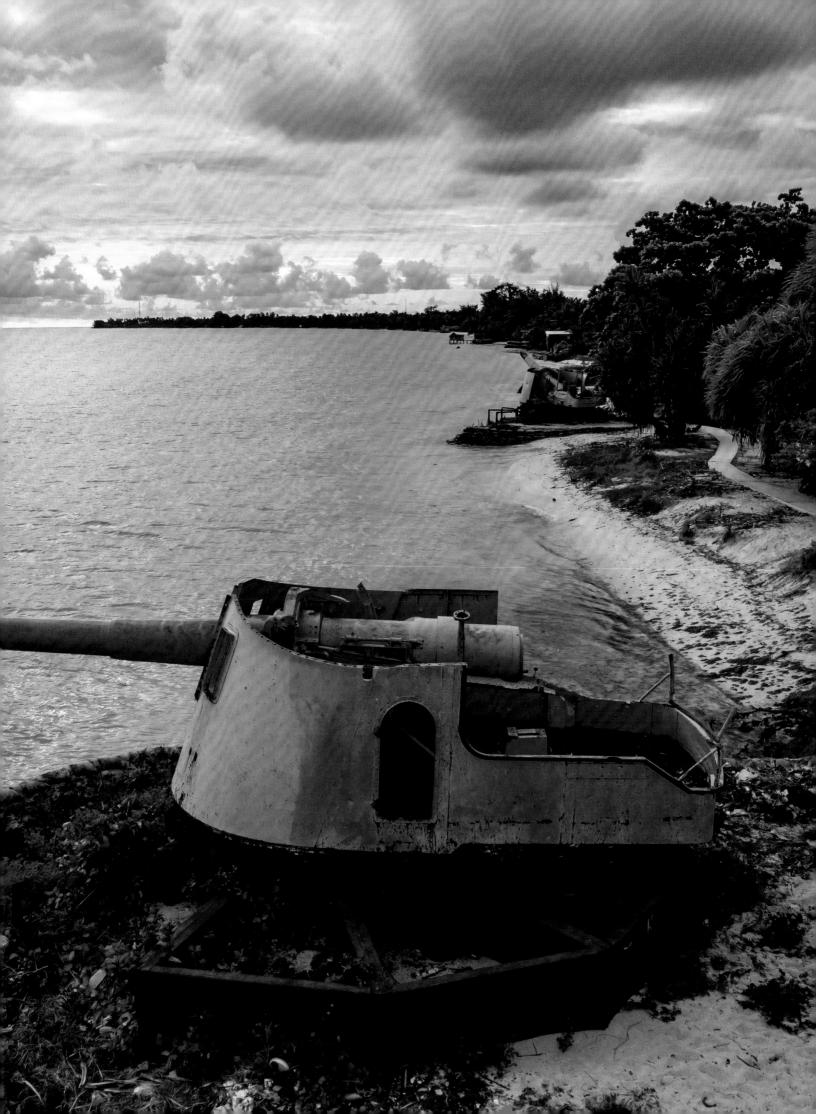

ABOVE & RIGHT:
Tarawa, Republic of Kiribati
Ahead of the assault on 20 November 1943, Admiral Raymond Spruance had assembled the largest invasion fleet to date, consisting of more than 100 ships and including 17 aircraft carriers. The fleet also carried 35,000 men to form a ground assault: the 2nd Marine Division and part of the US Army's 27th Infantry Division. There were delays on the day of the invasion and the tide had dropped, meaning that many of the landing craft grounded on the reef as they approached the northern beach. A swift response from Japanese artillery and mortars proved deadly and only a small number of Marines made it ashore, where they were pinned down behind a log wall. Eventually reinforced and aided by the arrival of some tanks, the Marines were able to push forward, despite heavy casualties.

Though Tarawa fell within three days, the losses (more than 3000 killed and wounded) incurred led the Allied high command to reassess how it planned and conducted amphibious invasions, leading to significant changes that would be employed for the remainder of the island-hopping campaign.

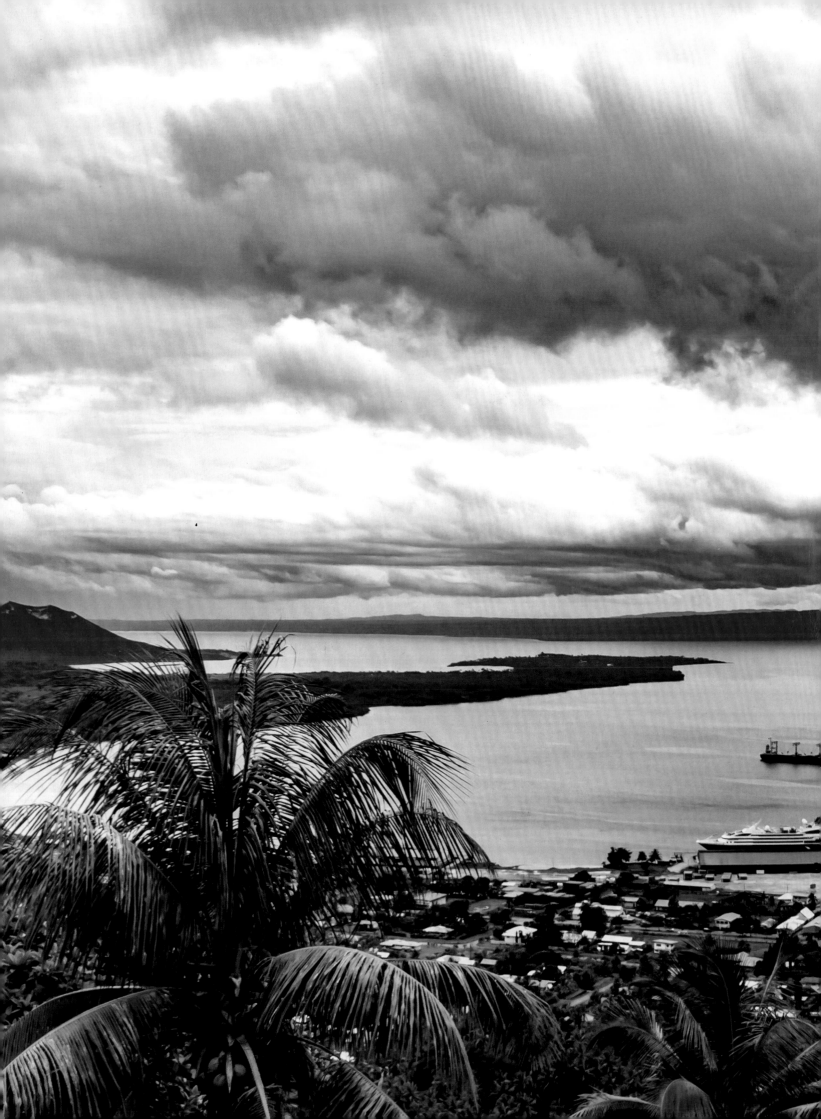

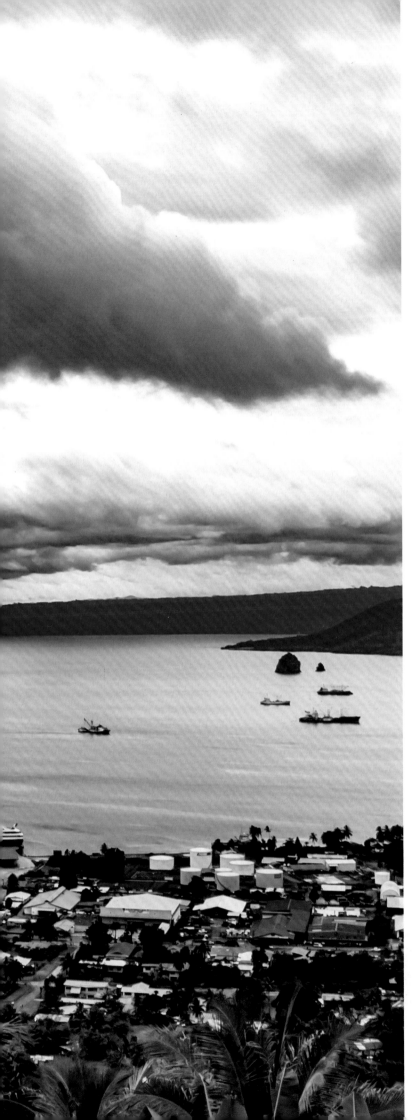

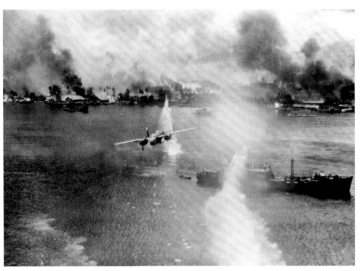

LEFT:

Rabaul Harbour, New Britain
Operation Cartwheel began in the summer of 1943 and was a series of amphibious assaults and naval manoeuvres intended to neutralize the important Japanese air and sea base at Rabaul on New Britain in Papua New Guinea. Admiral William 'Bull' Halsey led the eastern advance in the Solomon Islands and General Douglas MacArthur took control of the western advance via New Guinea.

ABOVE:

US Army Air Force B-25, Simpson Harbor, Rabaul
On 2 November 1943, a day that became known as 'Bloody Tuesday', elements of the 5th US Army Air Force attacked Japanese shipping, leaving 26 enemy vessels sunk or damaged, including six cruisers. This success was at a considerable cost, however, with eight B-25s and nine P-38s lost, and many others damaged.

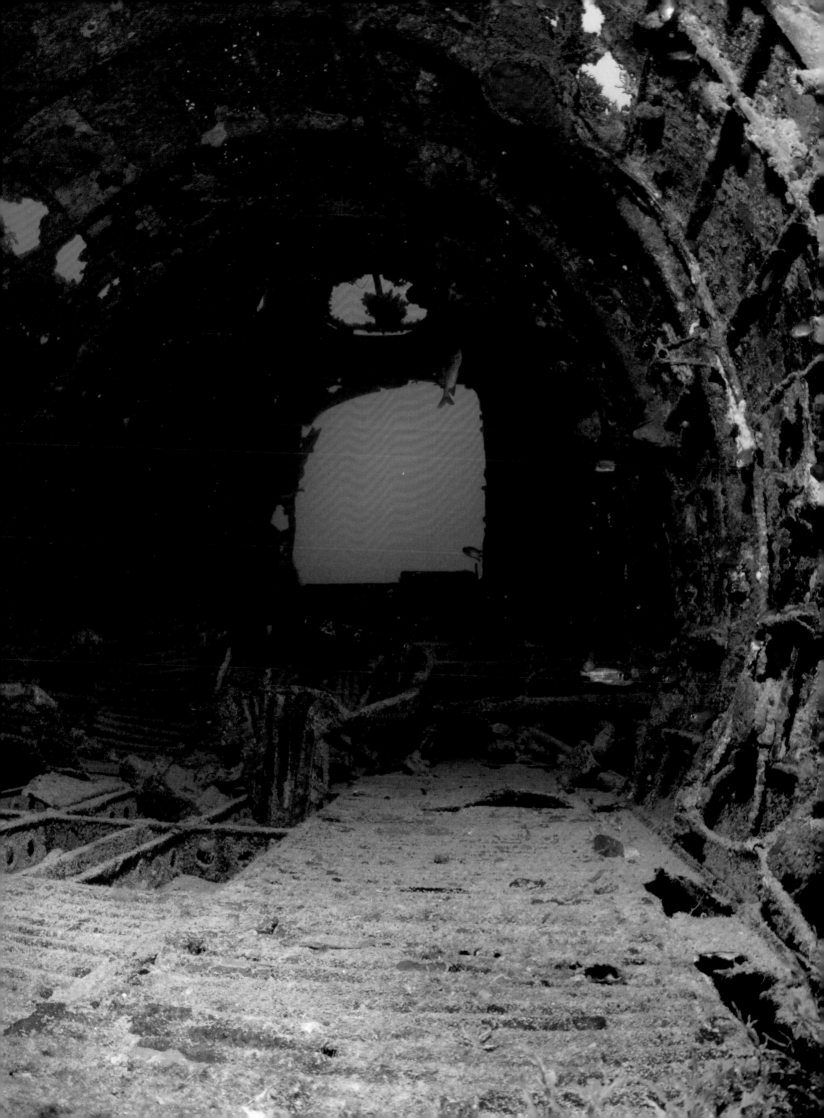

held bases ahead and leap-frog from strategic but less defended islands. Rather than landing ground forces against sizable Japanese garrisons on heavily fortified islands such as Truk and Rabaul, they could instead be attacked by air and sea and then effectively cut off to 'wither on the vine'. This tactic became known as island hopping.

For two long years, US forces moved west across the Pacific from locations hitherto unheard of by most Americans: Rendova, Makin, Tarawa, the Marshall Islands, the Maluku Islands, Saipan, Guam, Tinian, Peleliu, Iwo Jima and others. Some island assaults were swift and dynamic, others were drawn-out and bitter. All were bloody and most were costly, but each island secured would bring the now awesome Allied air and naval armada closer to Japan. Each base established would ease the supply headaches and each loss was another nail in the coffin for the Japanese empire.

CHINA AND BURMA

China had been fighting a barbarous war against the Japanese empire since 1937, and the impact of China's contribution to Japan's eventual defeat was substantial. At its peak, the Chinese Nationalist government under Chiang Kai-shek fielded four million highly committed troops; by 1945 China had lost an estimated 20 million people, both to the war itself and to famine. Furthermore, almost 80 million more Chinese became refugees. China's role as an ally of Britain and the USA is overlooked, largely because of the situation after 1949 when China's Communist Revolution ended most of the country's ties with its wartime partners. The long and arduous Burma campaign was

fought by a multinational force of Indian, West African, British, Commonwealth, Chinese and United States personnel. Grim jungle conditions, monsoon rains and a distinct lack of roads made fighting a somewhat seasonal affair, with effective campaigning restricted to around six months each year. The inexorable Japanese conquests of 1942 forced the Commonwealth defenders out of Burma and back to India, where they spent the next two years rebuilding.

This period of re-arming allowed the Allies to gradually develop a better intelligence network, including SOE operatives and local guerrilla cells, and to create the Fourteenth Army under General William Slim. March 1944 saw the Japanese launch the Operation U-Go offensive into the northeast regions of Manipur and the Naga Hills in India. Aimed at scattering Commonwealth forces and preventing them from mounting their own operations, it became one of the last major Japanese offensives of the war. Although it made some early progress, it came to a crushing end at Imphal and Kohima. Though significantly outnumbered,

OPPOSITE:
Mitsubishi G4M1 bomber, Truk Atoll, Micronesia
This Mitsubishi G4M1 attack bomber crashed into Truk Atoll (now Chuuk Lagoon) 0.8km (0.5 miles) short of its intended runway. The Mitsubishi G4M1 was nicknamed the 'Betty' by Allied servicemen and 2435 were built during the war. Although out-paced by Allied aircraft towards the end of the war, the Betty served on the front line for the entire Pacific campaign. On 18 April 1943, 16 P-38 Lightnings of the 339th Fighter Squadron shot down a G4M1 Betty carrying Admiral Isoroku Yamamoto. Operation Vengeance was hastily planned after analysts decrypted a Japanese message revealing that the admiral (the chief architect of the Pearl Harbor attack) would be flying from Rabaul to Bougainville in the Solomon Islands.

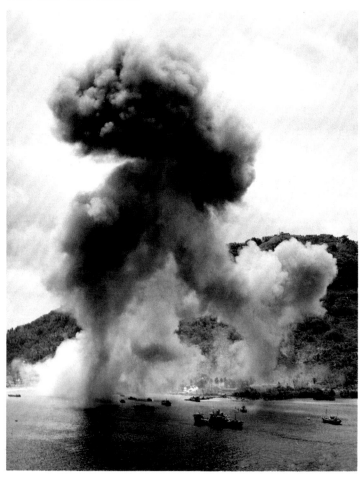

ABOVE & RIGHT:

Dublon Island, Truk Atoll, Micronesia

The US Navy carried out the bombing on 17 February 1944. Truk Atoll is 1770km (1100 miles) northeast of New Guinea and was Japan's main naval base in the South Pacific theatre. Following the successful capture of the Marshall Islands, American units could use them as a forward base to attack the Truk Atoll and on 17 February 1944 Operation Hailstone was launched.

Japanese intelligence suspected a massive US raid was being planned and had already withdrawn their carriers and cruisers. Nevertheless, an American force of carrier aircraft was able to sink 12 smaller Japanese warships, including light cruisers and destroyers, and 32 merchant ships, while destroying 275 aircraft, mainly on the nearby Japanese air strips.

Some historians believe the Truk Atoll is therefore one of the largest graveyards of vessels and aircraft of the entire war.

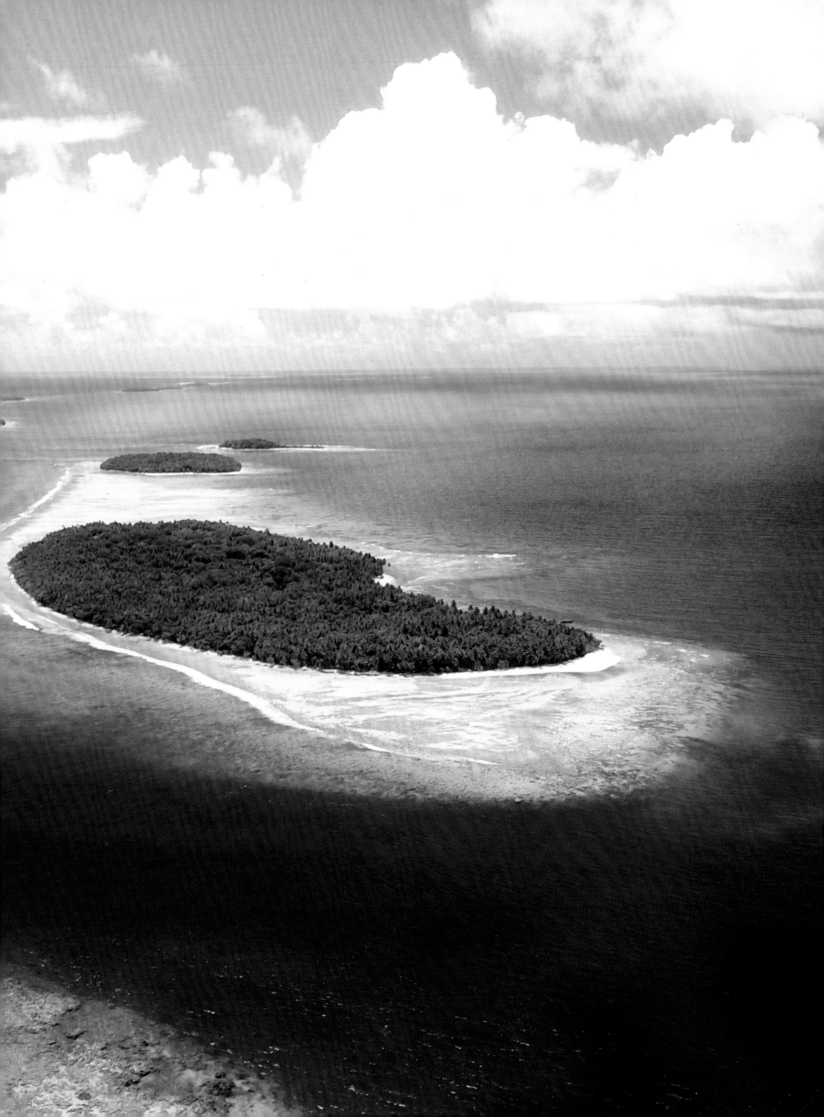

Japanese anti-tank gun, Truk Atoll, Micronesia
A rusting artillery piece remains on the deck of a Japanese freighter in Truk Lagoon. French oceanographer Jacques Cousteau and his team dived on Truk Lagoon for a 1971 television documentary and enthusiasts from around the world still dive on the many almost intact wrecks of Chuuk Lagoon today. After Operation Hailstone, Truk was effectively isolated and cut off as American forces continued their advance towards the Japanese home islands, but it was attacked once again from 12 to 16 June 1945 by part of the British Pacific Fleet during Operation Inmate.

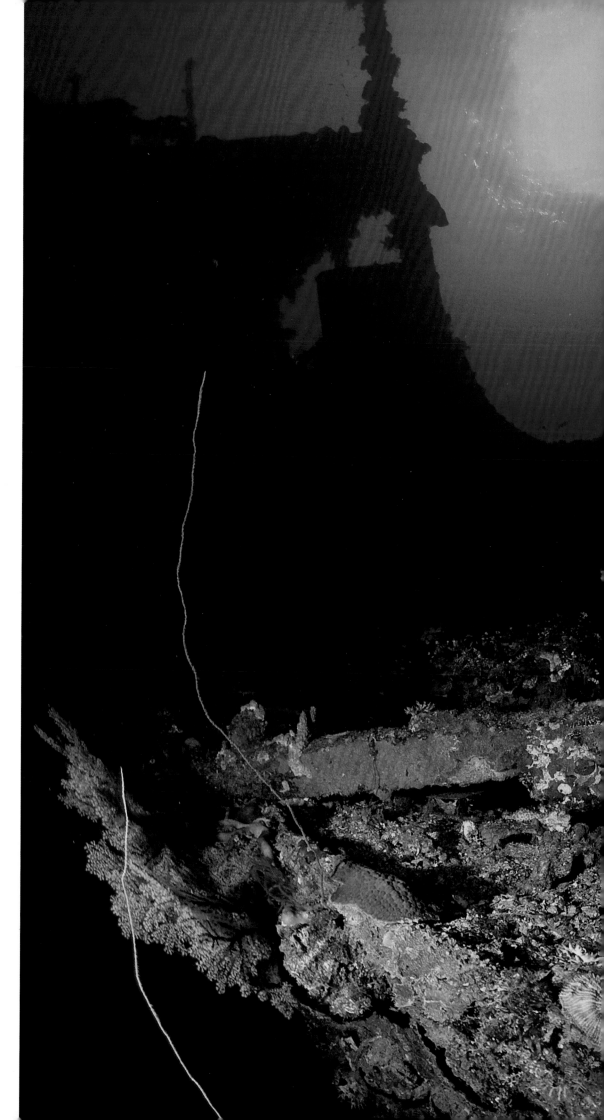

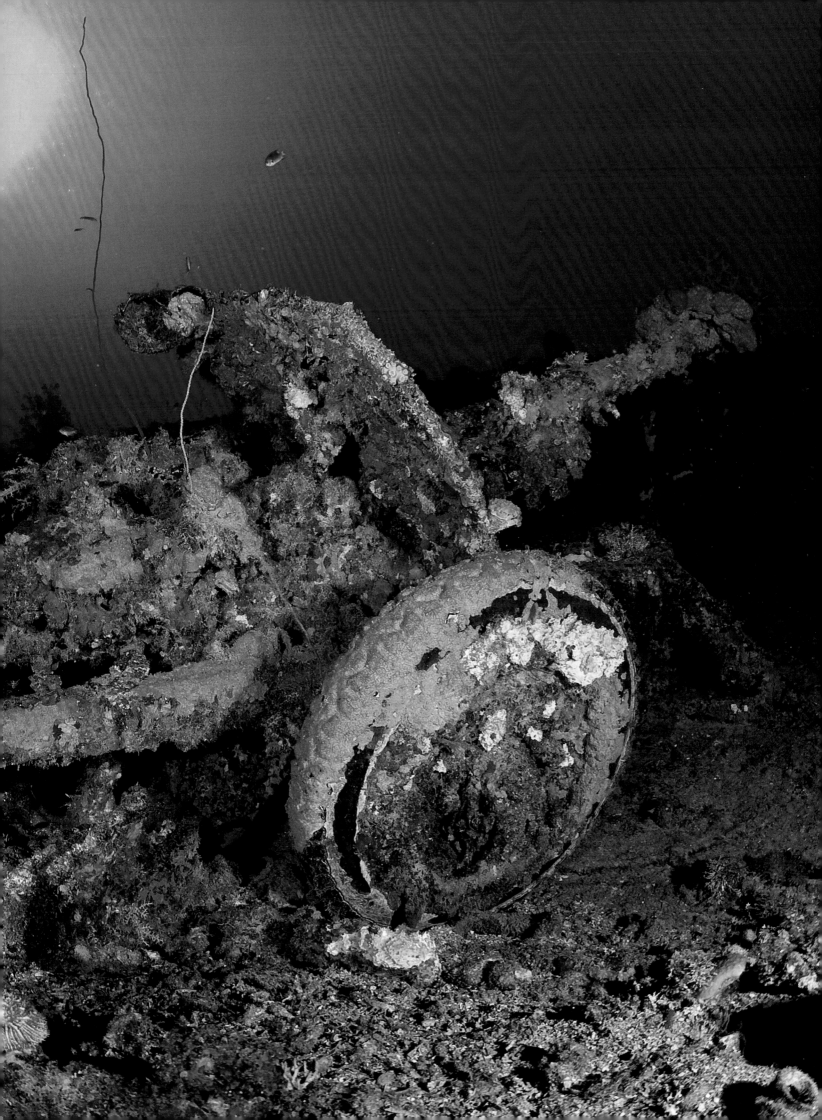

Saipan, Northern Mariana Islands
Saipan's strategic significance was obvious to military planners. It was located 2414km (1500 miles) from Tokyo and could act as a firm base for the final assault on mainland Japan. The fear of attacking Saipan was not of failure – by 1944 the Allies had naval and air superiority. The worry was that victory would come at a high price. The terrain gave Japanese forces a tactical advantage and the Americans were worried that a stubborn Japanese defence would inflict huge casualties on the invading American troops. The fears were justified and, on 9 July, nearly a month after the landings on 15 June 1944, when the last defenders were defeated more than 14,000 Americans had been killed or wounded. Japanese military and civilian casualties were 24,000 killed, including 5000 suicides.

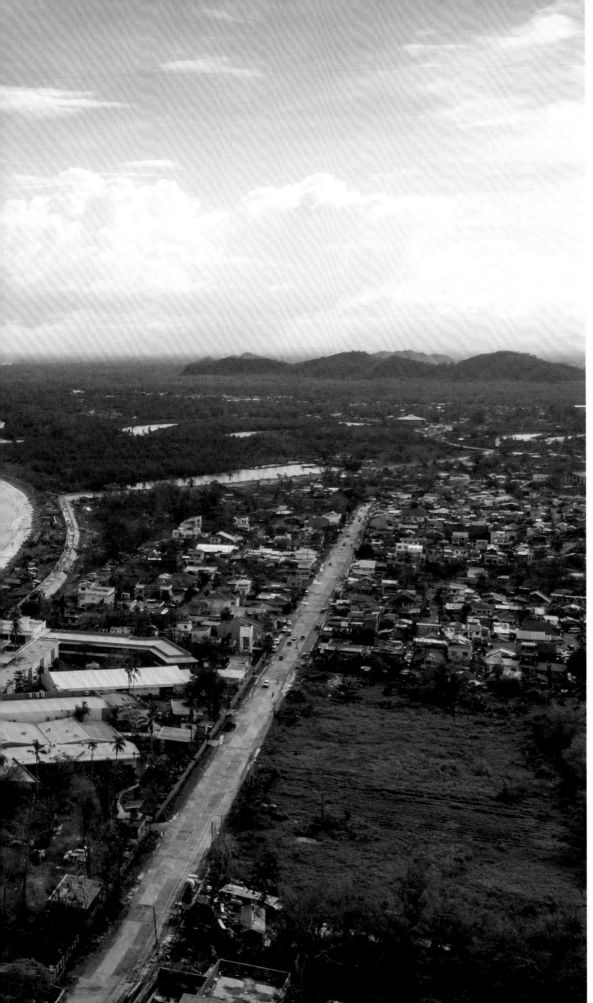

Coastline of Palo and Tanauan, Leyte Island, Philippines

The Battle of Leyte Gulf was the largest naval engagement of World War II. It raged in the Philippines from 23–26 October 1944. This epic confrontation followed amphibious landings by the American X Corps in the Palo and Tanauan area on the eastern coast of Leyte, a battle that didn't end until February 1945.

Leyte Gulf was where the Imperial Japanese Navy suffered its greatest loss of ships of the war, a total of 26 warships, including four aircraft carriers. It was also notorious for another historical first, when US Navy warships were hit by well-organized kamikaze suicide attacks, causing both material damage and fear. The battle was costly to both sides, with more than 23,000 American fatalities and 40,000 Japanese dead and wounded.

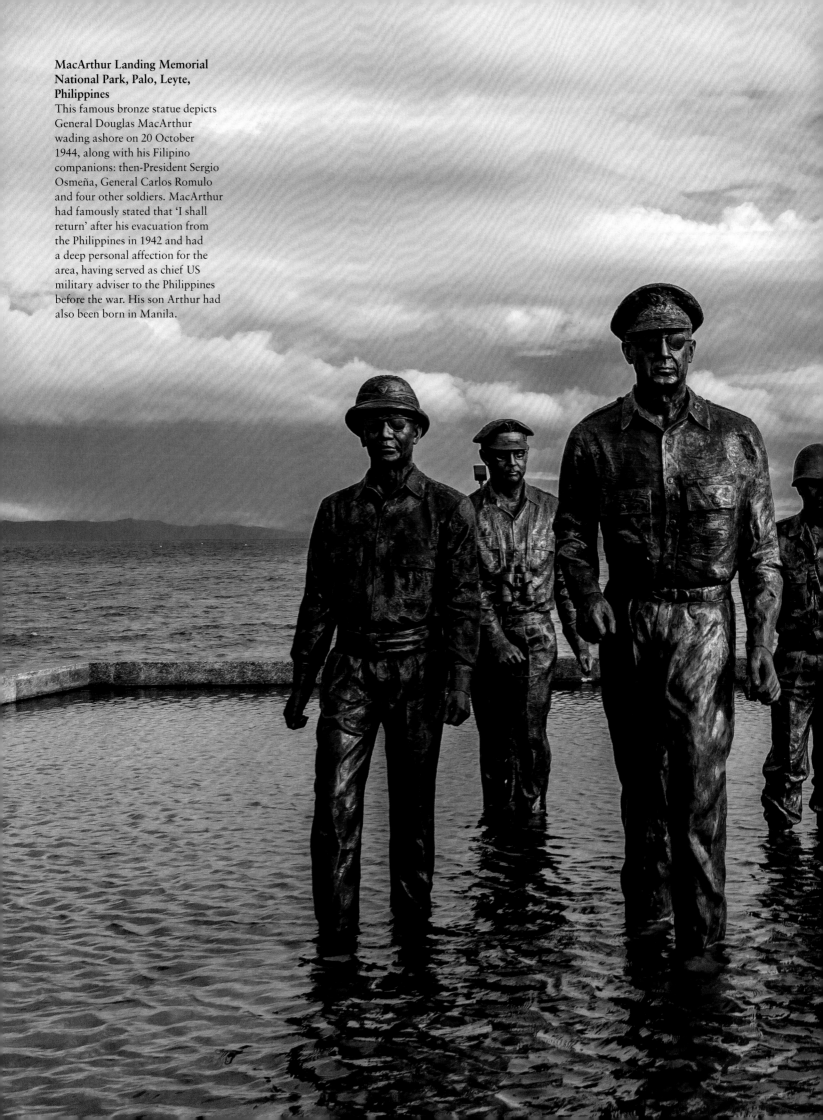

MacArthur Landing Memorial National Park, Palo, Leyte, Philippines
This famous bronze statue depicts General Douglas MacArthur wading ashore on 20 October 1944, along with his Filipino companions: then-President Sergio Osmeña, General Carlos Romulo and four other soldiers. MacArthur had famously stated that 'I shall return' after his evacuation from the Philippines in 1942 and had a deep personal affection for the area, having served as chief US military adviser to the Philippines before the war. His son Arthur had also been born in Manila.

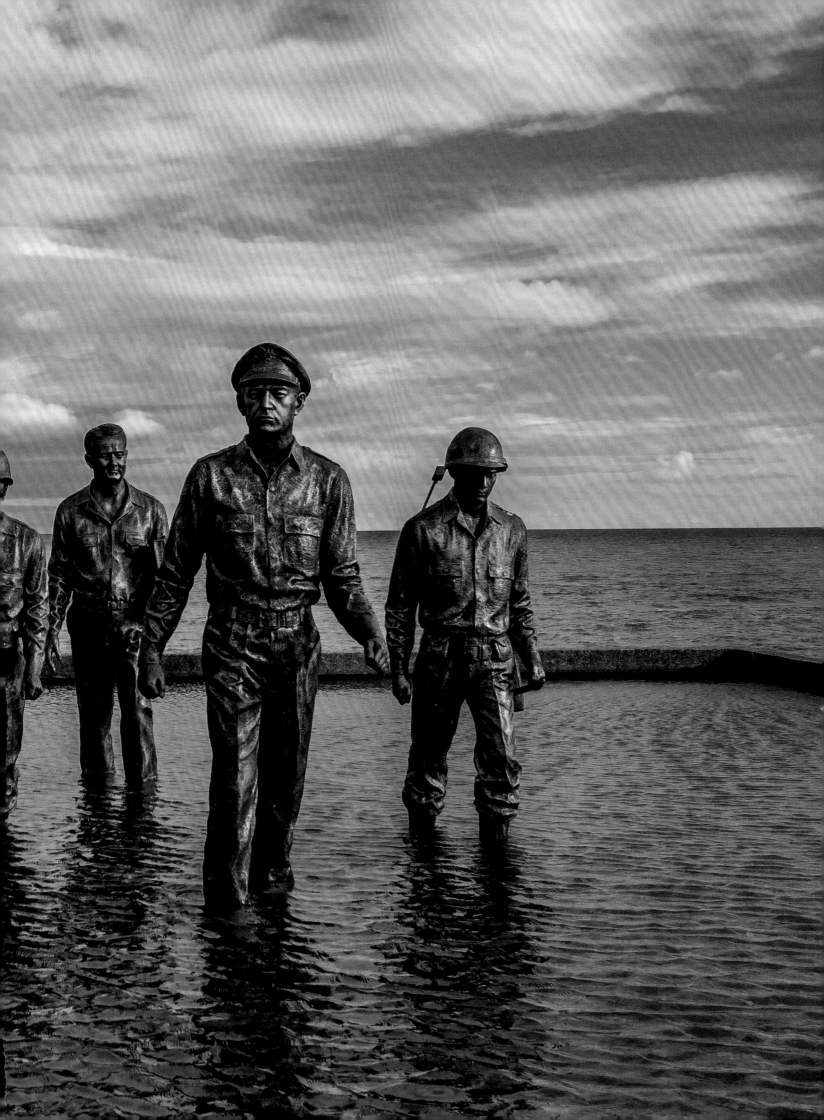

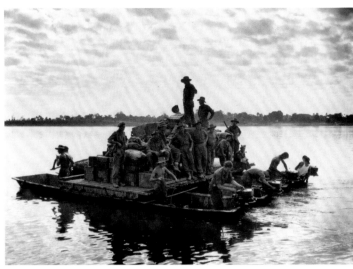

LEFT & ABOVE:

Irrawaddy River, Myanmar
By the beginning of February 1945, after a tiring but successful campaign, the British Fourteenth Army was ready to strike into central Burma (now Myanmar). The Japanese had seen three of their divisions decimated at Imphal and Kohima, and Allied commanders took the decision to press their advantage on through monsoon season and force the depleted and weary Japanese Army out of Burma for good.

To do that, the Fourteenth Army, consisting of troops from across the British Empire, would have to cross the wide and imposing Irrawaddy running north–south through the country. The 7th Indian Division's 33rd Indian Brigade would make the first crossing, while other units to the north and south would make noise and distract the Japanese.

In the early hours of 14 February 1945, the large flotilla of 120 boats and 18 rafts began to ferry the brigade across, one battalion at a time. It soon ran into problems: the current pulled boats downstream, heavy Japanese fire disrupted the process and navigation was difficult in the dark. But the brigade persisted and by the end of the day the nearby village of Nyaungu was in British hands.

2500 Commonwealth troops defeated 15,000 Japanese attackers at Kohima. It turned the tide of battle and forced the Japanese to fall back to Burma.

With momentum now firmly in their favour, in December 1944 the Allies launched their own last offensives into Burma. These followed other incursions and long-range penetrations by units such as the British Chindits and American Merrill's Marauders, during which better jungle-fighting techniques were honed and key Japanese strongpoints eliminated. The final campaign that liberated Burma was again a truly multinational affair. The Chinese Y Force attacked from the north, along with its American allies, and advanced into Yunnan, leading to the completion of the Burma Road.

OPPOSITE:
Burma Road, Chin State, Myanmar
The 1126km-long (700 mile) Burma Road linked Lashio in Burma with Kunming in China and had been built by 200,000 Chinese and Burmese labourers in 1937 to transport supplies for the Sino-Japanese war from the British colony of Burma to China. The road was cut in 1942 when the Japanese took Burma, but was retaken by the Allies in 1944. The Stilwell Road from Ledo could now connect to the Burma Road at Wanding in China, creating a new route; the first trucks reached China by this route in January 1945.

BELOW:
Huitong Bridge, Yunnan Province, China
The Salween Campaign of 1944 was General Stilwell's plan to recapture areas where his new Ledo Road would need to pass to link up with the older Burma Road on the Chinese border. Stilwell's Y force began to cross the Nu River on 11 May 1944 and 40,000 troops crossed that first day using hundreds of rafts and rubber boats. Fighting continued for the mountains beyond until September and then with a new bridge in place, the first supplies reached China via this route in January 1945. The reconstructed Huitong Bridge is now preserved as a monument to both the battles and the Ledo Road.

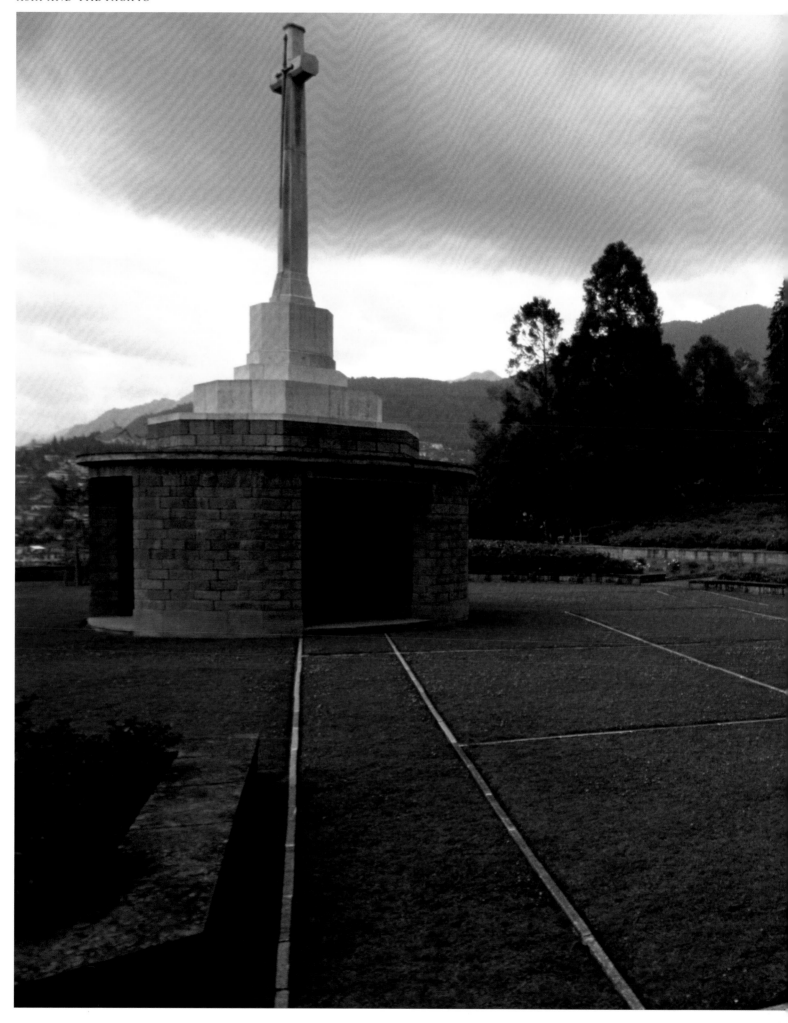

Kohima, Nagaland, India
Between 8 April and 1 May 1944 a battle raged around a small tennis court overlooking the District Commissioner of Naga Hills' bungalow that would determine the outcome of the whole battle for Burma. Days earlier, the Japanese had launched a large attack against British positions on the Kohima Ridge, hoping to drive on to India. During the ensuing battle the tennis courts were heavily mortared and shelled and saw some of the grimmest hand-to-hand fighting of the war. This was a battle of grenades and machine guns at close range and the losses on both sides were heavy. After a month of fighting the Japanese advance had failed and the British were pushing on to Imphal and beyond.

A Commonwealth War Graves Commission (CWGC) cemetery now sits in Kohima and, although no traces remain of the bungalow, white concrete lines mark and permanently preserve the historic tennis court.

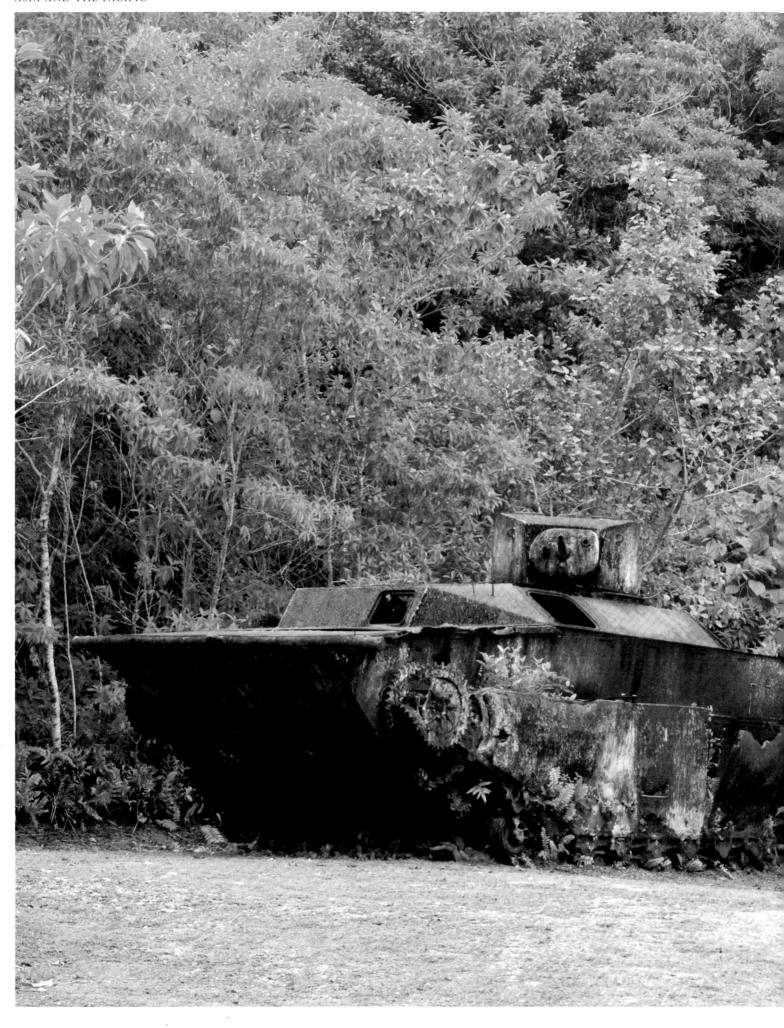

Peleliu, Palau Islands
A rusting LVT(A) stands by the steps to a Japanese cave on Bloody Nose Ridge in Peleliu. On 15 September 1944, the first wave of Marines from US 1st Marine Division landed on Peleliu, with hundreds immediately falling victim to Japanese gunfire. Despite these losses, the Marines pushed on through 46°C (115°F) heat for the island's airfield. Seventy-three days later, and after some of the hardest fighting of the war, the Japanese commander General Kunio Nakagawa proclaimed that 'our sword is broken and we have run out of spears', before performing ritual suicide. The Allies had won.

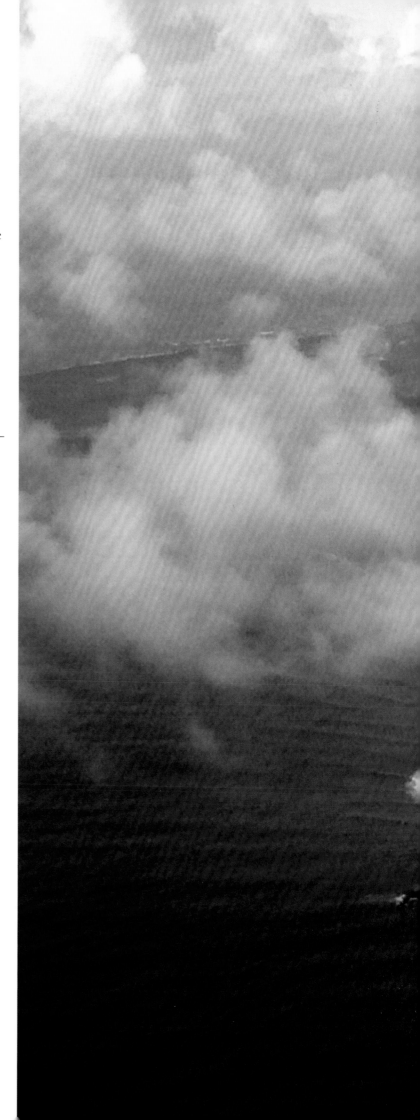

Meanwhile, Commonwealth amphibious landings in Arakan moved in from the west. By the time the Allies crossed the Irrawaddy River and overwhelmed Japanese units there, the end of the campaign was in sight.

The passage south to the city of Rangoon was now open, and it became a race between General Slim's Fourteenth Army and the start of the monsoon. With significant air support and assistance from the Royal Navy, the well-earned victory came on 4 May 1945.

CLOSING IN ON THE HOME ISLANDS

By early 1945, the island-hopping US forces had advanced as far as Okinawa, just 550km (340 miles) from Japan. The amphibious assault there was the largest of the Pacific War and some 180,000 troops fought a bloody and savage battle for control of the island over the next gruesome 83 days. Particularly shocking for those who came across them were the bodies of thousands of Okinawans who chose suicide over surrender.

It was due in part to the brutality of the campaign on Okinawa that President Truman chose to use other means to bring this abhorrent war to an end. Where the Eastern Front and Western Europe campaigns had ended jointly in Berlin, with a conventional ground battle with tanks and hand-to-hand infantry fighting, the war in Asia ended with the heralding of the nuclear age. On 6 August 1945 a B-29 bomber named 'Enola Gay' dropped an atomic bomb over the Japanese city of Hiroshima and approximately 80,000 Japanese were

Mount Suribachi, Iwo Jima
Mount Suribachi is a 165.8m-high (544ft) mountain on the southwest end of Iwo Jima. The name comes from its shape, resembling a suribachi, or grinding bowl. The famous flag-raising atop Mount Suribachi took place on 23 February 1945, five days after the beach landings. Associated Press photographer Joe Rosenthal took the photograph of five Marines and one Navy corpsman raising the flag. More battles followed the taking of Suribachi, including Motoyama Plateau and Hill 382, Turkey Knob, the Amphitheater and Hill 362. The battle in general became known as the 'meatgrinder' and 27 Medals of Honor were awarded for bravery on Iwo Jima – more than for any other battle in US history.

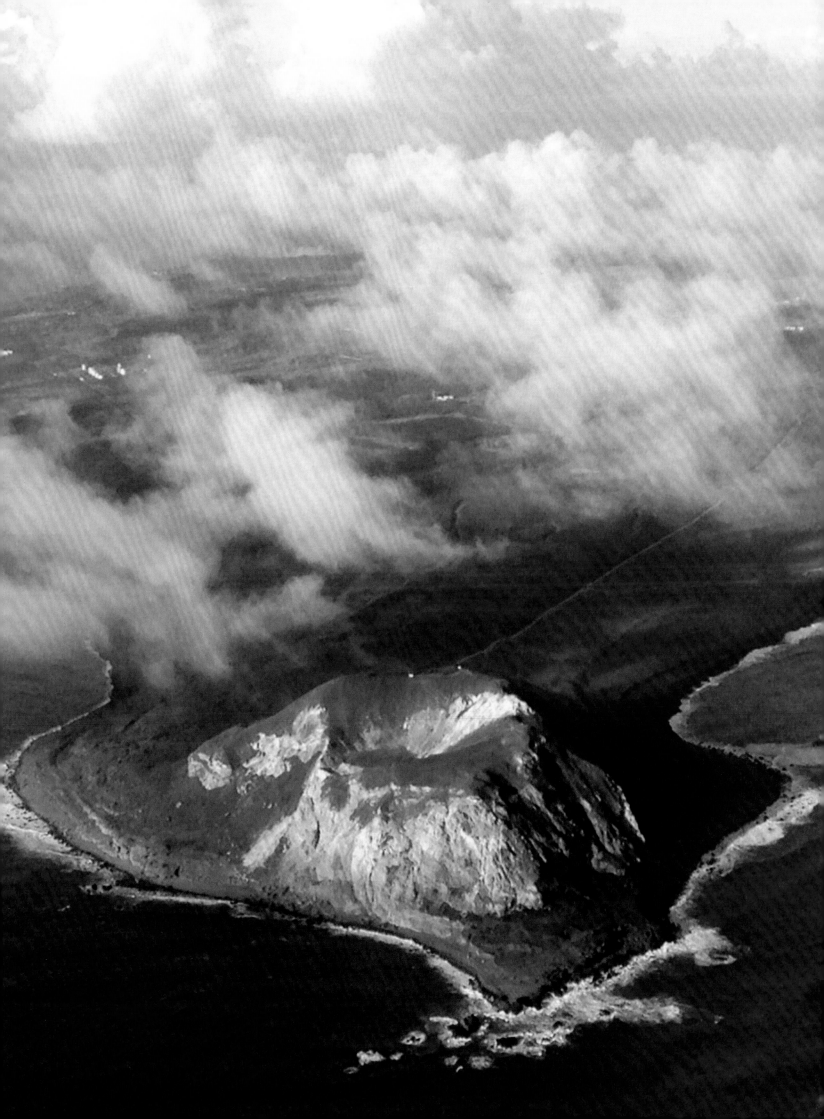

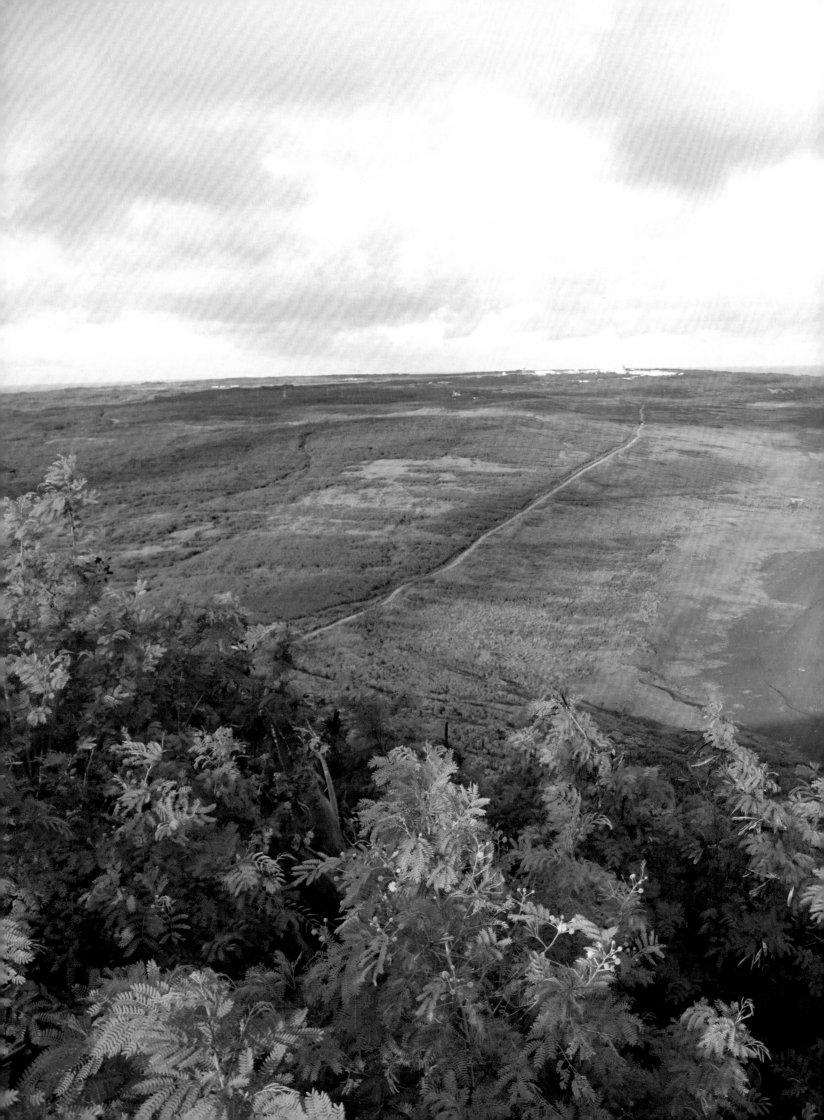

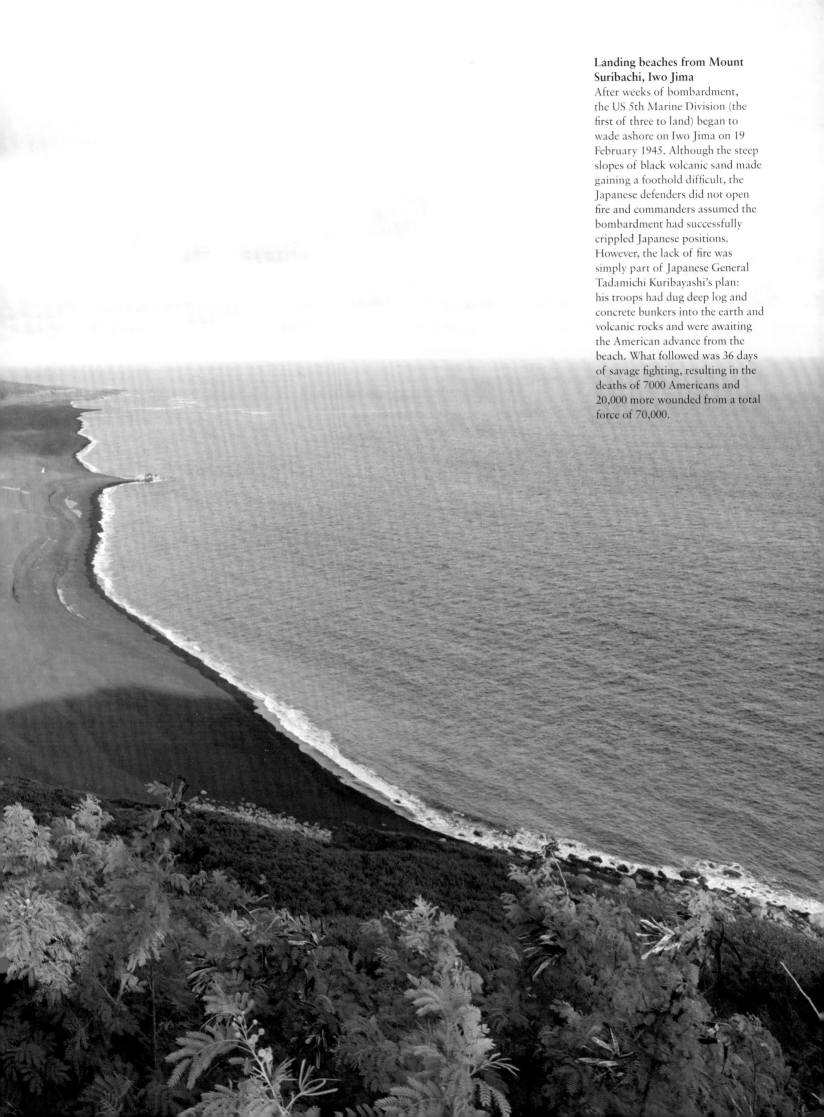

Landing beaches from Mount Suribachi, Iwo Jima
After weeks of bombardment, the US 5th Marine Division (the first of three to land) began to wade ashore on Iwo Jima on 19 February 1945. Although the steep slopes of black volcanic sand made gaining a foothold difficult, the Japanese defenders did not open fire and commanders assumed the bombardment had successfully crippled Japanese positions. However, the lack of fire was simply part of Japanese General Tadamichi Kuribayashi's plan: his troops had dug deep log and concrete bunkers into the earth and volcanic rocks and were awaiting the American advance from the beach. What followed was 36 days of savage fighting, resulting in the deaths of 7000 Americans and 20,000 more wounded from a total force of 70,000.

Shuri Castle, Okinawa, Japan
Between 1429 and 1879, Shuri Castle was a palace of the Ryukyu Kingdom, before becoming part of the Okinawa Prefecture of Japan. Today it is a UNESCO World Heritage Site. In 1945 it was at the centre of one of the final battles of World War II as the HQ of the Imperial Japanese Army, controlling a complex defensive system across the rugged southern part of Okinawa Island called the Shuri Defence Line.

On Easter Sunday (1 April) 1945, a force of 180,000 US Army and US Marine Corps troops descended on Okinawa for a final push towards Japan. Despite overwhelming odds, the Japanese initially conducted a successful defence of the island and the castle held out until 29 May when, after three days of shelling by the American battleship USS *Mississippi*, it lay ruined and ablaze. When Company A, 1st Battalion, 5th Marines, finally captured the castle it was a major psychological blow for the Japanese. Their final defeat was now just a matter of time.

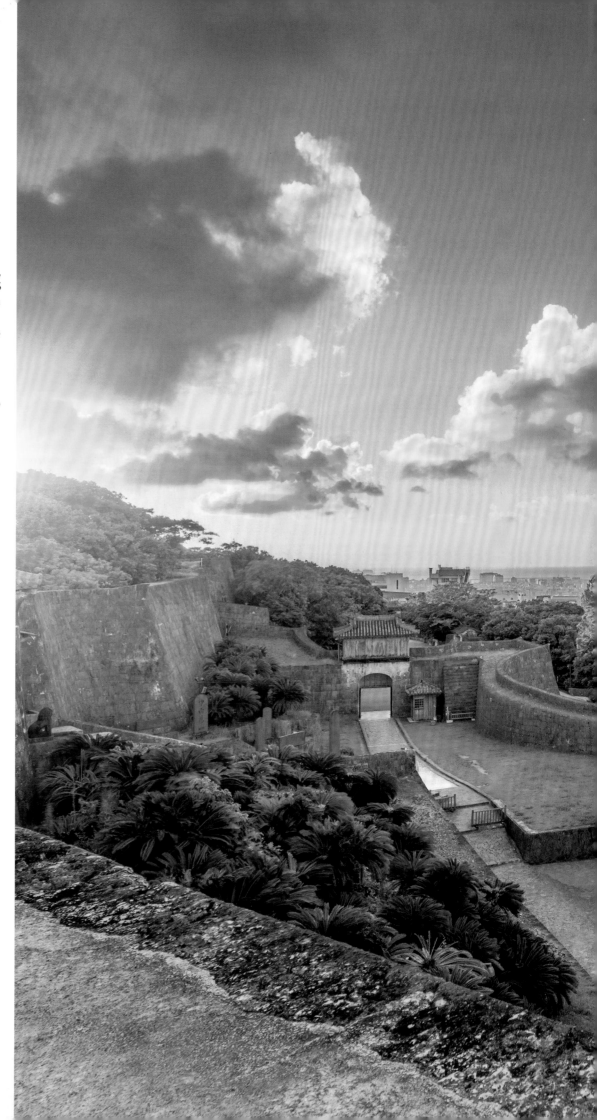

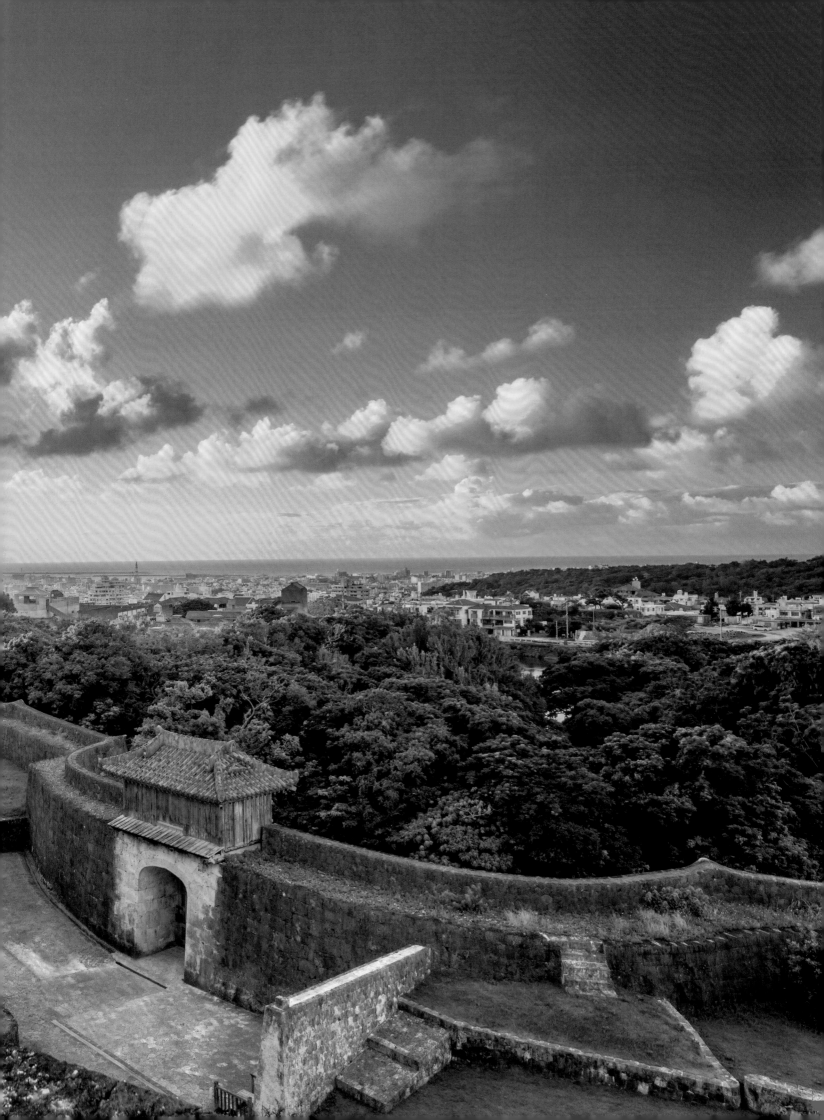

instantly killed. Three days later, a second B-29 dropped another atomic bomb on Nagasaki, killing a further 40,000 people. Tens of thousands more across Japan would later die of radiation exposure. Six days later, the Japanese Emperor Hirohito announced his country's unconditional surrender over the radio, citing the devastating power of a 'new and most cruel bomb'. The most devasting war in human history was over.

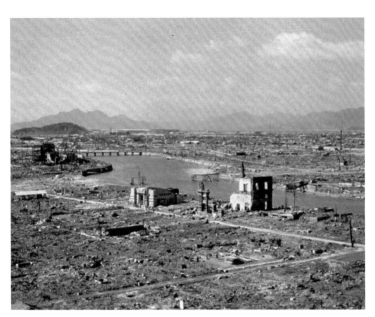

BOTH PHOTOGRAPHS:

Hiroshima, Japan
When the United States detonated two atomic bombs over the Japanese cities of Hiroshima and Nagasaki on 6 and 9 August 1945 it brought the greatest conflict the world has ever known to a dramatic and terrible conclusion. Up to 200,000 people were killed by the initial blast and the radiation that followed and the bombings remain the only use of nuclear weapons in armed conflict. Hiroshima was rebuilt after the war and proclaimed a City of Peace by parliament in 1949. One surviving building was the Genbaku Dome and it was incorporated into the Hiroshima Peace Memorial, which also contains a Peace Pagoda. The Peace Memorial and gardens represent both a place for prayer for the 1945 victims and a symbol of the struggle for permanent world peace. Today, Hiroshima is a prosperous manufacturing city with a population of more than two million people.

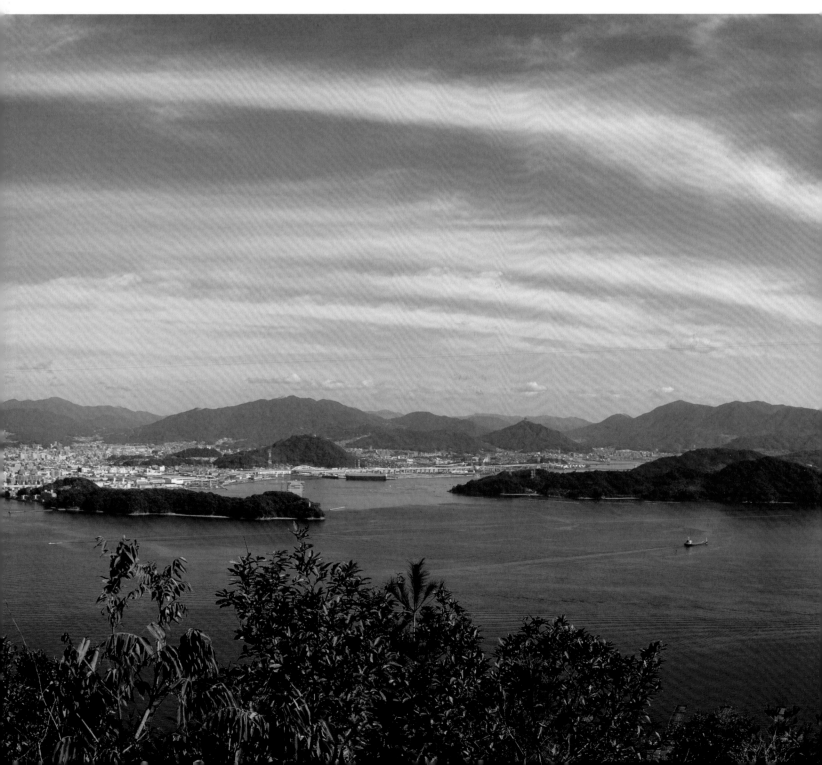

Picture Credits

Airsealand Photos: 48, 51 bottom, 86, 111, 172

Alamy: 8 (Imladris), 10 (Sueddeutsche Zeitung photo), 19 (Hemis), 22 (Rob Atherton), 23 (Pictorial Press), 33 (Interfoto), 37 (Prisma by Dukas Pressagentur), 42 (Maurice Savage), 49 (Wayne Farrell), 50 (Albatross), 51 top (Les Ladbury), 56 (Everett Collection), 57 (Les Ladbury), 58/59 (Nicolas Logerot), 60 bottom (Photo 12), 62 top (Interfoto), 73 (Rene van den Berg), 79 (Everett Collection Historical), 120/121 (Dpa Picture Alliance), 124 bottom (Pictorial Press Ltd), 128 top (),128 bottom (United Archives), 135 (Nigel J Clarke), 141 (World of Triss), 152 (ClassicStock), 164 (The Print Collector), 174 (Reuters), 175 (CPA Media), 176 (Wilf Doyle), 177 (The Photographer), 182/183 top (PJF Military Collection), 182 bottom (Gainew Gallery), 183 bottom (Rosanne Tackaberry), 184/185 (Hemis), 210 (Xinhua), 214 (Derek Brown), 217 (AH/Newscom), 223 top (Photo 12)

Dreamstime: 13 (Vof Vermuelen Perdaen + Steyaert), 45 (Gcostabella1969), 54/55 (Michael Mulkem), 95 (Robert309), 98/99 (Stas Vulkanor), 110 (Andrey Shevchenko), 122/123 (Pgaborphotos), 148 (Melissa Borguet), 150/151 (Rechittan Sorin), 156 (Enzo Minchella), 160 (Alessia Pinna), 165 (Waihs), 188 (Ethan Daniels), 196 (Naluphoto), 208 (Volodymyr Dvornyk)

Getty Images: 12 (Ullstein bild), 14/15 (Fabio Mauri/EyeEm), 20 (Heritage Images), 43 (PhotoQuest), 44 (IWM), 72 (Keystone/Stringer), 77 (Bettmann), 91 & 94 (Ullstein bild), 101 & 103 (Sovfoto), 108 (Universal History Archive), 118 (Sean Gallup), 142/143 (Alain Buu), 144–147 all (De Agoistini), 155 (Mondadori Portfolio), 166 (Barcroft Media), 186 (The Asahi Shimbun), 195 (Bettmann), 198 (Ullstein bild), 212/213 (Thierry Falise), 218/219 (Kyodo News)

National Archive and Records Administration: 189

Naval History and Heritage Command: 169

Nicholas Saunders: 35, 38–39 all

Paul Reed: 16/17, 24–31 all, 34, 46/47, 52/53, 62/63 bottom, 63 top, 64–71 top all, 74/75, 80–83 all, 130–131 all, 154 both, 158/159

Shutterstock: 6/7 (Jack Nevitt), 11 (Jelena Safronova), 21 (Aerial-motion), 32 (Henryk Sadura), 36 (Nicolas CM), 40/41 (Zachary L Gross), 60/62 top (Fokko Erhart), 76 (Chris Dorney), 78 (trabantos), 84 (Stephen Laude), 87 (Roman Babakin), 88/89 (M Velishchuk), 90 (Shoovar), 92/93 (Nahlik), 96/97 (Krivinis), 100 (KVN1777), 102 (Mistervlad), 104/105 (Fotogrin), 107 (Alexey Goloveshkin), 109 (Popoudina Svetlana), 113 (Vladimir Lednev), 114, 116/117 (Almazoff), 124/125 top (Alexey Fedorenko), 126/127 (ESB Professional), 129, 132 (Marco Fine), 134 (photovideo world), 136/137 (McCarthy's Photoworks), 138/139 (Gabriela Insuratela), 140 (Moussar), 153 (mkos83), 162 (SvetlanaSF), 168 (TechWizard), 170/171 (Allison Tackette), 173 (Pix Hound), 178 (Leemoc), 180/181 (JamesAus), 187 (Asia visions photography), 191 (maloff), 193 (Kyung Muk Lim), 194 (Tetyana Dotsenko), 199 (KKKVintage), 200/201 (Aquabluedreams), 202/203 (Bastrik), 203–207 all (MDV Edwards), 209 (Everett Collection), 211 (Sam DCruz), 220/221 (Kuremo), 222/223 bottom (fafo)

U.S Marine Corps History Division: 190

U.S National Archive: 71 bottom